Painting the
IMPRESSIONIST
LANDSCAPE

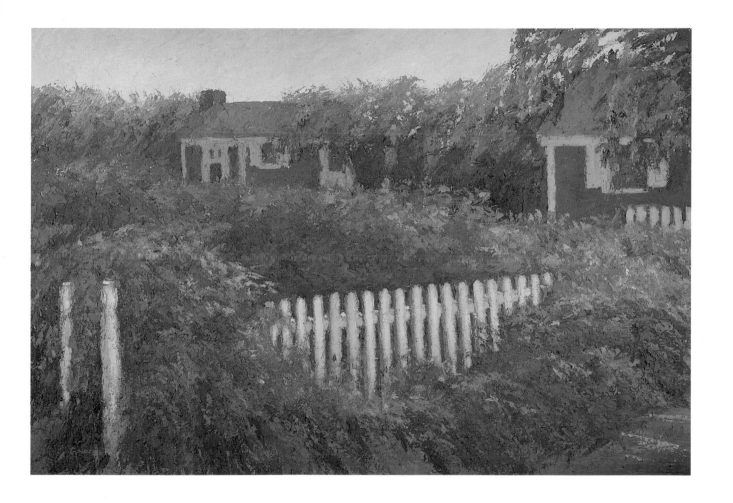

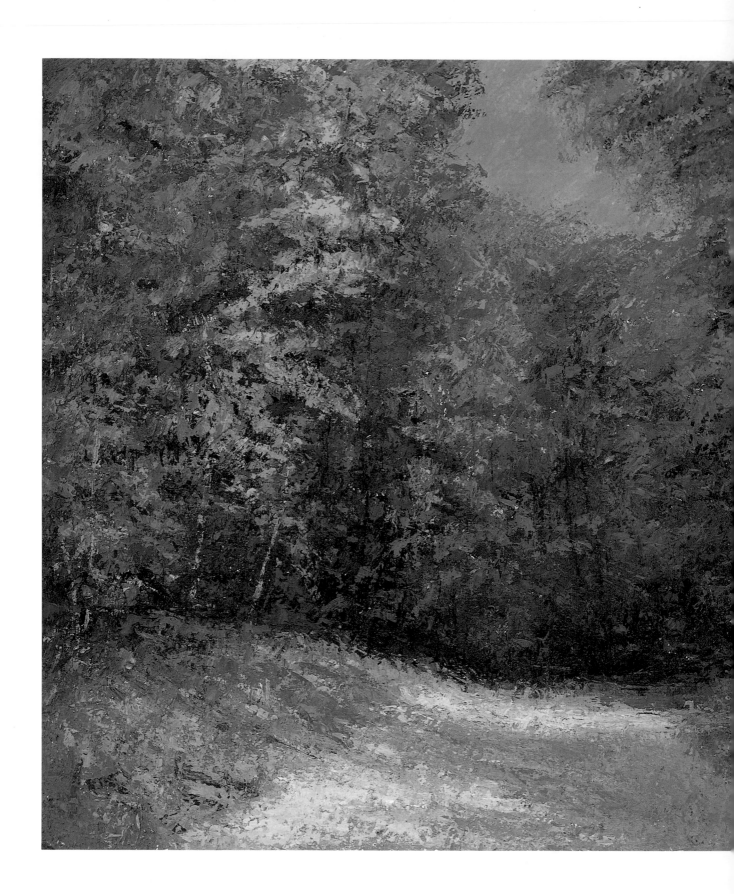

Painting the
IMPRESSIONIST
LANDSCAPE

Lessons in Interpreting Light and Color

Lois Griffel

Watson-Guptill Publications/New York

To my husband, Hal—who made me believe that anything is possible,
and who makes it all the more wonderful—for his support, patience, and love

Notes on the Art

Page 1:
LATE AFTERNOON ROSES by Lois Griffel. Oil on Masonite, 24 x 36 inches.
Collection of Til and Bob Chapman.

Pages 2–3:
PATH IN AUTUMN by Lois Griffel. Oil on Masonite, 24 x 30 inches.
Collection of Valerie Locher.

Pages 12–13 and 60–61:
Details of THE MOORS IN AUTUMN by Lois Griffel. Oil on Masonite, 24 x 30 inches.
Courtesy Rice/Polak Gallery, Provincetown, Massachusetts.

Copyright © 1994 by Lois Griffel
First paperback edition published in 2008 by Watson-Guptill Publications,
an imprint of the Crown publishing Group,
a division of Random House, Inc., New York
www.crownpublishing.com
www.watsonguptill.com

Library of Congress Cataloging-in-Publication Data

Griffel, Lois.
 Painting the impressionist landscape: lessons in interpreting light and color / Lois
Griffel.
 p. cm.
 Includes index.
 ISBN 0-8230-3643-X
 1. Landscape painting—Technique. 2. Impressionism (Art). 3. Light in art. 4. Color in
art. 5. Hawthorne, Charles Webster, 1872–1930—Influence. I. Title.
 ND1342.G75 1994
 751.45'436—dc20 93-45313
 CIP

ISBN: 978-0-8230-9519-3

Manufactured in China

1 2 3 4 5 6 7 8 9 / 16 15 14 13 12 11 10 09 08

ACKNOWLEDGMENTS

There are so many terrific people who helped make this book a reality. First, a heartfelt "thank you" to the marvelous staff at Watson-Guptill: Candace Raney, for her immediate and enthusiastic response to my proposal; Jay Anning, for a design that beautifully complements the artwork; and most especially to Joy Aquilino, not only for her exceptional skills and talents, which made my book better than I had ever dreamed it could be, but for being calm and understanding when I needed to "fix" something just one more time.

A special thanks to the many excellent photographers who understood my needs and gave me their best efforts: Marian Roth, Clifford Wheeler, Hank Gans, Linda McCausland, Jim Zimmerman, and Rodney Whitelaw. I would also like to express appreciation to the gifted friends and fellow artists who contributed their superb paintings, which were integral to a successful and complete explanation of the impressionist approach. My deepest gratitude and affection go to my wonderful friend Charles Sovek, an outstanding artist and author who so generously shared his insights, humor, and expertise with me, and whose experience helped me clear some difficult hurdles, thereby making my endeavor much easier.

I am extremely grateful that my artistic interest was recognized early in childhood and lovingly nurtured by my family: my parents, Gloria and Sid; my brother, Paul; and my aunts Mary and Esther. I would also like to express my appreciation to the students and colleagues who encouraged me to write this book. Their artistic achievements and unwavering interest in pursuing the beauty of nature sustain me with a limitless source of motivation. Ultimately, I was blessed with many opportunities to study with excellent teachers who shared their love of painting with me. From among them, I must single out the greatest artist I have ever known, Henry Hensche, whose creative accomplishments and devotion to the principles established by Charles Hawthorne created a desire for excellence within me that will remain an inspiration forever.

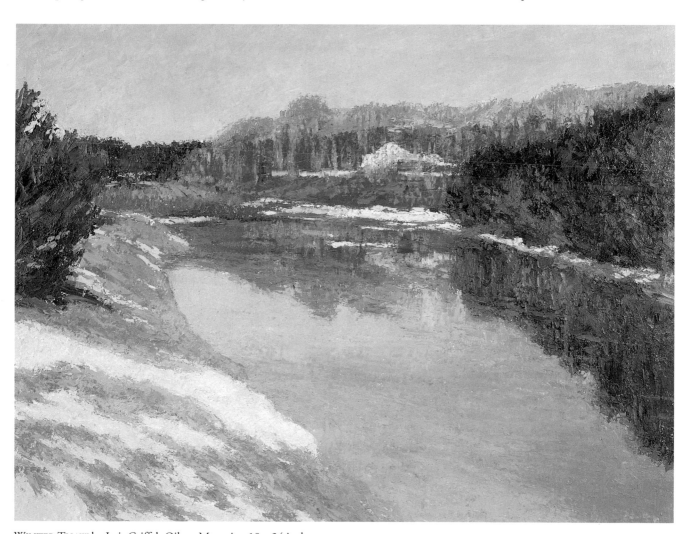

WINTER THAW by Lois Griffel. Oil on Masonite, 18 x 24 inches. Collection of Mr. and Mrs. Arthur Goldstein.

DAFFODILS ON THE HILLSIDE by Lois Griffel. Oil on Masonite, 18 x 22 inches.
Courtesy Herman-Krause Collection.

Contents

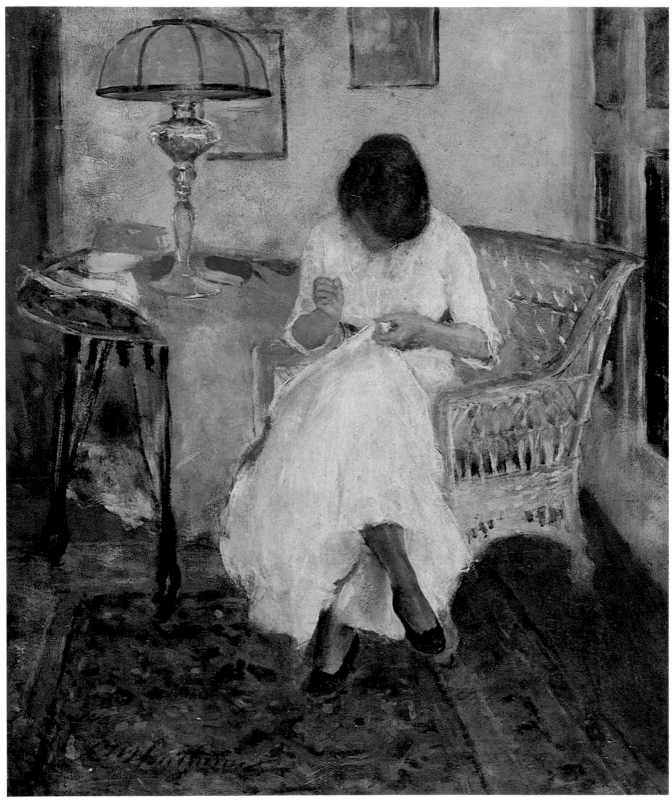

WOMAN SEWING by Charles W. Hawthorne. Oil on canvas, 29 x 24 inches.
Courtesy Provincetown Art Association and Museum, Provincetown, Massachusetts.

Introduction

Painting the Impressionist Landscape is based on the color theory originated and made famous by Charles Hawthorne, a student of William Merritt Chase and the founder in 1899 of The Cape Cod School of Art in Provincetown, Massachusetts. The school, which became the first in the United States to concentrate solely on painting outdoors, was responsible for the development of the artist's colony in Provincetown, which was dignified by the presence of many noted American impressionists, including Frederick Frieseke, Richard Miller, and Dwight Tryon. The passionate belief in the plein air approach that Hawthorne cultivated at the school simultaneously flourished at the artist's colony in Old Lyme, Connecticut, where Frederick Childe Hassam, John Henry Twachtman, and Julian Alden Weir were among the luminaries. Respect for Hawthorne is not limited only to impressionists, nor to artists working strictly in a classical style. Indeed, Hans Hofmann, one of the great teachers of abstract art in the United States, greatly revered him.

The color theory handed down from Hawthorne through The Cape Cod School of Art has far-reaching potential for anyone who loves color and who loves to paint. Many students have come to know this great artist and educator thanks to a small publishing phenomenon called *Hawthorne on Painting,* a compilation of notes taken in Hawthorne's classes by his students, which was first published by Dover Publications in 1938 and is still regarded as a definitive art instruction text.

Hawthorne said that "Everything under the sun is beautiful." Expressing the beauty of nature in painting is one of the primary goals of impressionism, which is the use of color to express a quality of light in the open air. It is an understatement to say that the world relates to and responds to color. From the young child opening her first box of crayons to the thousands of tourists who each year flock to see the gorgeous colors of New England's autumn, people love color. Is it any wonder that most artists

today want to enhance their color abilities, regardless of their painting style?

Within the tradition of American impressionism, Hawthorne encouraged his students to paint directly from nature. It should be pointed out that an artist cannot merely copy nature. Instead, artists must train themselves to interpret into paint the visceral reaction to what you are seeing. Luckily, achieving this sounds more difficult than it is; the basic prerequisites are an open mind and a sense of adventure, both of which will enable you to expand your visual awareness. This book, which is designed to show you how to observe the endless variations in nature and translate them into pigment, provides a means by which to develop your visual perception. The step-by-step color exercises will enable you to paint and explore color in a new and vigorous way, expanding your response to nature and help you see the infinite variety of light and atmosphere that the first impressionists captured in their paintings.

Artists paint because they want to share their love of nature. When we journey to a favorite landscape site, we are enthralled with light and color. As Hawthorne noted in *Hawthorne on Painting,* "The vision of the artist is the vision to see and the ability to tell the world something that it unconsciously thinks about nature." For me, art lifts the spirit and reminds me of the beauty of the world. Painting gives me the opportunity to share that feeling.

We can thank the impressionists for their legacy, which revealed to humanity the splendor of color and light in painting. We are truly fortunate to be able to continue in that tradition.

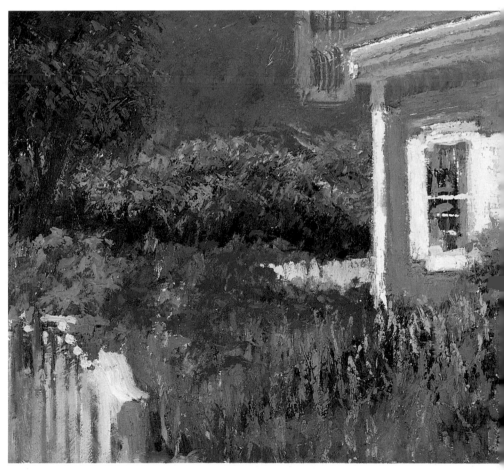

POPPIES IN A GARDEN by Lois Griffel. Oil on Masonite, 14 x 18 inches. Courtesy Rice/Polak Gallery, Provincetown, Massachusetts.

A Path to Color Awareness

Throughout my dual career of student and teacher of art, I have frequently considered the concept of artistic talent. I believe that while achieving a goal takes dedication and work, it is most important to take definitive steps in the direction you would like to go. Teachers should encourage students to explore greater horizons, as well as seek answers to their own questions. This idea was first expressed to me by a college instructor whose painting style I greatly admired. He refused to depart from his curriculum of the elements of design to conduct a class in painting because he believed he couldn't teach it without creating stylistic "clones."

After becoming a teacher, I understood his feelings intimately. Students should be given directions to their individual destinations, not led by the hand. With a strong foundation in the discipline of art, one can travel any path; without it, potholes and detours along the way can impede momentum toward improvement and growth. To paraphrase Degas, you must study all the basics, whose discipline yields artistic freedom.

In my own art education, I explored as many avenues of painting as possible, and as a result gained a well-rounded background. I concentrated on a classical approach at the Art Students League in New York, where I developed my drawing skills and studied figure and portrait painting. When I decided to expand my horizons to include landscape, I was drawn to studying light and color in Provincetown with Hawthorne's protégé, Henry Hensche, who continued to teach and advanced upon Hawthorne's methods of seeing and painting color. My association with Hensche and the school, as well as the beauty of the landscape of Provincetown, opened my eyes to light and color and kindled a spark within me that will remain in my heart forever. Hensche continued to serve as the director of the school until 1986, when I had the great honor of becoming its director. Since then I have elaborated on the color theory that has been taught at The Cape Cod School of Art since it was founded along with the fundamentals of good painting expressed in *Hawthorne on Painting* into a comprehensive curriculum.

Decades after its publication, *Hawthorne on Painting* still intrigues and inspires students of painting in general and of impressionism in particular. Unfortu-

PATTERNS OF LIGHT by Lois Griffel. Oil on Masonite, 20 x 24 inches. Collection of Peter and Susan Milsky.

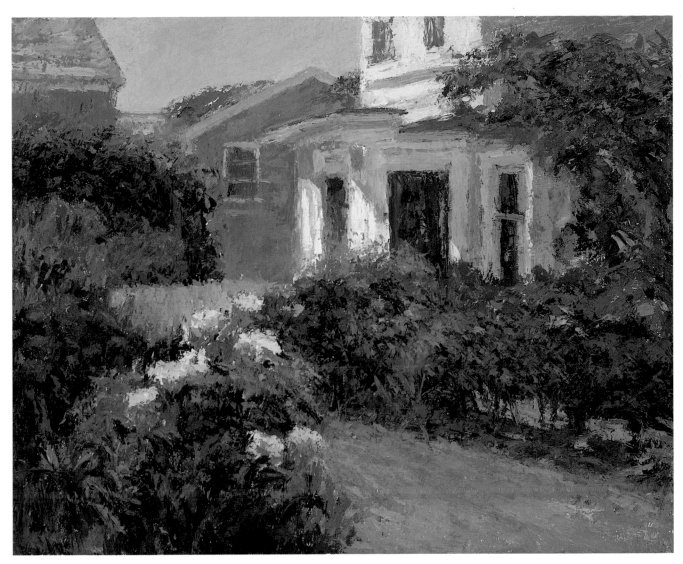

MY FAVORITE ROSE GARDEN by Lois Griffel. Oil on Masonite, 16 x 20 inches. Courtesy Rice/Polak Gallery, Provincetown, Massachusetts.

nately, many readers have expressed frustration at not being able to use the book as a practical guide, complaining that many of the concepts are not fully explained. With this in mind, I decided to develop a complete painting program that fleshes out Hawthorne's philosophy with concrete exercises and lessons, the result of which is this book: a practical application of Hawthorne's theories combined with my own methods of instruction.

First and foremost, *Painting the Impressionist Landscape* offers artists at every level of experience the potential to heighten their color awareness, guiding them toward a new path of color exploration. In order to illustrate Hawthorne's terminology and concepts, I developed charts and exercises that relate specifically to his theories. Readers are shown how basic color theory is used to reflect the fundamentals of the impressionist tradi-

tion, with an emphasis on how the delicacy and subtlety of the most challenging of subjects, the light effect within a landscape, can be captured in a painting.

The techniques discussed can benefit both the novice and the professional, and can be applied easily to all mediums. Within the demonstrations, which are structured so that readers can follow along with the text while working at their own pace, I explain how I made a decision about each color choice, and how each affects the development of the painting as a whole.

Regardless of your preferred subject or approach, this book will enrich your work. Learning to see color and light in nature is what painting is all about. I hope that this book opens your eyes to color, and that it bestows on you the gifts of awareness and confidence to paint with great daring and intensity.

Part One

FUNDAMENTALS OF COLOR AND LIGHT

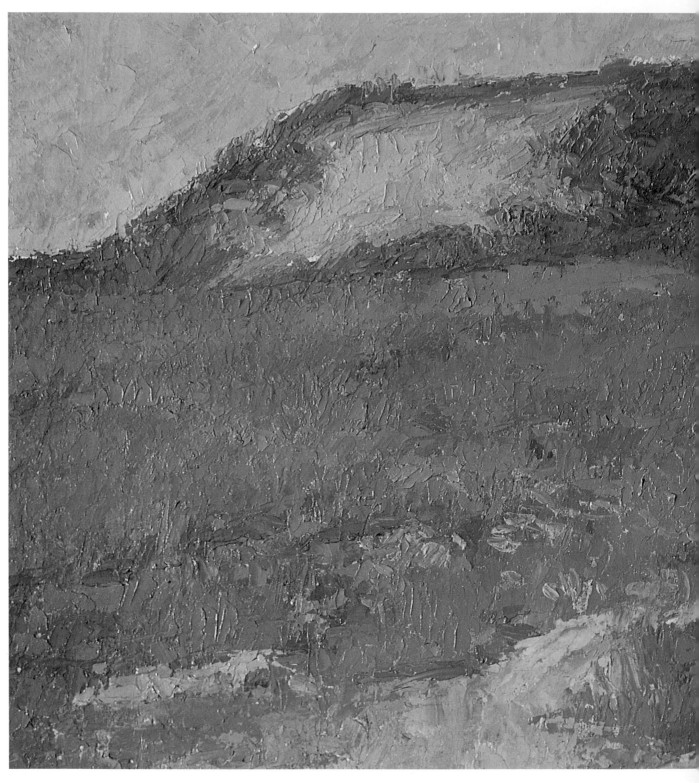

HAZY DAY DUNE by Lois Griffel. Oil on Masonite, 12 x 18 inches.
Collection of Suzanne Bouvassa and Pamela Kachurin.

Hazy light is never as dreary as we might first think it is. Rather, this beautiful and ethereal
variety of light allows us to see colors as rich and saturated, since they are neither bleached out
by bright sunlight nor cooled by its absence. It is exciting to offset the obvious greens of the
landscape with violets and pinks that give the greens a hazy quality. The overall effect is one of a
heavy atmosphere, expressed effectively through relationships of large, simple masses of rich color.

Color in Landscape Painting: From Tonalism to Impressionism

1

What does the term *tonalism* actually mean? The tonalists (also known as *valuists),* who include such painters as Rembrandt, Titian, Velázquez, and the Byzantine artists, were appreciated most for their skill in drawing and rendering. These "academicians" were trained to observe the visual world based on a tonal system of local color and value. Henry Hensche once observed that "the tonal sense of Rembrandt and Titian was so highly developed that the average onlooker is unaware of their limited color range." In this chapter, we will compare the painting techniques used in tonalism and impressionism, and review the progression from tonalism to the world of color.

PLEIN AIR VS. STUDIO PAINTING

The valuists or tonalists painted primarily with umbers and dark browns because other colors were simply not available to them. (It has often been said that Rembrandt would have been an impressionist if he had had access to the pigments that were developed and used in Monet's time.) When working on location, tonalists sketched black-and-white drawings, perhaps accenting them with Conté crayon. Back in the studio, these artists interpreted their observations of light from these drawings. Without the advantage of drawing on direct observation, they relied on generalizations about color in the world; for example, that the sky is blue and that trees are green.

While their paintings are indeed beautiful and artistically accomplished, the tonalists were not interested in seeking greater truth in nature. Their color was limited and formulaic not only because they lacked a variety of pigments with which to express an awareness of color, but because they lacked the understanding to see the amazing variations that exist both in nature and light.

It is interesting to compare the differences between one of Monet's early paintings and one of his later works. *Rue de la Bavolle, Honfleur* was an early attempt to paint landscape on location. Although this particular landscape does not have the heaviness that is generally characteristic of tonalism, its shadows are consistently brown, with little variation

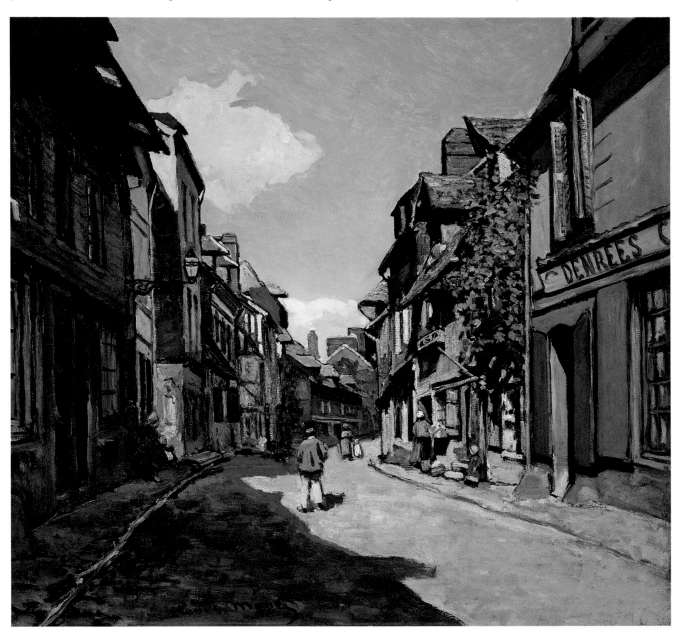

RUE DE LA BAVOLLE, HONFLEUR. Oscar Claude Monet (French, 1840–1926). Oil on canvas, 55.9 x 61 cm (22 x 24 inches). Bequest of John T. Spaulding; Courtesy of Museum of Fine Arts, Boston.

shown from one side of the street to the other. The sunlit portion of the painting is warmer and has a yellow influence, but there is still little variation between the buildings and the passersby. The overall effect is one of sunlight observed, but Monet had yet to paint its extraordinary richness and variety. Monet's structural approach to the street scene is significant because it suggests that at this point in his career he was still focused on the literal aspects of his subject. Once he opened his eyes to color, detail became much less important.

In addition to developing a wide range of vivid colors in the early nineteenth century, paint manufacturers also began selling their paint in pigskin bladders bound by twine, essentially making paint portable for the first time. Because of this, Monet and his contemporaries were able to remain outdoors and observe nature in its truest glory. With an opportunity to observe nature directly, Monet realized that it offered an incredibly diverse light effect. He then

dedicated his entire life's work to studying that diversity, while at the same time opening his viewers' eyes to nature.

In one of his later paintings, *Valley of the Creuse (Sunlight effect),* Monet used very pure color notes (Hawthorne referred to them as *spots)* to intensify all the color areas. These brilliant (and usually pure) pigments visually combine with subtler adjacent mixtures. The result is an intensified version of the landscape that appears to be illuminated by its own light source. Strokes of bright orange mix visually with rich notes of light green, making the grass appear sunny. When viewed from a distance, the colors combine to create warmth.

Monet created rich browns and earth tones by visually blending cool pigments over warm underpaintings. Notice that he uses accents of purple, green, and warm golds within the masses of the shadowed foreground. He creates a similar effect in the water, which is made up of blended strokes of green and blue, resulting in a rich, aqualike color.

VALLEY OF THE CREUSE (SUNLIGHT EFFECT). 1889. Oscar Claude Monet (French, 1840–1926). Oil on canvas, 65 x 92.4 cm (25 ⅝ x 36 ⅜ inches). Juliana Cheney Edwards Collection; Courtesy of Museum of Fine Arts, Boston.

IMPRESSIONISM: LIGHT AND ATMOSPHERE

Monet never tired in his search for visual truth, and dedicated his life to studying the principles of his revelations. He discovered the visual differences among atmospheric conditions, and became aware of the multiplicity of color even within morning, afternoon, and evening light. His insatiable drive to record every nuance and every light effect made him extremely critical of what he perceived to be his own limited artistic abilities.

As can be seen in the work of well known and respected American impressionist painters such as Frederick Childe Hassam, John Henry Twachtman, and Edward Henry Potthast (to name only a few), the response in the United States to Monet and the European impressionists was that American artists' eyes were opened to the discovery that nature is infinitely varied, that every day and every light effect is different. As a result of their freedom to travel to paint on location and the technology that led to the development of brilliant new pigments, American artists were able to pursue unlimited opportunities in landscape and light effect.

It is now legend that these paintings were at first scorned by the general public, who simply did not understand what they were seeing. Today, impressionism is widely embraced by both artist and layperson, and a love of color and light has been incorporated into nearly every type of painting that is practiced today.

In 1899, Charles Hawthorne happened upon a small fishing community—Provincetown, Massachusetts—whose beautiful clarity of light was similar to that of the village of Barbizon, located some twenty miles outside of Paris, where French impressionism had been nurtured in its infancy. He felt that he had found the perfect place to study light and color, and subsequently opened The Cape Cod School of Art. Hawthorne discouraged his students from worrying about details and "finished paintings," and challenged them to paint with putty knives so that they would focus on large "spots" or masses of color in order to clearly see and interpret the effects of light on form.

Hawthorne and his successor, Henry Hensche, devoted themselves to studying light and the way in which the ever-changing atmosphere influences our perception of color. Hawthorne's great contribution to art education and color theory was to change the historically accepted concept of tonality. Instead of placing an emphasis on linear drawing and a "filling in" of colors, Hawthorne, realizing that the eye sees large forms of light and dark before it registers detail, based his color theory entirely on looking and expressing those large forms of light and dark through color spots. However, he did not—and did not intend to—supplant the prevailing understanding of value. The first quote cited in his *Hawthorne on Painting* is from the great tonalist painter Edwin Dickenson (1891–1978): "That plane relationships are more representable through comparative value than through implications of contour drawing was a truth which Hawthorne drilled into his pupils." Emile Gruppé, who credited Hawthorne with inspiring his own study of color, explained that it is the process of taking those big value masses and seeing them as color spots that brings us out of the world of the tonalists and into the light.

MARSH, SUNNY MORNING by Peter Weber. Oil on Masonite, 12 x 16 inches. Private collection.

This painting uses large, simple masses that create a sense of light and space with very little detail. There is almost a jigsaw puzzle–like simplicity to the shapes. Hawthorne believed that you must be able to see large masses of color in order to paint their correct color relationships. Because he used rich color, Weber's landscape is still descriptive and understandable. With such effective simplicity, additional detail becomes unnecessary.

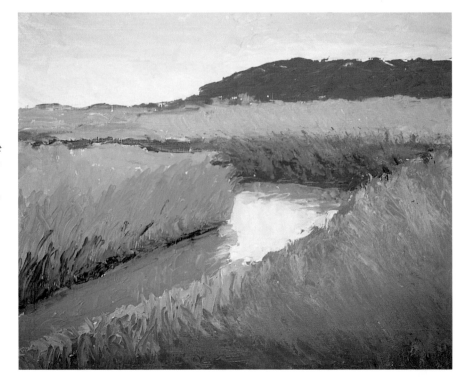

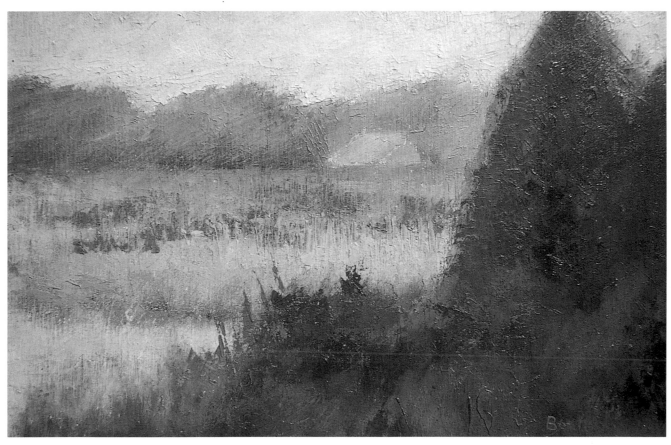

FIELD IN EVENING LIGHT by Jim Beatrice.
Oil on Masonite, 16 x 20 inches.
Collection of the artist.

As the sun sets, the evening light becomes very red, and this painting is infused with the effect that this rich light has on the landscape. The large masses are broken up with additional "spots" of color, but they do not break up the basic shapes of the landscape. The richness and vitality of the color convey the light key better than the use of minute detail, making a strong and simple statement.

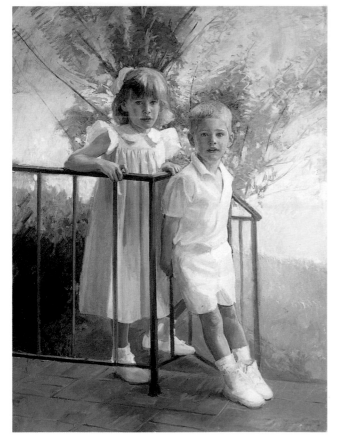

CHILDREN OF DR. AND MRS. JOHN BYRNES
by Cedric B. Egeli and Joanette H. Egeli. Oil on canvas,
54 x 40 inches. Collection of Dr. and Mrs. John Byrnes.

This commissioned portrait, which was influenced by the study of the effects of outdoor light with Henry Hensche of The Cape Cod School of Art, shows consummate skill in the convergence of the draftsmanship that is necessary for great portraiture and the ability to paint and capture light effect, and demonstrates a clear understanding of how to express light as color. Although the children are posed, their vitality is conveyed by the luminosity and airiness of the portrait; the entire painting is literally bathed in light. The shadows are light in value and filled with color. The light colors in the flesh notes and clothing are all different, and expressed with clear color, not washed-out tints.

Life would be so boring if we were only able to see and express the world in tonalist grays and browns. Not only did the impressionists change painting forever, they also created an awareness in their audience of the beauty and variety of our natural world. The fun of observing endless color is a lifelong preoccupation, one that never becomes tiresome. How thrilling to never run out of subject matter; to be able to see something familiar or mundane in a new way. This can only be done through the excitement and pursuit of impressionist painting. We are so lucky to be able to follow in the path of the impressionists; to continue their pursuit of recording our world as it truly exists.

Toward this ideal we embark on the study of color and light. Perhaps in doing so I can share, in some small way, the joy and fullfillment it has given me.

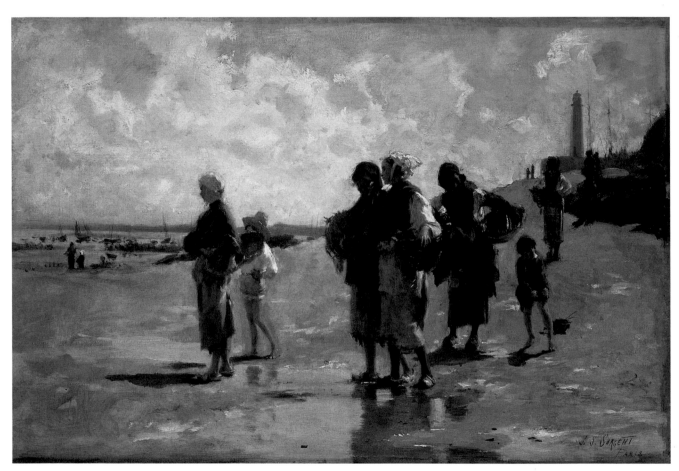

OYSTER GATHERERS OF CANCALE. John Singer Sargent (American, 1856–1925). Oil on canvas, 16¼ x 23¾ inches (41.2 x 60.3 cm). Gift of Mary Appleton; Courtesy of Museum of Fine Arts, Boston.

Sargent was highly praised for his virtuosity of light effect and draftsmanship. He was one of the first to paint figures outdoors within an actual landscape (rather than incorporating drawings of his subjects into a finished landscape at a later point, which was the accepted academic method), which gave the overall composition a truer sense of light and space. However, Sargent was still drawn to expressing details and rendering.

Although it is light-filled and luminous, this work is still essentially tonal. The darks throughout the figures and the cluster formed by the lighthouse, ships' masts, and rocks on the right are all painted with similar dark, somber colors. You can see, however, the richness of color illuminating the skin tones of the faces of the women and legs of the children. While tonal, the influence of the light on flesh notes is evident.

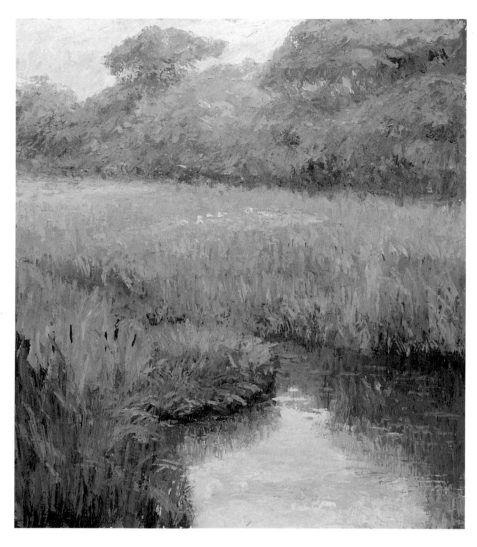

MORNING BY HERRING CREEK
by Robert Longley. Oil on Masonite,
22 x 18 inches. Courtesy Jacob Fanning
Gallery, Wellfleet, Massachusetts.

*This artist has captured the early
morning light as it starts to fill the
landscape, both through color and
composition. But it is the beauty of the
rich color, in both the light areas and
the shadows, that helps convey this
effect. Rather than reducing the greens
to one single formula, they are used in
great variety. The areas in shade are not
painted with greens darkened by brown,
but are instead composed of a rich, cool
green mixture. The sunlight on the trees
is expressed by golds vibrating beneath
the greens, giving the light areas an
astounding luminosity.*

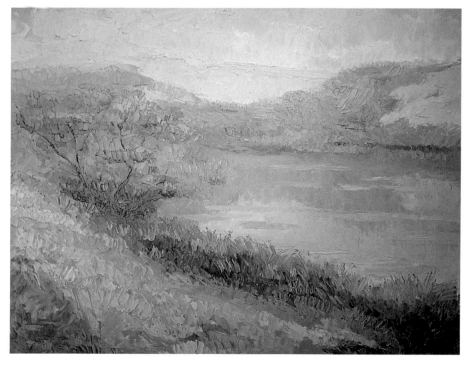

PILGRIM LAKE INLET
by Robert Longley. Oil on Masonite,
12 x 16 inches. Private collection.

*I picked another painting by the same
artist to show how similar compositional
elements can express an entirely different
light key. While both paintings contain
trees, grass, water, and reflections, there
is no question that this painting depicts
a foggy day. The colors are still rich and
vibrant, and have not been reduced to
transparent tints.*

*Compare the two paintings. All of
the greens of the landscape and the blues
used for the water and sky are painted
with different combinations. There are a
variety of pinks and purples influencing
the blues, and no two greens are alike.
The fog effect is created by color changes
as well as value control.*

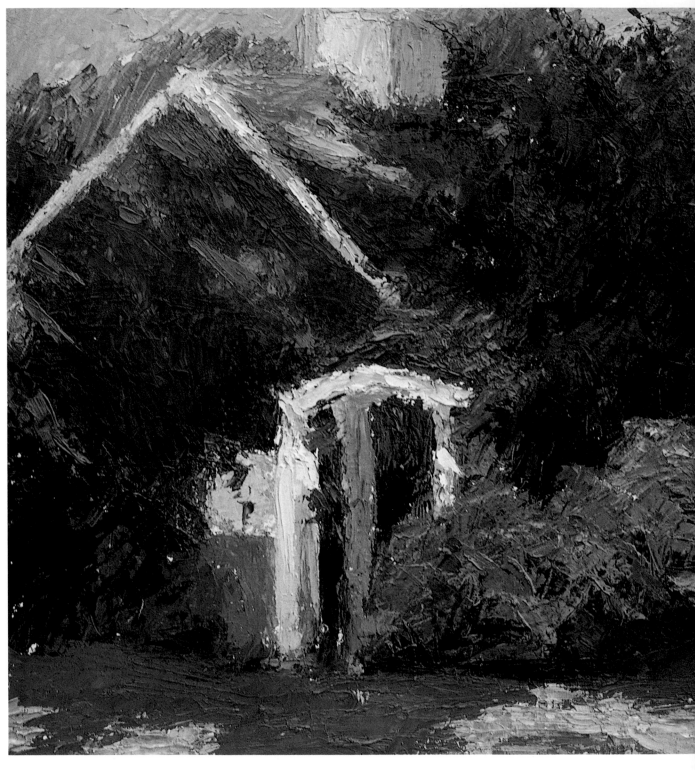

RED HOUSE #18 by Heather Bruce. Oil on Masonite, 11 x 14 inches. Private collection.

Although your eye readily accepts the sense of shadows falling across the house, what you don't immediately see is what makes the use of color so effective. The red in the sunlight wasn't applied directly out of the tube, but was enhanced by further warming, and the reds of the shadows weren't simply darkened with black or gray. Compare the heat of the light on the ground with the richness of those shadow notes. Observe the differences between the colors that express the shadows on the house and those on the ground. The artist's intelligent use of color makes this painting exciting.

A Color Journey: From Block Studies to Landscape Painting

2

*O*bserving simple objects whose colors are stronger and more obvious than those seen in a landscape deflects the artist's desire to produce a "pretty" or "salable" painting. Using large, brightly colored blocks eliminates the need to render elaborate objects within a complex composition, thereby simplifying the process of learning to interpret light and express it with color. A successful block study that truly captures a light effect is a beautiful exercise that can be a wonderful learning tool.

WHY PAINT COLORED BLOCKS?

Painting blocks will enable us to pursue brilliantly colored objects under different light conditions. Becoming familiar with strong, obvious colors will help you tackle the subtleties of landscape. By learning to solve relatively easy color problems first, you won't have to struggle with the complexities of color while pursuing more difficult subjects. It becomes overwhelming to worry about composition, likeness, drawing, and other details when you are actively working on a painting. To have a familiarity with color beforehand makes the task of painting outdoors much easier.

An artist can also use block exercises in much the same way that an accomplished musician practices the scales. By the end of one summer workshop in which my students had completed several block studies, most were able to paint a red house dappled with light. One woman who had joined the workshop late couldn't get started no matter how I tried to help her. The light effect on the red house intimidated her so much that she finally quit. Painting a red block in the same sunlight effect would have alleviated some of her confusion, helping her solve

many of the color problems posed by the landscape. Turning a block lesson into a house could have been fun and easy.

As I start new paintings at the beginning of each season, I do block studies to acquaint myself with atmospheric color changes. Block studies can also teach you about the light key, or the specific quality of light, in an entirely new environment, demonstrating its individuality. For example, the sunlight in Santa Fe is brighter and warmer than that on Cape Cod. Unfortunately, I haven't disciplined myself to do it except when teaching a workshop.

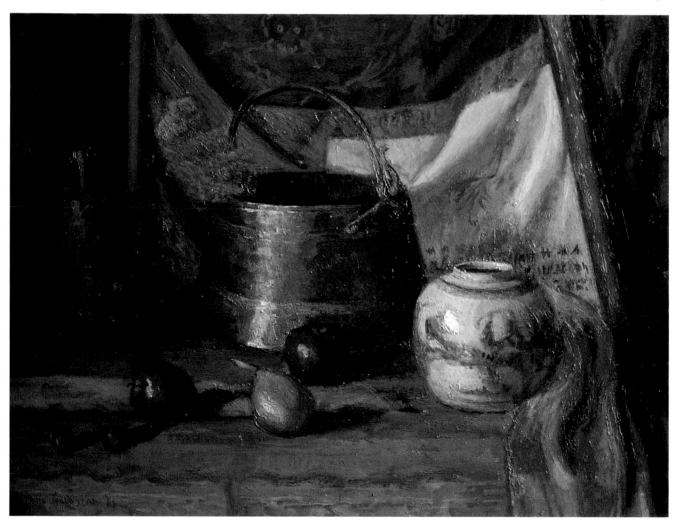

STILL LIFE INDOORS WITH CHINESE SILK by Fredric Goldstein. Oil on canvas, 24 x 30 inches. Courtesy of the artist.

This beautiful north-light still life is a study in textures. The composition, which contains a diverse arrangement of materials and objects, holds together extremely well because of the strong light effect. The color changes that fall across the surfaces of the copper bucket and vase demonstrate that earth-tone colors of metal objects must be painted with rich, varied color notes.

FROM BLOCKS TO STILL LIFE

Blocks teach us to see color as simply as possible. By mastering the interpretation of color on flat planes, we can then move on to other, more complex forms. After becoming familiar with blocks, it is easy to make the transition to rounded objects, such as those that are commonly used in still life compositions. Because color and light in nature and portraiture are so much more subtle, it is logical for still life to immediately follow block studies. The lessons learned from the blocks easily translate to brightly colored still life objects and flowers.

These still lifes are painted in subtle north light (opposite page), in full sunlight (below left), and in shaded light (below right). Atmospheric conditions create variations in a still life composition, as they do in all subject matter. Now we observe rounded objects instead of flat planes. We will search for more colors within their curved and rounded forms, and learn to model and create dimension with these additional notes.

Many impressionists, including Monet, Renoir, and William Merritt Chase, painted still lifes. The rounded forms and glistening reflections are fun to paint. When we look at flowers close up, or at a beautiful piece of pottery, we are able to observe some of the richest notes of color.

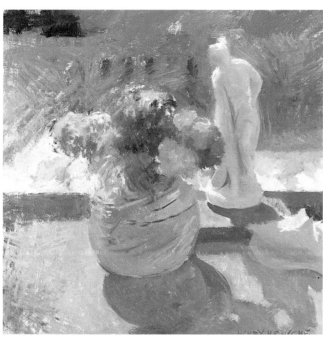

STILL LIFE WITH FLOWERS by Henry Hensche. Oil on canvas, 25 x 26 inches. Courtesy Provincetown Art Association and Museum, Provincetown, Massachusetts.

This luminous still life is typical of Hensche's ability to depict sunlight. Although some artists think of still life as subtle and somewhat dull, until they paint a still life outdoors this form's incredible potential will go unrealized. In this painting, the combination of still life and landscape achieves a range of colors, textures, and light effects. Its complexity is further enhanced by the inclusion of the pan of water, which is used to create reflections. Hawthorne loved to challenge his students to paint—and thus find the beauty in—the ordinary. Completing this creative composition with a sculpture and flowers, the dishpan has been elevated to new visual heights!

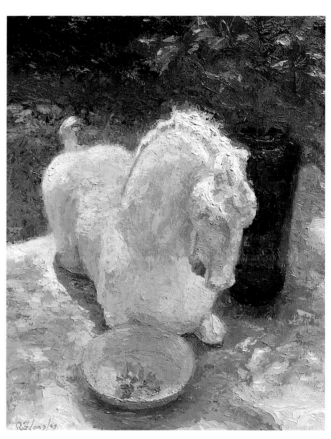

CHINESE HORSE by Robert Longley. Oil on Masonite, 20 x 16 inches. Collection of Steven Craighead and Susan Harmsen.

The light effect on the white horse has been described by many lovely color changes, a wonderful example of the myriad of colors that can be found in the shadows of white. I selected this still life to compare the color used on the horse with that used for the white figurine at left. I also love the dramatic color and light in the brown bottle and landscape behind the table.

FROM STILL LIFE TO PORTRAITURE

Painting still lifes teaches us to solve the problems posed by rounded forms, which add dimension to and create volume within a composition. Although the face and figure are far more complex subjects than vases or pitchers, we can apply the lessons of still life to painting portraits. As they are all developed from the same set of procedures—large areas of color first, then divisions of these masses afterward—each form and type of subject matter teaches us about the others.

The impressionist movement encouraged artists to express skin tones with a new palette. It became obvious that skin tones change depending on the light key, and are as different and varied as any subject in light. Compare the painting that I copied from the tonal but beautifully executed portrait by Degas to the portrait of Mary Springer by Cedric B. Egeli. In general, Degas's portraits were lighter and had richer color notes than those done by tonalists who preceded him. His shadow notes were luminous, and he expressed differences in the skin tones of his subjects. These early portraits fostered his passion for skin tones, as can be seen in his later series of women bathing.

In contrast, Egeli's outdoor portrait, *Mary Springer* (below), is a magnificent example of interpreting color, demonstrated by his depiction of the subject's skin tones and blouse, as well as the surrounding landscape. A result of an extensive classical background in art as well as many years of study under Henry Hensche, Egeli's portrait is expertly rendered, combining the likeness of the subject with the beauty of the light effect. Egeli's use of color is alive and vital; he isn't limited by formulaic color or by the confines of an interior setting. Egeli illuminates the blouse by using colors expressively: Although it doesn't contain even a spot of pure white pigment, its sense of "whiteness" as expressed in the layers of color is absolutely true. Instead of reducing them to browns and ochres, Egeli varies the skin tones, as he has done with his colors

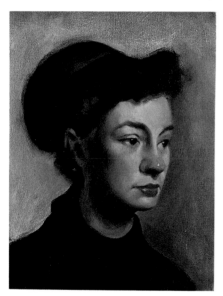

PORTRAIT AFTER DEGAS by Lois Griffel. Oil on canvas, 9 x 12 inches. Collection of the artist.

MARY SPRINGER by Cedric Egeli. Oil on canvas, 33 x 27 inches. Collection of Mary Springer.

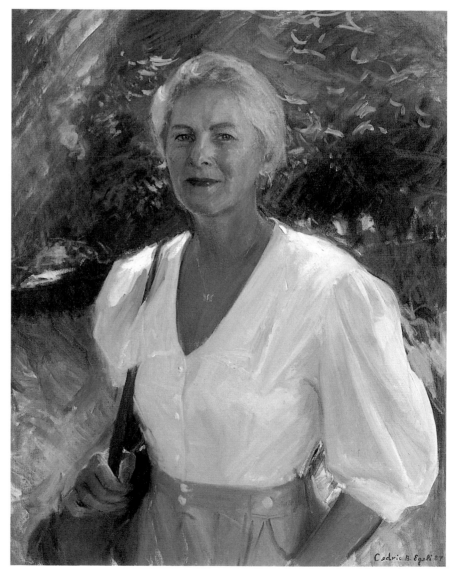

throughout the painting. By employing these impressionist techniques, artists learned to see and use color. The same effective quality of light can also be seen in the work of masters such as Joaquin Sorolla y Bastida and Frank Weston Benson. I believe Egeli is a worthy heir to their legacy of portraiture.

THE MUD-HEADS

The term *mud-head*, which refers to figures that were posed against the sun so that their facial features could not be seen, is a method of teaching about color and light made famous by Charles Hawthorne at the Cape Cod School of Art. The mud-heads painted by his students prove that the portrait is simply one more vehicle by which to express light and atmosphere. As Hawthorne said in *Hawthorne on Painting*, "I don't care about the roundness of the head. That takes care of itself, if your color is right as it comes against the background."

Examples of the mud-head portrait are shown above right. It is difficult not to feel the sun beating down on the subject or taste the salt in the air. In contrast, the face was painted without detail; instead, rich, brownish notes express the skin tones illuminated by the blazing sunlight. Knowing that they couldn't actually see facial features, Hawthorne constantly admonished students for trying to draw them. The simplicity of the color notes speak volumes! This lesson on color massing and simplicity can be translated to all subject matter, as you will see throughout this book.

Portraits can express variations of weather and seasons. The detail in Egeli's *Portrait Study* describes the individuality of the sitter, although not through the careful draftsmanship that can be seen in my copy of Degas's portrait. The features are just spots of color, placed to create the illusion of a nose or eye, without any linear drawing. There is more attention to shapes. The hair, neckline, and shoulders are painted with large color notes, but give more specific information about the subject. More important, a light key is expressed by the color used. The sunlight on the figure and the thick trees behind her are immediately clear.

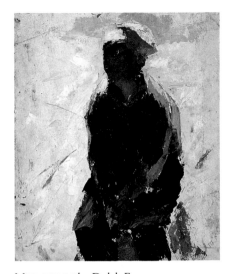 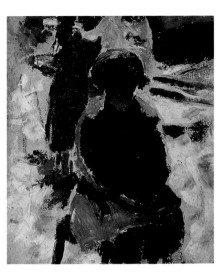

MUD-HEADS by Dulah Evans.
Oil on Upson board, 18 x 24 inches. Collection of Lois Griffel.

I couldn't resist including some of these wonderful sketches. I own five of them, and they hang side by side at the school. Seeing them all in a row is a visual delight. From a distance, you feel as if you are looking at a group of children sitting together on the beach, even when the room is dark! On closer inspection, you can see how thick the paint is: Large, flat shapes that were clearly applied with a putty knife. I can't imagine these paintings being any more effective and wonderful, even if there were more detail. The effect of sunlight and the individuality of the children really comes through in these masterful statements about color and painting.

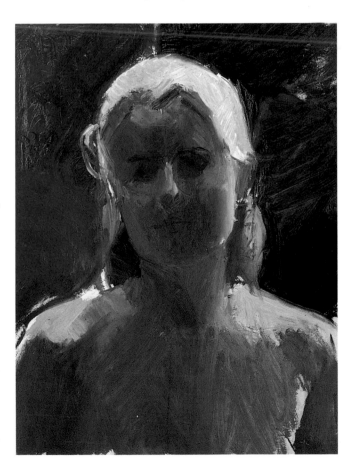

PORTRAIT STUDY by Cedric B. Egeli. Oil on canvas, 16 x 20 inches. Collection of the artist.

By making his subject more recognizable, Egeli's *Top Knot* takes the concept of the mud-head a step further. Top Knot is a local fisherman who spends a great deal of time in the sun. The richness of his skin tones are as familiar to me as his features. Although a sitter's skin tones, hair color, and clothing can be expressed in an infinite number of ways, both within a single portrait and from portrait to portrait, the colors in this example are used to depict the individual's ruddy skin, and do not simply show someone who has a bad case of sunburn. Someone can be known and even recognized for their particular skin tones. The essence of this portrait is created not so much by his likeness, but by the expression of the light key on the individual.

Hawthorne's exhortation—"Do not put in the features. The right spots of color will tell more about the appearance, the likeness of a person, than the features or good drawing"—can become very exciting once it is understood. My own introduction to the efficacy of this approach serves as a good example of this. For many summers, I painted portraits in a small studio that I shared with other artists. In one of his portraits, a fellow artist had merely lain in his main masses of skin tone, hair color, and a few notes of clothing, very similar to the example shown below left. Absolutely no features were painted in. When the family of the model returned to the studio after taking a short walk, they exclaimed, "It looks just like her!"

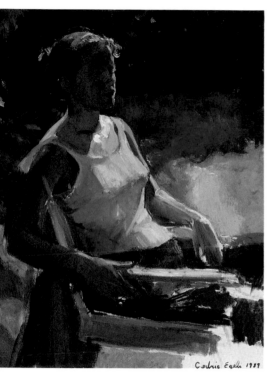

BRONWYN by Cedric B. Egeli.
Oil on canvas, 16 x 20 inches.
Collection of the artist.

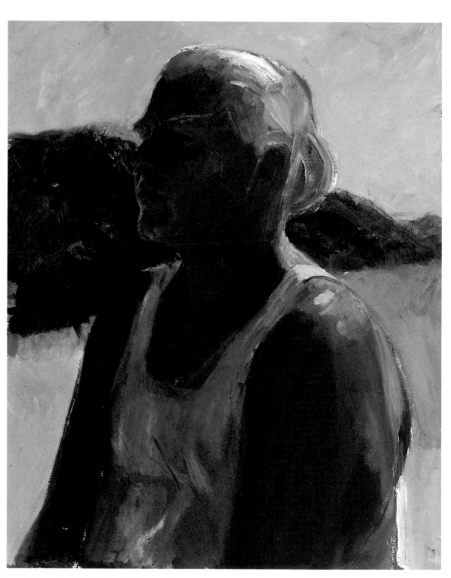

TOP KNOT by Cedric B. Egeli. Oil on canvas,
16 x 20 inches. Collection of the artist.

FROM PORTRAITURE TO LANDSCAPE

As we become sensitive to the color changes that become evident in the progression from still life, to portraiture, to landscape, it is obvious that we can never run out of subject matter. We rejoice in the work of our fellow artists as they pursue a familiar subject with a new point of view. We can leave unsolved mysteries of light conditions and subject matter behind us for generations to come.

In addition, we can follow Monet's example and paint a series of paintings on one subject. An endless dialogue of color is possible even within a simple still life! Joe Hawthorne, Charles's son, said of one of his father's studies that it "recreated a particular day so well that I could tell which way the wind was blowing." To be so sensitive to light and atmosphere is a supreme achievement, and it makes an artist feel completely at one with the continuity and diversity of nature.

Landscape poses new painting problems. Rounded elements become long, flat planes. The viewpoint of still life and portraiture—relatively close, with little distance behind the subject—is eliminated in landscape, with the space between foreground and background greatly increased. A landscape composition with mountains in the distance may encompass miles of visual expanse, which is referred to as *aerial perspective*. By using the correct color notes you will create these spatial relationships. Painting the landscape and solving problems of aerial perspective will enable you to see nature's infinite variety, as well as surmount some of your most difficult artistic obstacles. I love the landscape of Cape Cod, with its horizons and shorelines—typical scenes of colorful tidal flats and distant dunes. I stood on the dunes as I worked on the painting below, whose challenge was the ocean's reflection of intense blue: I had to keep the color subtle in order to create the distance.

In addition, landscape painting may well try your patience. On one day that I worked on the scene below, I had forgotten my sunscreen and got a severe sunburn. On another day, the sky filled with clouds and within minutes I was completely drenched! As I ran for cover I had to remind myself that the beauty of nature and of the landscape make the pitfalls and challenges all worthwhile.

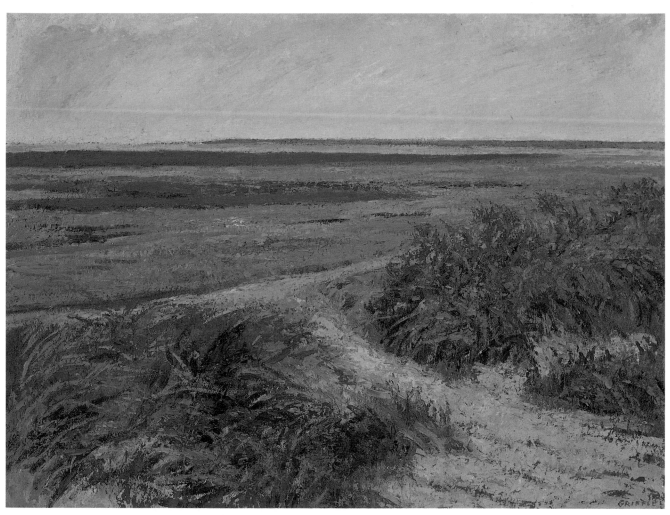

BAY VIEW, FLATS AND DUNES by Lois Griffel. Oil on Masonite, 18 x 24 inches. Collection of Richard and Barbara Nemiroff.

DEPICTING VARIATIONS OF ATMOSPHERE IN LANDSCAPE

I started a number of paintings of the yard (opposite), shown filled with purple and blue hydrangeas. The weather during this particular August was very inconsistent. The colors grew more astonishing with each changing light key. I couldn't resist painting a series.

The strength of the sunlight in the painting at top influences the greens of the foliage. The underpainting is done with light red and with Cadmium scarlet mixed with Magenta. I used these warm colors to balance the deep violets and blues of the shadows in the bushes. The greens are warm mixtures of Permanent green and Cerulean blue. In contrast, the same scene on a cloudy day is underpainted with a colder mixture of warm colors. The Indian red is mixed with Cobalt violet to balance the greens— mixed from Viridian and Cobalt blue— and to express the colder light conditions.

The hydrangeas in the warmer painting provide more of a contrast. The blue blossoms in this case appear as a strong violet, derived from the warmth of the red underpainting. The colors on the cloudy day were as intense as those on the sunny day, but instead appeared to be very blue.

I tried to exaggerate the differences in the two paintings. I encourage you to really push the concepts of "warm" and "cool" to the limit when you're starting out, creating extremes of sun and shade so that your eyes will really start to see them!

NEAR THE PAMET RIVER by Robert Longley. Oil on Masonite, 16 x 20 inches. Collection of Lois Griffel.

This painting is a masterful interpretation of strong sunlight in the height of summer. The greens throughout are influenced by the rich underpainting. The shadows are very warm, in contrast to the fact that we so often perceive shadows as dark and cold. And yet, these shadows remain shadows because they are played off against the even warmer colors used in the sunlight areas. Extra warm and light colors are added to the grass, which intensifies the light on it. All in all, the sunlight is warm, and it beckons us to travel into the landscape.

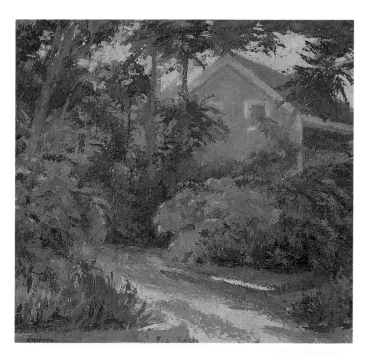

HYDRANGEAS, SUNNY MORNING
by Lois Griffel. Oil on Masonite,
19 x 20 inches. Courtesy of the artist.

HYDRANGEAS, RAINY MORNING
by Lois Griffel. Oil on Masonite,
20 x 24 inches. Courtesy Rice/Polak
Gallery, Provincetown, Massachusetts.

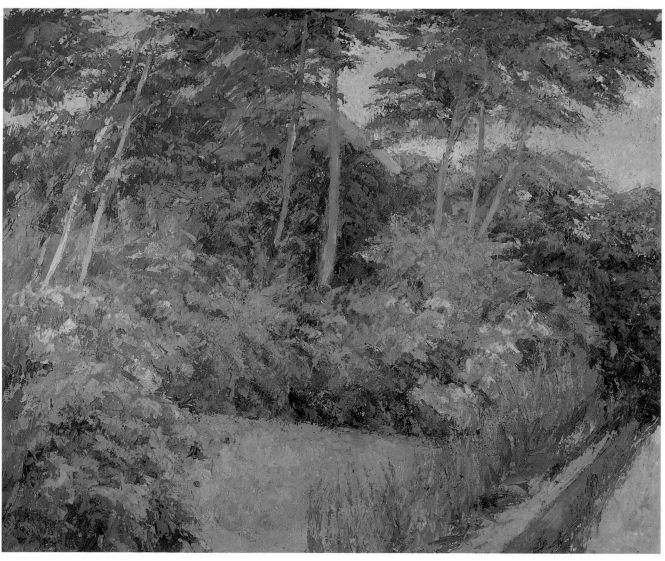

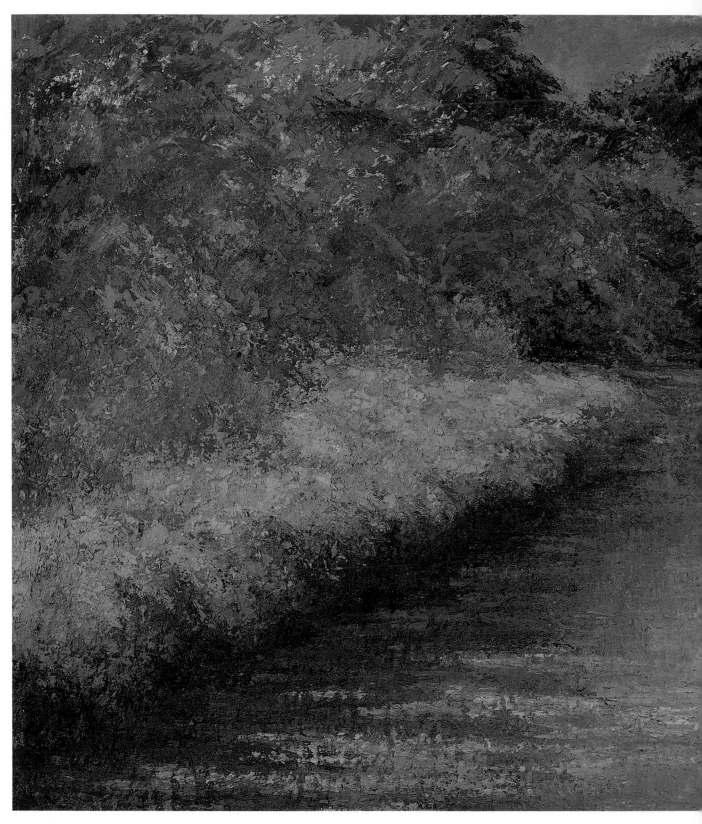

FOREST POND IN AUTUMN by Lois Griffel.
Oil on Masonite, 24 x 30 inches. Courtesy
Landsman Gallery, Magnolia, New Jersey.

It is more than the unmistakable reds of autumn that make this painting so warm. The greens are much warmer overall, the sky is warmer even though it is blue, and the passages of light on the bank are imbued with yellow. Even the contrast of the colder and deeper shadow notes convey a feeling of warm light by making the sunlight masses look warmer.

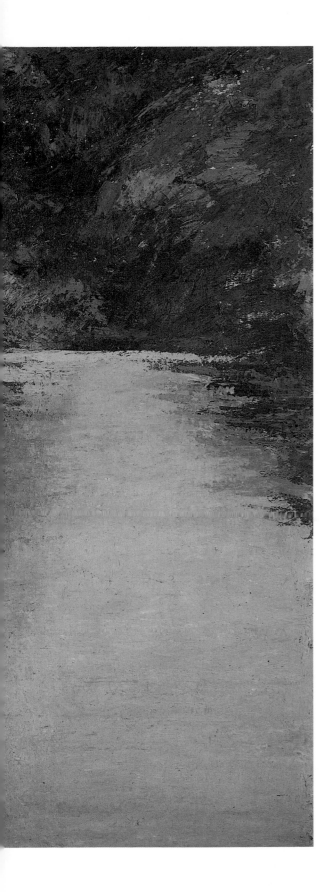

The Elements of Color

3

You must be familiar with the color terms that are used throughout this book, as they are fundamental to a thorough understanding of the activity of painting. These concepts are the foundation of all painting, and are integral to the basics that are necessary for learning to see color and light. I have found that by giving my students a vocabulary by which to describe the experience of seeing color, it makes the learning process that much easier.

VALUES

The concept of *value*, which is the relative lightness or darkness of a color and its relationship to the other colors that are used in a composition, plays an important part in the process of learning to interpret light. In color theory, black is the absence of light, and white is its presence. Neither is a color, and neither exists visually in nature. When you mix pigments of black and white the result is a value, or a gray note. Thus, any tone that is a mixture of black and white can be considered as gray. A *halftone* is the mixture of equal parts of the lightest and darkest aspects of a color, or the middle value.

Values can give us a lot of information about a painting's subject. When comparing the illustrations of the arrangement of the bottle and blocks below, the immediate differences among them are the values of the areas of the objects' surfaces. Each version expresses a different light effect, an interpretation of atmosphere through the use of value. How is this done?

1. This illustration looks the most sunny because of the contrast of the main notes. On a sunny day, the contrast between the masses is extreme. The shadows in the first example are darker than those in the second.

2. Although the shadows are all comparatively lighter in this illustration, the background and table values are exactly the same. This visual change makes the arrangement appear less sunny, imparting more of a hazy light effect.

3. In this example, the entire composition, including the background, is significantly lightened, except for the table. This creates an entirely different light effect: that of an overcast day.

By using the same composition, we learn that length and direction of shadows also express the time of day. Note, however, that I deliberately kept the values of the shadows the same in each illustration so that your attention would remain focused on the movement of the light.

4. Because the cast shadows are shortened, this illustration gives the viewer the impression that the light source is directly overhead, which is true high noon.

5. Here you can see that the shadows have shifted around on the table. The bottle casts a shadow on the block in the foreground, which makes an interesting pattern. These cast shadows can be major elements of a composition. The shadows have become a little longer, indicating that the light source is not only moving but is positioned lower.

6. In illustration 6, the shadows have lengthened even more and traveled around the objects, suggesting that time has elapsed.

The effect is different in each of the illustrations. The combination of both the amount of light and shade in the values of objects, as well as the direction of their shadows, gives us an infinite number of light effects to paint.

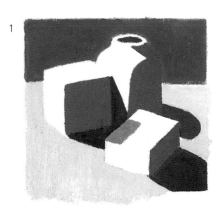

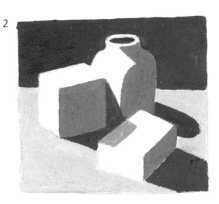

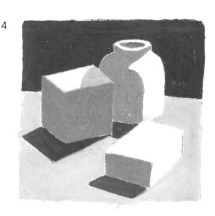

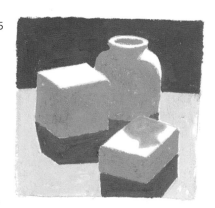

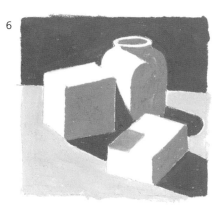

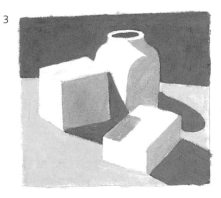

The effects of light on a composition depend on its position and strength.

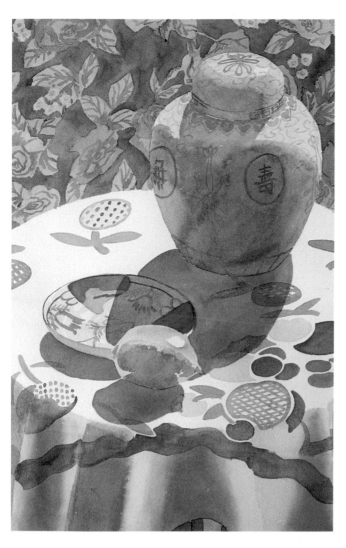

GINGER JAR
by Gail Browne. Watercolor on paper,
12½ x 19½ inches. Collection of the artist.

*It is easy to see the light effect discussed on the
opposite page on this lovely watercolor still
life, in which the description of the forms is
enhanced by the cast shadows. You can see the
color change in the dish from the cast shadow
of the jar, and the richness and warmth of the
color of the shade on the jar against the color
of the cast shadow completes the message. I
especially like the way the yellow warms up
the light planes of the jar.*

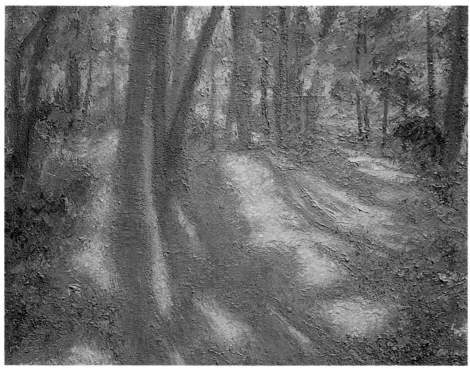

THROUGH THE WOODS
by Lois Griffel. Oil on Masonite,
20 x 24 inches. Collection of
Valerie Lochei.

*In this painting, I used the cast
shadows to bring the viewer's eye
into and through the landscape.
When you first experience this type
of light effect, it is easy to paint the
shadows too heavily. I started them
with a dark value, and then
gradually lightened them with
additional colors, in order to give
them a feeling of lightness and
openness. Hensche always
admonished his students when they
painted shadows too darkly and
densely, and advised us to paint
them so that we would want to walk
into them. This concept was my
motivation for this painting.*

Color Masses

In Chapter 2, the "mud-heads" illustrated how large areas of color express form. Those large areas of color are referred to as *masses*. When looking at these big shapes, first we see light, then we see their sizes and dimensions, and then the details of the composition. The two illustrations on page 27 show how we could manipulate the values of those masses. Those changes in lightness and darkness created variations in the light effects.

An endless number of grays can be mixed between the extremes of black and white. However, many great artists, including John Singer Sargent, felt that too many values can be distracting. We can create the illusion of light with a minimum number of values, perhaps six or seven. Too many values in one mass creates "spottiness" and distorts relationships among masses, and too many values in a painting generates visual confusion. A simplicity of values, both within a mass and within a painting, is most effective.

In the sketches below, the composition is exactly the same, with the same arrangement of shapes and masses. However, the values within these masses are arranged differently. In the sketch below left, your eye does not know where to look because the value structure isn't simple or consistent. If you squint at the image, you aren't visually directed. There are too many spotty notes in the trees and bushes, and the shadows on the white house are too light in comparison to the roof of the shed next to it. The bushes in the background are darker than the bushes closer to us, which distorts the sense of space. The trim on the house in the foreground is confusing because it looks as if light is falling on it, while the rest of the house is dark, as if in shade. The light plane on the top of the bushes along the garage—which is inaccurately depicted, because the bush is surrounded by shadow—contrasts too strongly with the part of the bushes in shadow. If there were

indeed a light plane on the top of the bush, it is lost because it is the same value as the cast shadow on the white house.

The illustration below right is simplified and better organized. When you squint at it, all of the masses of light and shade come together. The house in the foreground appears to be entirely in shade. The trim is still lighter than the shingles, but remains solidly within the value scheme of the entire mass. The leaves in the tree are simplified, so that the tree mass isn't spotty and holds together as one solid note. No longer broken in half, the bush near the garage is more clearly discernable, and the bushes in the background are lighter than the bushes in front, which makes the sense of depth and space more effective. As a result of these choices, you can now see the brilliant light on the white house and the garage. This painting is more interesting because it is organized, and the desired light effect has been established.

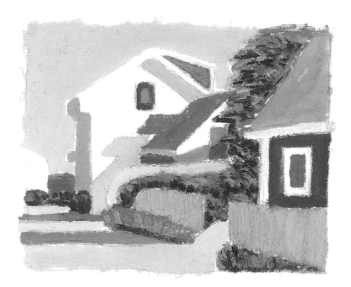 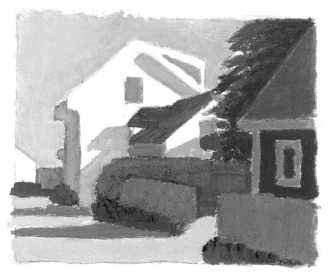

The values in the sketch at right are better organized and more consistent than those in the sketch at left.

SIMPLIFYING COLOR MASSES

Cameras record all details in a composition evenly, from foreground to background. In a landscape photograph, blades of grass are as clear as a house or a mountain in the distance. Many fine artists are referred to as "photo-realists" because they paint in the same way. But, in order to really see the light key of nature as it really exists, we must learn to see the masses, or the large patterns of color, first.

This is in fact expressive of the way we see. We do not recognize the world from linear detail. As a result of the interaction of sun and shadow, we see form and space, and respond to the beauty of the world in terms of atmosphere, form, and mass. This is what stimulates our excitement about light and color.

In order to see color and light accurately, we must reduce our vision to simple large masses or shapes. To see these masses effectively, we must learn to eliminate superfluous details and minimize the details of linear observation. This can be simply achieved by squinting. We must study the large color note of the sky against the foreground, or the color of a tree against the sky. This helps us to analyze colors and their relationships to one another. It is only with these first main notes that we establish the light effect. The large masses give us clues to the atmospheric conditions, the time of day, and the light key.

I chose to do the exercise shown here on a cloudy day despite the fact that it is easier to see masses on a sunny one. Extreme sunlight simplifies masses, as can be seen with the mud-heads or in my painting *Through the Woods* (shown on page 35). However, simplifying masses on a cloudy day can be just as easy. The real difference in that context is that contrast is not necessarily found within the planes of individual objects, but *between* the objects.

When you squint at the landscape in the photograph, you can see that strong sunlight isn't beating down on the tops of the trees and bushes. This would give you very specific light and dark planes. Instead, you get a variety of light effects from each tree and bush in their relationships to one another.

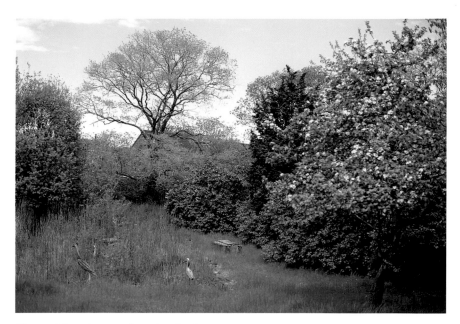

Composition photograph: spring landscape.

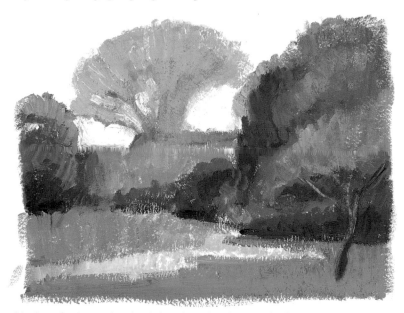

A black-and-white value sketch based on the photograph above.

In the black-and-white sketch, you can distinguish the large tree in the center by its outline. It has depth because it is painted in a value that is lighter than the rest of the painting. There are shadows in this landscape, although they are not as extreme as would be found on a sunny day. I have indicated them by making the notes under the bushes a little darker than the rest of the trees. By keeping some of the grassy area lighter in the center, a sense of variety is indicated that may be due to differences in the color of the grass or a light effect created by cast shadows.

Notice that the sketch mimics the fact that the entire composition is almost one large silhouette against the sky. If I broke up the huge mass of the painting with too many notes, and with notes that were too light, I would lose the whole effect of the light scheme. As Hawthorne reasoned, "You should do planes against light, not leaves and grass—I would like you to have seen that not anatomically, as you have. There isn't any reason for not doing every leaf if we can, but we can't, so only do the large notes."

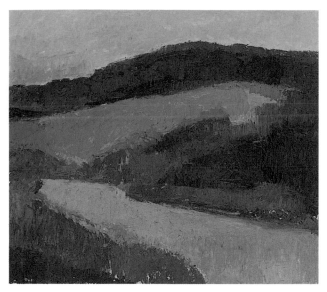

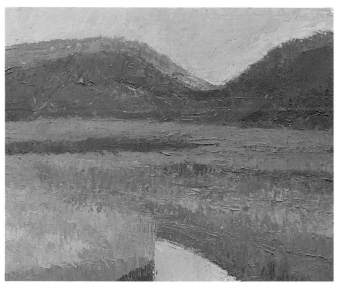

These two studies—Simple Masses of a Dune *(left) and* Simple Masses of the Moors at Sunset *(right)—emphasize the point that color and shape convey a painting's message about light and how we see it. Keeping your colors reduced to jigsaw puzzle–like shapes will not in any way detract from your understanding of the subject matter or a sense of space. In a*

way, their simplicity makes these two studies more interesting. Even without descriptive detail, you can tell that one study is of dunes and sand, and the other is moors and water, and that each was done at a different time of day. The light keys are created simply with large masses of color, their value relationships to each other, and attention to their drawing.

TREE STUDY by Lois Griffel.
Oil on Masonite, 12 x 16 inches.
Collection of the artist.

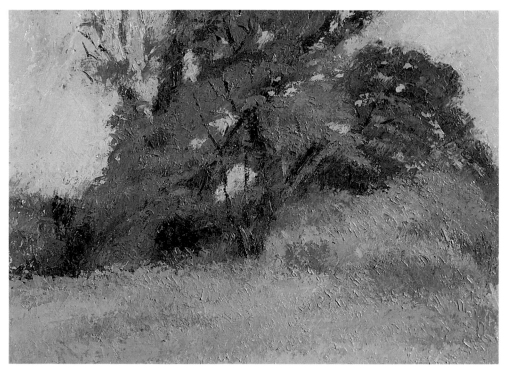

This study was begun in exactly the same way I started the sketches above; its ultimate difference is that more colors were added between the large masses. It is also similar to the sketches in that the masses and details are very simple, though in this case the masses more clearly define the curves and rhythms of the landscape forms. This painting is actually "finished" because I added many more strokes of color to establish the darker and lighter areas of the tree, but without developing details such as individual leaves and grass. Instead, the large strokes and layering of paint convey those kinds of messages.

CREATING FORM IN COLOR MASSES

Masses must be observed for all subjects. Look at a still life, or observe a landscape. When you isolate one object at a time, you can only see details. Shapes such as labels or designs on a vase become distractions. Staring into the mass of a meadow, leaves or blades of grass become lines and details. You lose the large simplicity, the forest for the trees!

In the still life studies at right and below, the large notes of light and dark are simply established. Each object is described by its shadow and sunlit planes. Color changes that occur within and move across a form are expressed with spots of color. The objects are simply seen and no details are observed. Without including the details, two entirely different conditions have been recorded.

About form and roundness, Hawthorne said, "Let color make form, do not make form and color it in. Work with your color as if you were creating mass—like a sculptor with his clay." As you begin to see more colors across a mass, you will be able to describe these properties. This is the main difference between looking at nature from a linear point of view, as opposed to observing masses.

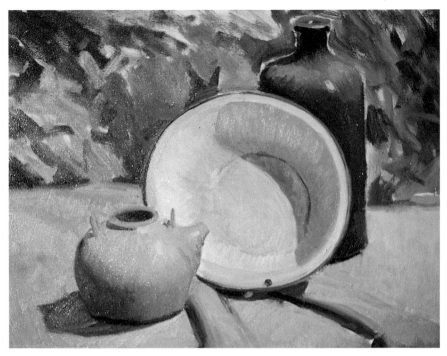

SUMMER LIGHT (DEMONSTRATION) by E. Principato. Oil on Masonite, 16 x 20 inches. Courtesy of the artist.

This luminous study was done simply as a demonstration. As he worked, the artist knew that the light was about to change and rushed to get it to this stage as quickly as possible. When I saw the results of his work, I encouraged him to feel that it was "done." Principato knows how to keep his masses simple. The first color notes are so clean and accurate, they express the light key with a minimum of fuss. An artist who focuses on detail would not have been able to go as far or as fast this effectively.

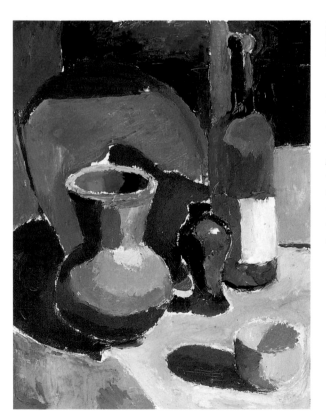

STILL LIFE WITH INDIAN POTTERY by Fredric Goldstein. Oil on Masonite, 20 x 16 inches. Collection of Lois Griffel.

The simple masses are integral to establishing this still life. Again, using only rich colors and large puzzle-like forms, the objects are clearly identifiable, as is the time of day. The colors are brilliant because they are used in an essentially pure state. The light is expressed by the warm color notes in the light planes, against rich, saturated tones for the shade. It is unimportant that the artist did not "finish" it. If you have expressed light, atmosphere, and the individual character of the objects, what more is needed?

The paintings below have more detail, but are still composed of large, simple masses. The composition in *From Out Back* is reduced to two main areas: houses and hillside. The houses are literally block studies whose simple planes suggest light by their color. The hillside has subtle variations, but that mass is held together by a minimal amount of color variation. It remains a singular large shape against the smaller shapes of the houses.

The house in *Street in Key West* appears to be a more complicated subject, but is actually done with three main masses, the light on the house and street, the shade notes, and the shrubbery. If details like the windows and doors were left out, you would still understand the painting. We easily feel the intense heat of Florida, compared to the sunlight of the Cape Cod painting. It is the slight variations in color that create the visual differences. These paintings aren't successful because they are "portraits" of houses; rather, it is their light effect that makes them so convincing.

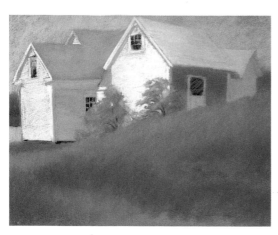

FROM OUT BACK by John DiMestico.
Pastel on paper, 24 x 30 inches.
Collection of Diane and Harry Washburn.

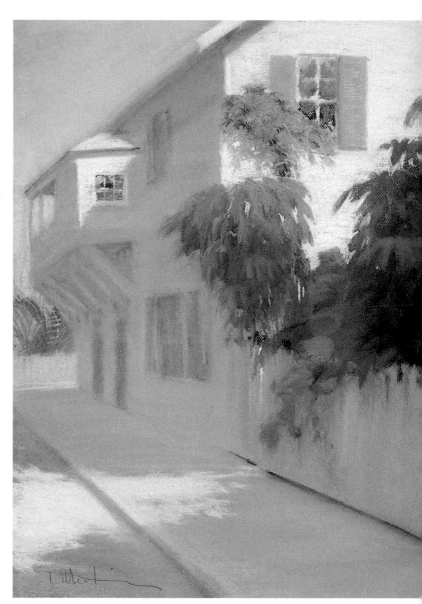

STREET IN KEY WEST by John DiMestico.
Pastel on paper, 30 x 24 inches. Private collection.

LOCAL COLOR

Local color is the actual color of an object, uninfluenced by reflected light or color. Although we can't be sure that everyone sees in exactly the same way, we agree generally on what red looks like. This ensures that when we go to a store and ask to try on a red shirt, the salesperson will have some idea of what we want to see.

At an early age, we were rewarded for coloring trees green and the sky blue, making it easy for us to believe in these judgments. As we become aware of the infinite variety of nature, we struggle to unlearn our color "stereotypes" and open our eyes to color. Even Monet was heard to say that he wished he could awaken and begin each day as if he had been blind for his entire life; to be able to see nature without prejudice. Frustrated by his own limitations, he pushed himself daily to see new colors and explore new light effects.

If we could be open-minded about color names and simply react to light as it affects an object's color, we would begin to see! We must understand that local color does not express light or atmosphere; that in our painting we attempt to express the way that sunlight affects local color. This is the essence of the philosophy of The Cape Cod School of Art: By interpreting the way that light affects color, it will never be local again!

The cubes above right both include a light, a middle, and a dark tone of orange, which aptly describe a lighted cube. The differences between the tonalist and impressionist approaches can be seen by comparing the two. As the left cube illustrates, the tonalists mixed black into their colors to create the beautiful and luminous notes of their dark values. In the cube on the right, the shadow is painted with a color. It gives the cube more life, yet still reads true to the light effect. Monet observed that dark shadows do not have to be the dark counterpart of a local color. It isn't enough to say the cube is light, medium, and dark orange; it is much more fun to see variations and color in shadows. When you truly believe that you will learn to see beyond local color, you will never see the world in the same tired way.

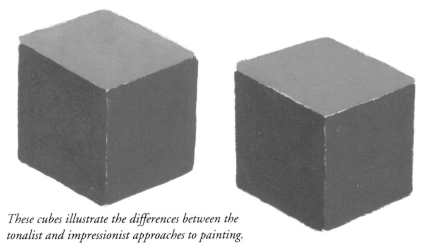

These cubes illustrate the differences between the tonalist and impressionist approaches to painting.

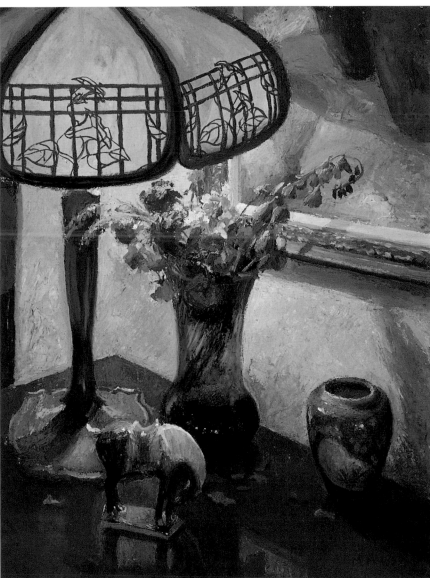

THE TIFFANY LAMP by Margaret E. McWethy. Oil on Masonite, 20 x 16 inches. Courtesy Wohlfarth Gallery, Provincetown, Massachusetts.

This is a wonderful rendering of light effect. McWethy has created the sense of warm electric light on primary colored objects without having to limit or restrict the way she used color.

FIGURE STUDIES: THE BATHER

I decided that the best way to demonstrate how color creates light variations would be to follow Monet's example and paint the same still life setup at different times of day. The figurine, a study of rhythms and curves, was a favorite of Hensche's, and as his students we all acquired copies. My particular cast of her is a warm white that easily reflects the changes in the light and the time of day.

I worked on the paintings during the summer, and deliberately painted the first two within two hours of each other in order to keep the changes as subtle as possible. In the painting below left, the figurine is close in value to the cast shadows. She has a warm, pinkish quality, which was similar to the color of the shadows. The contrasting textures of the weathered table and the figure's smooth surface gives the two main masses their distinguishing qualities. The grassy area in the background was actually filled with light, but because very early morning sunlight is not as brilliant and deep as it appears later in the day, the contrast wasn't as extreme against the shadowed objects as one would think.

The difference between the first and second studies is immediately visible in the cast shadows, which were caused by a lattice fence near the table. As cast shadows inevitably do, they moved around in the second painting and became much warmer. The bits of brilliant light on the figurine in the second study were enough to make her appear much cooler in color, although the colors that were used are deeper and more saturated, and the table is also much brighter. The values between the cast shadows and the table are more extreme, and changes are also evident in the background and in the flowers. As the light moves, the contrasts in the grass are deepened and the blossoms look warmer, and the colors of the vase and bottle are deeper and richer.

In the painting below right, the differences are very obvious. The sculpture is almost in full sunlight, and the painting is completely infused with warmth. The sunlight on the bather is painted in rich strokes of yellows and pinks and her shade area is more violet, which is influenced by the reflected light from the table. The table is painted with more yellow to make it look especially sun-filled, and the background is now dark, with very deep colors expressing the shade. As a result of the direct sunlight, the blossoms are substantially warmer while the colors of the bottle and the vase are significantly brighter.

This may have been one of the most challenging series of paintings I have ever done. I think I will continue to do them on a regular basis, both with still life and with landscape.

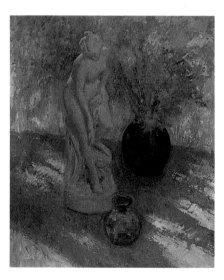 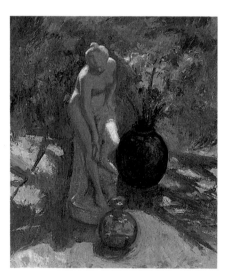 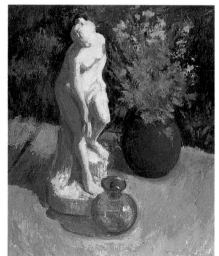

FIGURINE, 8 A.M., 10 A.M., AND 2 P.M., by Lois Griffel. Oil on Masonite; 8 and 10 A.M.: 18 × 22 inches; 2 P.M.: 16 × 20 inches. Courtesy of the artist.

COLOR MIXING

Since science has given us an amazing variety of new colors, it is crucial that we understand what color and pigment are all about.

The three *primary colors*—red, yellow, and blue—cannot be created by mixing other colors; however, by mixing the primaries in various combinations, and adding white and/or another pigment, we can make every other color, effectively slashing our supply list. However, because we cannot mix a primary color and it isn't always convenient or time-efficient to mix colors, pigment and paint manufacturers have produced an extraordinary variety of colors.

The *secondary colors*—orange, green, and purple or violet—are all mixtures of two primaries. Red and yellow make orange, blue and yellow make green, and red and blue make purple. For our purposes, secondary colors are fairly standard throughout the color experience.

A *tertiary color* is a mixture of equal parts of a primary and a secondary. Depending on the brand of paint you use, blue-green might be called Teal or Aqua, and orange-red might be referred to as Cadmium scarlet. By mixing an unlimited number of color combinations, paint manufacturers have spawned a rather unstandard variety of colors; what one calls "Chinese Red" another labels "Scarlet Lake." The inconsistent usage of color names among manufacturers makes it important for you to have at least a nodding acquaintance with them. In addition, it is imperative that you are intimately familiar with your choice of palette colors, as well as how to make them. Running out of a color on location is every artist's nightmare—one that doesn't need to happen!

COLOR TEMPERATURE: WARM AND COOL

Although temperature is essentially a subjective color characteristic, most people categorize colors as "warm" or "cool" fairly consistently. For instance, we usually use yellow, orange, and red to express warmth and light, and blue and purple to convey cold and shadow. However, between these two poles lie innumerable possibilities, directed by personality and inclination. For example, where someone would use red to describe fire, another might use it effectively to paint a turbulent rainstorm.

Monet often used intense or exaggerated colors in his paintings to create an atmospheric light effect. In the painting at the bottom of the following page, I painted the marshlands with a selection of colors leaning primarily toward greens and blues.

It is not necessary to use profuse detail for color to convey a message. The landscape below has many nuances and rounded edges that create a specific place, while the paintings on the following page have almost no detail, there is no doubt as to the light effects, which are composed entirely of color masses whose temperatures intermingle and interrelate. The effects that these paintings capture are not unlike those that Monet painted in many of his series.

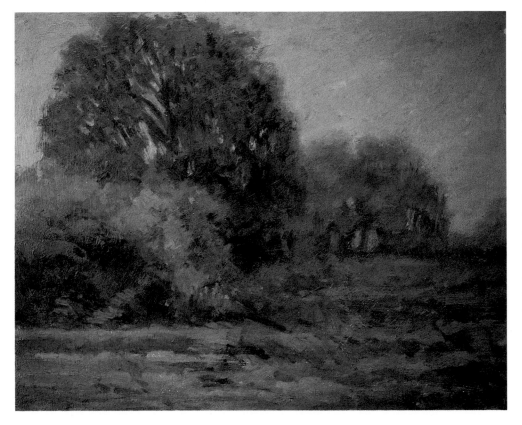

RAINY MORNING LIGHT by Fredric Goldstein. Oil on Masonite, 24 x 30 inches. Private collection.

The beauty of this landscape is not limited to the masterful painting of the trees, but is also derived from the infinite variety of greens with which they were painted. The cool nuances of the greens keep the entire painting from looking too yellow and warm. The painting not only captures the atmospheric effect of the rainy morning, but makes what could have been a commonplace and limited composition more intriguing.

LOOKING THROUGH FOG TO LITTLE
GOTT by Peter Guest. Oil on Masonite,
8 x 11 inches. Private collection.

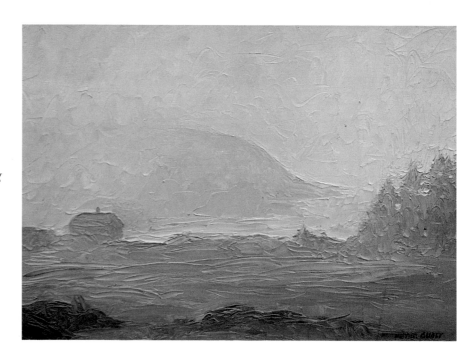

*By using rich colors and by making the
value key darker and more intense, the
attempt to convey the light key of fog in
this painting is quite successful. Some
beginners paint cloudy days well because
they realize that the light key of fog is
relatively dark when they resort to turning
on the lights in their homes or studios.
Often, though, we don't have a way of
knowing how dark and rich colors in fog
really are. The richness of the pigments
and the coolness of the colors in this
painting really create the illusion of fog.*

SUNSET, TIDAL FLATS by Lois Griffel.
Oil on Masonite, 12 x 16 inches.
Collection of Valerie Locher.

*The values of the colors used in this painting are very deep and saturated; however, its warmth
isn't limited to only reds and yellows—it actually contains a great deal of blue. The simplicity and
lack of detail are what make the light effect work. If the colors weren't pushed by the rich warm
notes, the sense of light could not have been conveyed.*

THE SUBJECT IS LIGHT

Because we know that a yellow block will look sunny when it is painted with yellow paint, it is easy to make bright, warm-colored blocks appear sunny in a painting. The real difficulty lies in painting cold blue and purple objects in the sunshine. Painting warm-colored objects on a gray, cloudy day completes the challenge,

The purpose of these exercises is to underscore that we are not concerned with an object's or landscape's colors, but are instead attempting to capture in our paintings how they are influenced by light. Color is about light, not the color of the object. This concept, truly the essence of Hawthorne's theory, was the motivation of the still lifes at right and below: to express light condition regardless of subject matter. Both are painted with a palette knife, on the same gray table, and in the same back yard. The only difference between them is the perception of the light effect. The most important aspect of these paintings is not the arrangement of their elements, but how the light key or atmospheric conditions play a role in our observation. The subject matter isn't the color of the objects, but the influence of light and atmosphere on them.

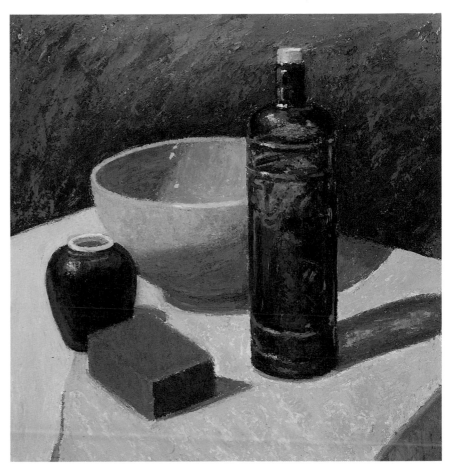

Sunny Day Still Life with Cool-colored Objects (top) and Cloudy Day Still Life with Warm-colored Objects (right).

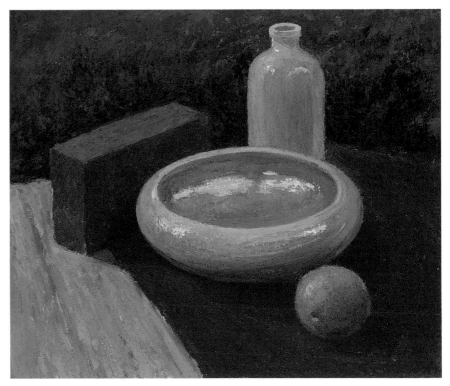

FLOWERS ON CINDER BLOCK
by Lois Griffel. Oil on Masonite, 14 x 24 inches. Courtesy Rice/Polak Gallery, Provincetown, Massachusetts.

While setting up this still life, I kept thinking of Hawthorne's advice to his students to look for beauty in the ordinary. Noticing its wealth of color and realizing how well it would serve my purpose, I decided to use the cinder block that was already in my studio as a platform for an arrangement of flowers, which was essentially "gilding the lily." The entire painting was done without any gray, black, or brown pigments; Yellow ochre was the only neutral color that I used. I started the cinder block with an underpainting of red that had been grayed with some green, then painted grayed blues and ochres over it. I began the background with a grayed violet, which also contained mixtures of grayed greens, blues, and some reds. Isolate the colors by looking closely at the picture, then by holding the image at a distance and squinting. Notice how the visual mixture creates "gray."

Color
Theory

4

The first color problem that students encounter is the visual difference between the palette and the painting. What seems irresistible and brilliant when mixed on the palette might look lackluster on the canvas. What looked light and luminous suddenly becomes dark and gray! How does this happen? ❧ The most important characteristic of color is that it is affected by colors that are adjacent to or surround it. This concept, which embodies the theory of the color field, was one of the main principles that Hawthorne incorporated into his teaching methods.

SIMULTANEOUS CONTRAST

The concept of the color field is based on the visual effect of *simultaneous contrast,* which is how two adjacent colors affect each other's value, saturation, and hue. The interactive attributes of color were studied in great depth by Josef Albers (1888–1976), an artist and teacher at the Bauhaus, an influential school of industrial design and art located in Weimar, Germany. The illustrations below show how a field of color can affect our perception of another color's value. Although the two blue squares in the center of the orange and yellow squares are exactly the same shade and value, the influence of the color that surrounds each one makes them look different. While the lightness and brightness of the yellow field make the blue square look relatively dark, the orange field, which is darker than the yellow, makes the blue seem considerably lighter. The blue in each note is the same; the surrounding fields of color inevitably influence the way we see them.

Albers dedicated his life to investigating the principles of simultaneous contrast, and discovered that any color can be made to shine like sunlight or glow like mist, depending on the field of color surrounding it. In its practical application to painting, the moment you transfer a color from your palette to a canvas, it will change. Because we use white board or canvas for all of the paintings in the book, your first color notes will look somewhat darker if you use a wooden or toned palette. However, as you continue to work, the canvas will take on a middle tone due to the complexity of the color you have already applied, taking on the halftoned character of the wooden palette. From that point on, as you mix new colors, they will remain essentially the same as you work from the palette to the canvas.

Because of the field influence, some students prefer to start a painting using a white palette. However, once the canvas is covered, your colors will then differ because the palette will remain white after your canvas is covered with color. Part of learning to work with color is being able to anticipate these kinds of visual differences as you mix.

SATURATION OR INTENSITY

Whether a color is a primary, secondary, or tertiary, it is the most saturated, or intense, when it is taken directly out of the tube. As soon as a color is mixed with white or another color it loses some of its brilliance by becoming a "paler" or less intense version of the original. Adding white will also "cool" a color slightly. The pure yellow and magenta swatches shown at the top of the opposite page are obviously more intense than those that have been mixed with white.

By mixing two pure colors, you can achieve one of two different effects. By mixing a cool color into a warm one, you will lessen the intensity of the warm color. For example, a small amount of blue mixed into orange will give you a "toned" orange whose initial saturation or intensity is diminished. If you mix two warm or cool colors, the saturation of the resulting color will be different but not necessarily lessened. In the example on the opposite page, Cadmium orange and Permanent rose lightened with white were mixed to make a third color which is still bright but not as saturated as either of the starting notes. Compare the three spots of color: The Cadmium orange spot on the left is more intensely orange and the lightened Permanent rose spot on the right is a more saturated pink than the center spot. However, the middle color is still rich and vibrant, because the two colors created an equally rich and vibrant note. It simply isn't as warm as the orange or as cool as the pink. This example indicates that you can cool a very warm color such as orange or yellow with a color other than blue or purple. On the other hand, you can warm blue or purple by mixing them with red or orange, rather than always having to reach for your tube of yellow.

Albers also conducted color experiments to create visual differences in saturation. The squares in the center of the fields of color shown opposite are both painted with Cerulean blue that has been lightened with white to make it more opaque. By surrounding one square with cool violet and the other with warm green, the saturation of each is affected: The purple field, which is cooler than Cerulean, makes the Cerulean square in its center look greener and darker compared to the other square, while the green field, which is warmer than Cerulean, makes its Cerulean square look bluer. This kind of interactive color effect will hinder you in much the same way that mixing color on a toned palette will inhibit your color mixing before your white canvas has been filled with paint: Although you might think that a color you have mixed on your palette is warm or cool enough, you notice that it looks unexpectedly different as soon as you lay it down because it was influenced by the color that is already on the canvas.

The illustration opposite below also demonstrates the visual effects of simultaneous contrast, this time by making two different colors appear the same.

An illustration of Albers's color field theory.

Although they look like the same color, the square in the center of the orange field is Permanent magenta, which is a warm red-purple, while the one in the center of the cool purple field is Permanent mauve, which is comparatively cooler. The fields were chosen to make their two center squares look exactly the same. The cool purple field makes the Permanent mauve appear warmer because it is cooler and more saturated. Even though Permanent mauve is a relatively cool color, it still isn't as cool as the purple field, and so it appears warmer. The same is true with the other square: The orange field is so much warmer that it cools down its Permanent magenta square. Because of the effects of simultaneous contrast, the two center squares appear more similar than they really are, and the values of all the squares are affected as well. By taking a piece of white paper and cutting holes in it to isolate the center squares, you can clearly see how fields of color influence the colors within them.

Using the illustration below as an example, if you use a light green on a tree in one area of a painting and want to use it in another, it would look different if the color of the second area is even only slightly different than the first. As a result, you would need to adjust the light green so that it would look the same as it did in the first color area.

Albers's experiments give us an excellent understanding of how colors interrelate. As we learn to see and think in large notes and spots of color, we will put this knowledge to use. As Charles Hawthorne once observed, "The weight and value of a work of art depends wholly on its big simplicity—we begin and end with the careful study of the great spots in relation to one another."

The pure color spot on the left in each pair is more saturated or intense than the mixtures on the right, which contain white.

Mixing Cadmium orange (the color spot on the left) and Permanent rose (on the right) yields an equally rich and vibrant color (center).

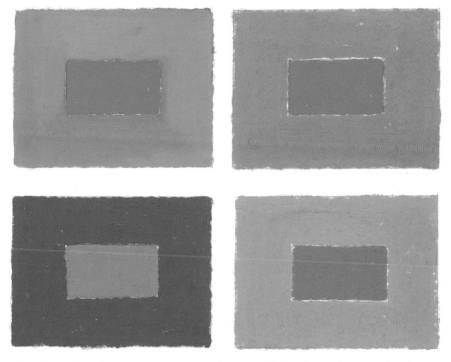

The effects of simultaneous contrast can influence a color's value so that a single color will look different (above) or two distinct colors may appear to look the same (below), depending on the surrounding field of color.

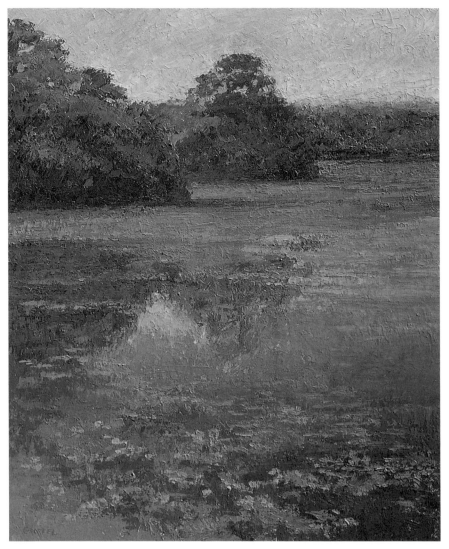

AUTUMN IN BEECH FOREST by Lois Griffel. Oil on Masonite, 24 x 18 inches. Collection of Lorraine Trenholm.

Because of the singular quality of their colors, I applied many of Albers's principles to these landscapes. While there is a strong sense of space, variation, and harmony within the use of color, its subtleties may not necessarily be accessible to the viewer at first glance. For instance, oranges and golds were used throughout Autumn in Beech Forest—*in the water in the foreground, in the reflections in the center, and in the distant trees—to give the painting a cohesive look, though the differences in saturation and value were used to create the illusion of depth.*

The same principles were applied in Mountain Overlook *so that the sense of light effect would be consistent for objects that share close spatial relationships. For example, the green in the evergreen appears similar in value and saturation to the greens in the foreground, but they are in fact quite different from one another.*

Because color works differently in every painting, there is little to be gained by memorizing these detailed examples. However, in order to avoid confusion during the early stages of learning this method and to help you understand how you mixed a color that doesn't look "right" once you have applied it to the painting surface, it is necessary to understand the concepts behind color as well as why and how these concepts work. It is self-defeating for students to berate themselves for mixing the "wrong" color—they are simply using it in the wrong place.

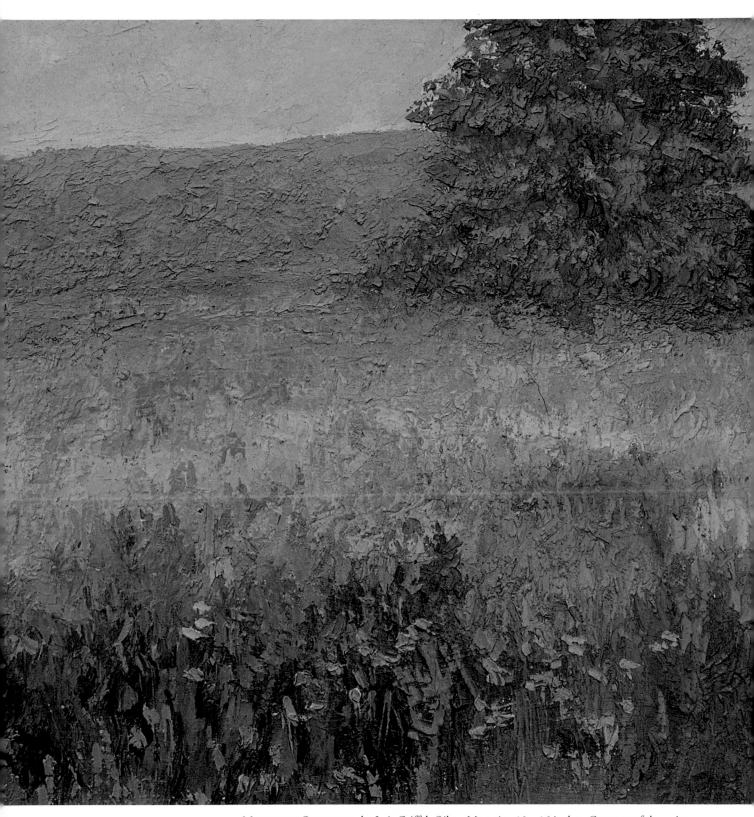

MOUNTAIN OVERLOOK, by Lois Griffel, Oil on Masonite, 12 x 16 inches. Courtesy of the artist.

OUR PALETTE

The color chart on the opposite page will help you discover many new things about color and teach you about paints: It will familiarize you with color names, show you how each color looks directly out of the tube, acquaint you with the concepts of temperature and saturation, and help unlock a few other new doors to color.

To start off, let's look at the colors we are about to use and why they have been selected. Although the color names in the list below are used by most manufacturers, neither names nor colors are standardized, so the basic elements and characteristics of each color are described in detail. By supplementing the descriptions, the chart can help make your color journey somewhat easier. Creating your own color chart will help you evaluate the pigments further, and determine exactly what you will need.

Lemon Yellow or Cadmium Lemon Compared with other yellows, these are the lightest and coolest. They shouldn't be as bright as primary yellow; in fact, Lemon yellow is slightly duller, though each contains a little tinge of blue. Because the yellow family is so warm, these are assets when you need a yellow that appears warm in the light but is cool enough to recede visually. When you want to warm a color with yellow and would prefer to avoid making it too hot, these are good choices.

Cadmium Yellow Pale This warm, luminous yellow is the primary yellow of the color wheel—the "true" yellow needed to create all the other mixtures. Your Cadmium yellow pale should look like the bright, pure yellow from your "Crayola Crayon" colors.

Cadmium Yellow This "yellow" is somewhat deceptive: In spite of its primary namesake, it is actually a tertiary color mixed from yellow and orange. It is warm, rich, and vibrant, darker in value than Cadmium yellow pale and lighter than Cadmium orange.

Cadmium Yellow Deep or Cadmium Orange Mixed from red and yellow, Cadmium orange is a true secondary color. This pigment should have the same clarity as an orange Crayola crayon. Because it is a mixture of two warm colors, Cadmium orange is one of our warmest notes, and can appear warmer than Cadmium yellow. Depending on the brand of paint, Cadmium Yellow Deep can serve adequately as a primary orange; otherwise, you may find it to be slightly lighter and warmer than Cadmium orange, in which case it is a middle tone between Cadmium yellow and Cadmium orange.

Cadmium Scarlet and Cadmium Red Deep or Chinese Red These two reds have been selected because one is warm and the other is cool. Because there is such a wide variety of reds on the market, you should try to select one warm and one cool version. My favorite "true" red is Chinese Red by Liquitex, which mixes like a primary red but also has a very slight touch of blue. Cadmium scarlet, which is also called Cadmium red light, is almost an orange red.

Sometimes you need to add white to these two reds in order to see their underlying tones. For example, Cadmium red is actually *not* a primary red: When white is mixed into it, it becomes very gray and cool. If you are thinking about adding it to your palette, just remember that it has a very neutral, almost "earth-tone" quality.

Permanent Rose This beautiful pink color mixes well with just about everything. Its transparency requires that white be mixed into it in order to evaluate it. It is cool in comparison to Alizarin crimson, but it is significantly warmer than Permanent magenta.

Alizarin Crimson and Permanent Magenta These colors, both of which are transparent, are similar in value and intensity. While the former is warm, the latter is a cool red-purple. It is to your advantage to know how these colors look directly out of the tube because they offer so much variety when mixed with other colors.

Permanent Mauve and Violet These two transparent purples were chosen because one is warm (Permanent mauve) and the other is cool. Though it's not necessary to have both at the beginning of your color journey, I included them here for your future reference. Since violet is easily mixed, you need only one. It is easy to warm any violet with red, or cool one with blue. Some people may prefer to use violets that are already mixed with white; note that these are more opaque and lighter in value. Violets and purples are the least standardized of all the colors, varying widely among manufacturers both in name and in degree of saturation.

Ultramarine Blue This is a dark, transparent blue that, when mixed with white, immediately calls to mind the true primary blue. This is our "workhorse" blue, as it is useful for everything and mixes beautifully with all of our colors. As a primary, it is the coolest blue.

Cobalt Blue While Cobalt blue is warmer than Ultramarine blue and cooler than Cerulean, it isn't a true mixture of the two. I find it useful because it makes a wonderful green when mixed with warm colors, thus providing an extended blue range. However, you will find that you won't need to use it at the beginning, as you can easily warm Ultramarine blue.

Cerulean Blue This relatively warm blue was selected because it is a little lighter than Ultramarine and is usually somewhat opaque. It mixes well with yellows to make a great assortment of greens.

Viridian or Emerald Green Many people prefer to mix all their greens, and sometimes I do too. However, if you like to have a premixed green on your palette, it is helpful to know about this one. Dark and transparent, Viridian is the most standardized of the greens available on the market. When mixed with white, it creates a beautiful pearly green. Some so-called Emerald greens—a variety of cool greens—are actually Viridians with white added to them.

Permanent Green Light or Cadmium Green Pale These luminous, middle-value greens are quite warm, and both work well with earth tones and oranges. As with most other colors, these two are not standardized and will vary greatly among manufacturers. There are many other greens available; for example, Sap green, a neutralized or "grayed" green (see "Grays, Browns, and Neutrals," later in this chapter). However, greens can be so easily mixed and/or neutralized that there is really no reason to carry around an extra tube of paint. If you start with the purest and most saturated colors, you can mix anything else whenever you need it.

Burnt Sienna This dark, rich color is important because it increases luminosity when added to dark notes, helping to neutralize them without lightening them too much.

Light Red or Indian Red In addition to Yellow ochre, these are two more earth tones, one cool and one warm. There are a number of similar colors available, including Venetian red and Red Earth, but if you wish to include more than one of this type of red in your palette, make sure that there are appreciable differences between them. If you prefer to limit your selection, either will do. These subtle, neutral colors, which are actually very brilliant, mix well with everything.

Yellow Ochre Although this beautiful color is deceptively dark in value, it has an amazing range in temperature. It mixes wonderfully with everything, and its versatility never ceases to amaze me.

White I use a Titanium white because I love its covering power and opacity. Thinner and more transparent whites are also available, so you should experiment to decide which you prefer. Regardless of your choice, make sure you carry a large tube!

LEMON YELLOW

CADMIUM LEMON

CADMIUM YELLOW PALE

CADMIUM YELLOW

CADMIUM YELLOW DEEP

CADMIUM ORANGE

CADMIUM SCARLET

CHINESE RED

PERMANENT ROSE

ALIZARIN CRIMSON

PERMANENT MAGENTA

WINSOR VIOLET

ULTRAMARINE BLUE

COBALT BLUE

CERULEAN BLUE

VIRIDIAN GREEN

PERMANENT GREEN LIGHT

BURNT SIENNA

LIGHT RED

YELLOW OCHRE

Our color chart.

MAKING YOUR OWN COLOR CHART

Rather than limiting yourself to the color chart reproduced on page 53, you will find the process of making and learning to use your own chart invaluable. To begin, draw a grid of eight by twenty squares on a white rectangular board or canvas. The eight squares, which will run horizontally along the top of the chart, will contain the gray value scale, and the twenty squares, which will run vertically, will be used for the colors. You can adjust the latter number of squares to accommodate the number of colors you use.

In the horizontal column of squares, paint a scale of eight values, starting with a very light gray at the left and ending with black at the right. The fourth value from the left will be the middle tone. (You do not need to paint the white square; the white of the support will do.)

To use a term coined by my colleague Charles Sovek, the origin value of a color taken directly out of the tube is its *starting* or *home value*. This does not mean, however, that all yellows or all reds would have the same home value. The home value of each color that is used in the chart is positioned within the grid as it relates to the gray scale at the top. (As was mentioned earlier, colors vary among manufacturers, so it's likely that yours will differ from those shown on the chart on page 53. Familiarize yourself with the colors in your palette so that you can learn to recognize the home value and saturation of each one.) Next, lighten each color to match the light values, but do not darken them. Now let's test some of our color assumptions and draw some conclusions by looking at the chart.

1. Because warm colors appear lighter than cool colors, it is often assumed that yellows are always lighter than oranges, and that oranges are always lighter than reds. However, by looking at the chart, we can see that this isn't always the case. For example, although Yellow ochre is a warm color, it is a middle tone. Also, Permanent green light is very warm compared to Viridian, but it is actually a dark note.

2. Home values vary for every color, even within a family of similar colors; for instance, four of the yellows have three different home values. In addition, because some pure colors are transparent, their home values may seem lighter than they actually are. For example, Permanent rose looks darker than Alizarin crimson when compared side by side because the latter contains white, which adds lightness and richness. In some cases, you may need more than one layer of pigment to distinguish transparent colors. Finally, colors with the darkest home values are still not comparable to black on the gray value scale.

3. Some colors will not easily fall into perfect value categories. In the chart on page 53, Cadmium yellow pale, Cadmium yellow, Cadmium scarlet, and Permanent green light are all half steps in value, which means that none was dark or light enough for the value square above or below it. I indicated this by cutting their home values in half.

4. All colors, regardless of their temperature and starting value, can be made equally light or dark.

5. Even within the lightest portion of the grid, the colors are rich and vibrant. You should avoid lightening colors so much that they lose their "personalities."

6. We also do not want to "blacken" colors by darkening them to match the darkest gray scale value. Although all colors can be made darker and lighter by adding white or black, to keep our palette brilliant we must refrain from darkening any colors with black and/or umber.

7. Notice the hard edge that occurs between Permanent green light and Burnt sienna. No matter how much you squint to soften the edges between each patch, these colors will create a contrast. This is so because the last three on the chart—Burnt sienna, Light red, and Yellow ochre—are grayed and are not pure colors, and thus would startle the eye no matter where they were placed on the chart.

8. None of the home values was matched to the darkest note of the gray value scale, which is black. This was done so that you would avoid using pure black; its extreme density would interrupt the continuity of your painting because it simply cannot convey color.

9. The more white you need to lighten a color, the less saturated the resulting color will appear; hence, the Cadmiums are much richer and brighter in the lightest values than the rest of the colors.

10. The brilliance and saturation of a color affects our perception of its value.

USING THE CHART

After you have completed it, your chart will contain a selection of origin colors coupled with their lightened values. In much the same way that a pastellist uses many sticks of color, you can refer to an assortment of colors to choose your starting notes. These colors are either pure or have been mixed with only white. We will interpret all light planes and all shade planes and dark areas by starting them with pure colors. The chart will provide information on the nature of these colors, as well as how colors relate to and affect one another.

When representing a shadow note, you will select a color from the chart that is darker than your origin color. For example, a yellow block in sunlight cannot be described by three shades of yellow that have been darkened by browns or blacks. Instead, the lightest side of the block will be represented by Lemon yellow, the halftone portion of the block will be painted with Cadmium yellow, and the part of the block in shadow will be painted in something warm yet dark, such as Permanent green light.

Monet discovered that the purer the color the more luminous the effect. He used brown only in its purest state, such as a rich Yellow ochre or a Terra rosa, and began all his darks with strong pigment to encourage brilliance. It's so easy to make muddy colors—why start out with them? I have never understood why the impressionists have been criticized for using pure color. Why should the vigor of rich, gorgeous color directly out of the tube be compromised immediately? Because Monet knew that color was the most saturated directly out of the tube, he will act as our guide on this color journey.

A WORD ABOUT GRAYS, BROWNS, AND NEUTRALS

Students constantly complain that they mix a lot of muddy colors. To paraphrase Henry Hensche, there really is no such thing as a muddy color; there are only colors that have been used in the wrong place. As Hawthorne expressed, "Some of the most beautiful colors in a canvas are nothing but mud when taken away from their combination." Before learning how to use beautiful, subtle mixtures of gray and brown within a painting, we must first understand how they work.

As was discussed in the previous chapter, white and black are not colors but the presence and absence of light. Gray is a value of light and doesn't really exist in nature as a color. When we observe grey and brown, we are actually seeing mixtures of colors that are neutralized visually by their inherent complementary qualities. Colors that are directly across from each other on a color wheel are called *complements*. (The main complements are orange and blue, yellow and purple, and red and green.) When you mix complements together in equal parts, they neutralize to create gray. Each complementary combination, when

mixed with a little white paint, creates a variety of beautiful colors that are commonly referred to as *mud*, which can actually be quite beautiful when used effectively. Another way to look at complements is that you are creating a neutral by mixing a primary with a secondary color, which means that you are actually mixing all three primaries. Thus, the equal mixtures of all three variations of complementary colors will look somewhat the same.

The spots of color at the center of the illustration below (labeled "C") are the three complementary neutrals. These spots were mixed from equal amounts of the blue and orange (top row), green and red (center row), and purple and yellow (bottom row). Note that of all the colors shown, these are the dullest and look most like brown or gray. Because they were each produced by mixing a primary and a secondary, they are thus composed of all three primaries, which is why they are so similarly "muddy," or equally low in intensity.

Rather than habitually adding brown or black to dull a color (which can make those mixtures look repetitious), combin-

ing complements to create a neutral will retain a greater individuality of color. The color spots in rows B1 and B2 are mixtures of complements, but contain unequal parts of each color. While the blue in row B1 is silvery and warmer and the orange in row B2 is duller and darker, both retain the character of the original color. These "grayed" colors will become indispensible when we begin to paint.

Using complements to create subtle mixtures will give you a larger selection of rich and varied colors. When you add white to these combinations you give the mixture luminosity, creating what is referred to as "gray"; without white, the mixture appears darker and looks "brown." Experiment with complementary mixtures to see how much of each color is needed to make various colors warmer or duller.

Because they are premixed by the manufacturer, tube browns, grays, and other neutrals become very dense and boring when mixed with white. Payne's gray or black is so completely "gray" that it doesn't look like a color when it is used by itself. It visually separates from the rest. Payne's gray tends to overwhelm other

Creating neutral colors by mixing complementaries.

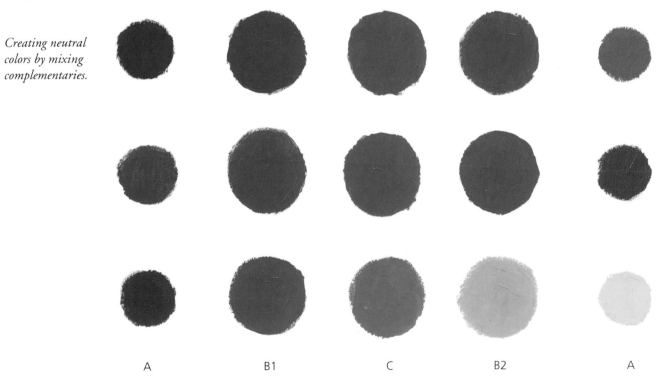

A B1 C B2 A

colors when it is used in mixtures because it is so saturated. Since it is easy to mix grays and browns, there is no reason to waste precious palette space when you can create a more beautiful color instead.

We will eventually learn to see these colors not as tube pigments but as subtle complementary color combinations. We must unlearn. You should avoid reaching for Burnt umber every time you paint a

tree trunk, and learn to see it within the context of its light effect that it is in fact a beautiful green-purple or brown-purple. This will make your color choices more original and luminous.

By gradually increasing the amount of a color that is mixed with its complement, we transcend their neutral to produce another color.

STOP SEINE by Lee Boynton. Watercolor on paper, 23 × 38 inches. Courtesy Foxhall Gallery, Washington, D.C.

This is a wonderful example of how to express shadow with vibrant color in a complex composition. Because it is difficult to layer many colors with watercolor, Boynton has rendered the shadow notes of the fishermen's slickers and the shadows under the boat into a deep orange cooled by green. This mixture isn't dull, yet it still works as a shadow note. Although it is true that warm colors advance while cool colors recede, Boynton used a complementary mixture to keep the warm yellow water note "recessive" while keeping it bright and light-filled.

ORIENTAL OBJECTS by Fredric Goldstein.
Oil on Masonite, 24 x 30 inches.
Courtesy of the artist.

The term "brown" doesn't refer to a single color, but represents a mixture of two complementary colors. This still life contains three "brown" objects: a violet drape in shadow, the Buddha figurine at left and the copper bucket at right. In order to paint the drape in shadow, Goldstein mixed purple with its complement to keep the color subtle. However, this is not the only option for creating a neutral. In this painting, the vibration of the red that was layed in under the somewhat grayed—but not muddy—purple actually makes the latter look even duller. On close scrutiny, you can see that the figurine is made up of strokes of greens, yellows, and reds that mix visually to create the illusion of "brown."

STILL LIFE WITH JUG by Hilda Neily.
Oil on Masonite, 20 x 16 inches.
Courtesy of the artist.

Although this still life study was painted in a low light key, the subtly colored objects and the magenta cloth are all rich in color. The highlights on the jug are painted with beautiful violets. Rather than using ochre to express its local color, bright touches of yellow and blue introduced in the halftones instead give the jug a great richness. The purples within the blue plate have a graying effect, which creates the illusion that the plate is behind the jug and catches some of its shadow in its reflection.

VISUAL MIXING AND COLOR VIBRATION

In order to work with a secondary color such as orange, we must either mix two primary colors (yellow and red) or use a premixed color (for instance, Cadmium orange). Monet discovered that by putting a stroke of pure red next to a stroke of pure yellow, the side-by-side vibration of the two notes results in a richer and more vibrant orange. This technique is called *visual mixing.* Other artists of his time, including Camille Pissarro, Georges Seurat, and Paul Signac, took this "breakup" of color to extreme heights. Their approach became known as *pointillism,* which was essentially a scientific analysis of the use of color dots to create color sensations.

Taking yet another step, Monet took advantage of this approach to produce various color effects, using brilliant color notes to lay in his masses. Then, by applying strokes of rich color over them, the vibrations enriched the original color notes. These vibrating color mixtures shook the very foundations of the art world of Monet's day, and the fruits of his discovery have proven invaluable to the artists who followed him.

One assumption of the science of pigment and color is that by mixing two colors both will change. Color is never as pure or as bright as when it is in its least-mixed state. For example, when red and yellow are mixed to produce orange, a new color is created that is both lighter and darker than its two original parts.

What can you do when you want to warm or cool an area of your painting, but would also like to retain the area's original value? By simply stroking a color of the same value over the home mass (a technique known as *scumbling),* you can retain the area's value. (Scumbling will be discussed in greater depth throughout this book.) Scumbling is an easy way to add color to an existing note without changing it drastically. By allowing the underpainting to show through, you enhance the existing masses. By increasing the number of color changes in an area, or when creating form, scumbling refines the subject's point of view.

Monet's discovery also works because of the complementary nature of color mixing. When you add two colors together, especially when you are not trying to create palette colors, the two original colors become grayed. Laying down strokes of pure color can help to retain color brilliance and freshness, and keeps us from creating areas of dullness. By making these discoveries, Monet has given us infinite color possibilities. Many artists use the scumbling technique instead of mixing all their colors on the palette. I particularly love to leave a lot of the underpainting showing through, especially for foliage. The color spots below illustrate and compare five scumbling techniques.

1. The first color spot is pure Cadmium orange, directly out of the tube.

2. The second color spot is alternating stripes of pure Cadmium scarlet and pure Cadmium yellow.

3. The third color spot was begun by painting Cadmium scarlet, then letting it dry. A day later, it was dry enough so that it did not mix with the Cadmium yellow that was scumbled over it. Notice that where the scarlet shows through it is still pure and bright, and that the Cadmium yellow also retains most of it brilliance. The yellow was applied in small delicate strokes, so that the vibration results in an orange color.

4. The fourth color spot was started with Cadmium scarlet, then Cadmium yellow was mixed into it while it was still wet. This wet-in-wet technique creates a subtler mixture, whereby both colors lose their individual richness but still create a bright new color.

5. The fifth spot was made by painting Cadmium scarlet, then thoroughly mixing Cadmium yellow into it. This of course becomes "pure orange."

When we look at the five color spots from a distance, they all look orange,

1 2 3 4 5

6 7

Examples of color mixing techniques.

though the three that were created from visual mixtures have different levels of brilliance. (The last two color spots demonstrate that scumbling can be done with any two colors.) All of these techniques can be used effectively to achieve different results.

In his painting of the grainstacks, Monet did not use a brown pigment directly out of the tube. The rich glow of his earthy brown is created by a warm green underpainting. The complement of green, which is red, is used in several variations, and is scumbled over the first note. The second strokes of color are Vermilion and Yellow ochre, which mix visually to "brown" the green. By applying color in this manner, we lessen the density of the color note, making it lighter and more airy.

Also notice the warmth radiating on the green grass. The illusion of sunlight is created by rich strokes of oranges, pinks, and yellows over light greens. If orange had been mixed *into* green, the green would have looked dull and grayed. Thus, laying down separate strokes enabled the color mass to remain light and rich.

In the painting at right, I used the underpainting not only to create a richness of color, but to suggest a sense of shadow. All of the shadows in the background bushes were begun with pure Magenta, stroked side-by-side with Indian red. The Magenta looks almost cool next to the Indian red. The shadows under the rhododendron bushes in the foreground are more within the shadows of the building. Because they were cool shadows, I used Purple and Magenta to create a darker and cooler underpainting note, then layered warm and cool greens over them. By making the greens lighter, the underpainting emphasizes the dappled shadow effect created by the leaves. In the lighter green areas, the foundation notes were started with bright oranges and ochres, with even brighter tones for the sunlight notes on the grass. When the lighter green notes were scumbled over, the sunlight looked convincing.

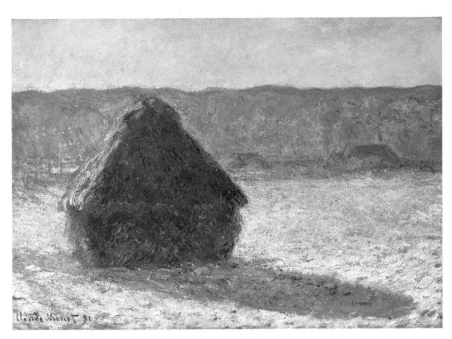

GRAINSTACK (SNOW EFFECT). 1891. Oscar Claude Monet (French, 1840–1926). Oil on canvas, 65.4 x 92.3 cm (25¾ x 36⅜ inches). Gift of Misses Aimée and Rosamond Lamb in Memory of Mr. and Mrs. Horatio A. Lamb; Courtesy of Museum of Fine Arts, Boston.

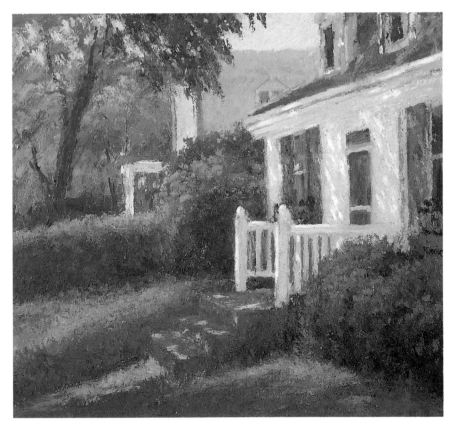

SUNLIGHT AND RHODODENDRONS by Lois Griffel. Oil on Masonite, 26 x 28 inches. Collection of Daniel Filoramo.

Part Two

IMPRESSIONISM
IN PRACTICE

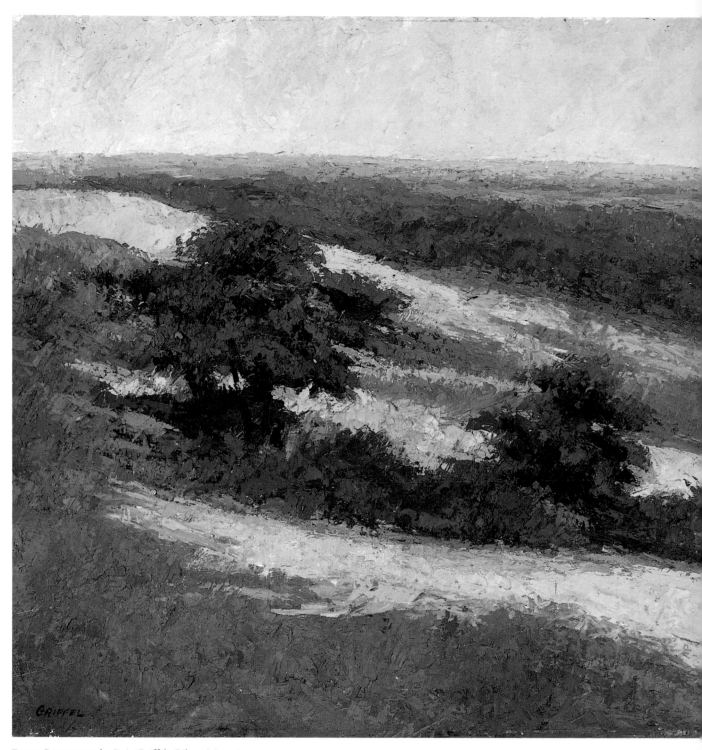

DUNE PANORAMA by Lois Griffel. Oil on Masonite,
18 x 24 inches. Courtesy of the artist.

*Many locations can be very hard to get to. I live at the tip of Cape Cod, which is known
for its beautiful rolling sand dunes, and getting to this particular spot takes stamina and
strong legs. I usually paint on location with nothing more than my half-box French easel
slung over my shoulder and a few paper towels in my pocket.*

Materials and Equipment

5

orking outdoors is easy when you are familiar and comfortable with your equipment. Reacting spontaneously to a fleeting light effect or a particularly interesting shadow pattern can be jeopardized when your easel won't open or you have forgotten an important item. I spend a lot of time on location helping students or teaching them how to use their easels (all types) because they hadn't taken the time to learn how to set them up or were running around to other class members to see if anyone had an extra palette knife. Taking a few dry runs before you begin to paint outdoors will solve the logistical problems so that you can devote all your time and concentration to the painting itself.

EASELS

While you are gathering equipment to practice plein air painting, it is important to purchase a good portable easel. While there are several types and styles of easels available, French easels and aluminum or wooden tripod easels are the most commonly used for painting outdoors.

Many people prefer the French easel (also called an outdoor easel), a masterful synthesis of the complete painting environment made specifically for portability which contains a paintbox, a palette, legs, and a canvas holder. However, when loaded with supplies, a French easel can be a little heavy and awkward to manage. Half-box French easels hold almost as much, but are significantly lighter and somewhat easier to handle.

The other popular easel alternatives are sturdy aluminum or wooden tripod easels, in which you can carry a paintbox or sketchbox, paints, and other supplies.

Regardless of the type of easel you choose, a good white painting umbrella that can be attached to an easel is an essential accessory. The umbrella serves two purposes: It can be used to adjust the quality or position of the light by shading your painting from the sun (which will be explained in detail in Chapter 6), and can be used to keep the rain or the sun from interfering with your work when the weather becomes difficult.

PALETTES

The palette may be the most important item when painting outdoors because it is the main vehicle of your color mixing. This is not the item you should choose to skimp on. Frustration caused by mixing color only reduces the enjoyment of learning to see it!

A palette is a very personal item. I myself prefer the classic arm-held mahogany palette because it is balanced and lightweight, provides a good middle tone on which to mix color, and can be cleaned easily.

You may prefer to mix color on a white palette (mixing color on a white ground is discussed later), which is usually made of Plexiglas. This type can be cleaned easily while working and travels well, fitting inside your easel or sketchbox. If you like the large arm-held type, you can make a separate carrying box for it to help keep the car clean when you leave your painting site.

Although I can readily acknowledge the convenience of palette paper, its use is limited for on-location painting because it is rather flimsy. It also takes too much time to save colors and mixtures by transferring them to a fresh sheet when the paper becomes filled with paint.

As you develop your skills and begin to use other mediums, you will see how pastel was literally made for this method of painting because the color is visually mixed by laying color over color. Pastel colors are applied one stick at a time, so choosing colors for their saturation and intensity is a great part of the learning process. In this painting, DiMestico used strokes of pure, rich color in the water passages, while stroking colors over and under each other in the marsh grass. This approach—bold color and simple composition—gives the ethereal light effect of the water and reflections.

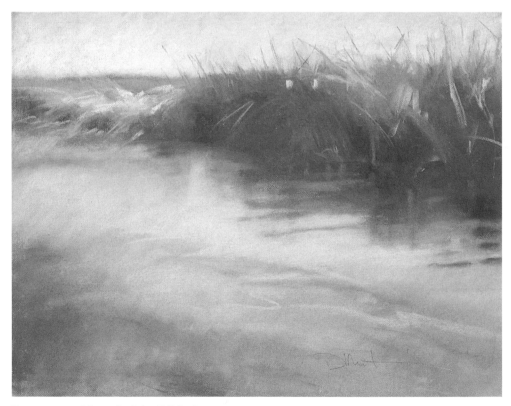

EDGE OF THE MARSH by John DiMestico.
Pastel on paper, 24 x 30 inches. Courtesy of Lampo-Lawrence Collection.

VILLAGE STREET
by E. Principato. Watercolor
on paper, 18 × 24 inches.
Private collection.

As one of Hawthorne's favorite mediums, watercolor deserves its own book. However, I couldn't resist including watercolors by some of my fellow artists who are profoundly influenced by him. This particular painting has a wonderful sense of light and space. The landscape notes are left yellow and bright to express the sunlight. The light on the house is warmed by a pink tone, and the shadows are made with vibrant mixtures of purples and blues. This painting isn't labored and detailed, but was left loose and painterly to express the warm sunlight.

PAINTING MATERIALS

Learning this method of painting requires that its students make definitive choices about their materials: That they use good-quality colors (regardless of medium) without painting mediums, palette knives instead of brushes, and Masonite rather than canvas.

PIGMENTS

Regardless of your choice of medium (more on this below), it is important to use good-quality pigments. At the beginning you may want to use the less expensive versions of some colors that a few reputable manufacturers include in their line of products. These are generally more desirable than any of the very cheap generic brands that you might find in your art supplies store. For example, Winsor & Newton makes a series of colors called Winsor. Winsor red, for example, is less saturated and more fugitive than the Cadmium red from the more expensive line. As you gain confidence in your work and begin to master the techniques, you should upgrade your pigments in order to maximize the quality of color in your work.

Although this book deals primarily with oil paints, pastel is also an excellent medium for learning Hawthorne's method; in fact, every technique described in this book can be applied to pastel. Degas used the pastel medium to its fullest potential, exploiting its vitality and brilliance. If you do use pastels, it is of the utmost importance to have at least a full set of Rembrandt pastels, which contains a selection of over 200 colors. Pastel artists using this color theory usually supplement this with more colors, and even additional pastel sets, in order to give themselves optimum variety and selection. Don't skimp!

Acrylic paint dries too quickly to be used effectively outdoors while learning this technique. Because much of the learning process consists of mixing wet colors into wet, they are unsuitable at the onset. However, many artists later apply what they have learned to acrylic paints, and are extremely pleased with the results. Hawthorne's color theory, is, after all, adaptable to all mediums.

The very nature of watercolor poses other problems for learning these techniques. Learning to see by adding colors into other colors, as well as using the white of the paper as a light color note, does not lend itself well at the initial stages. As with acrylics, however, many artists easily apply their newfound visual knowledge to the watercolor medium with great rewards.

PALETTE KNIVES VS. BRUSHES

An extremely demanding teacher, Charles Hawthorne wouldn't allow his students to use anything other than a putty knife to apply their oil paints. I suggest that you try a few varieties, then settle on a palette or painting knife that is flexible yet firm, and feels comfortable to use. I prefer to use a 1½- to 2-inch diamond-shaped knife with a curved neck.

At first, painting with a palette knife feels similar to frosting a vertical cake—unwieldly, stiff, and foreign. Although it may at first be difficult to appreciate, the awkward feeling that accompanies this technique is actually intended because it encourages painters to not worry about making a "finished" painting and keeps them from focusing on detail. The clumsy application of pigment with the palette knife is designed to limit students to thinking only about color and their reactions to it. You must not try to draw (in the classical sense), you must not try to define edges, and you must not become preoccupied with "perfection." It is simply easier to *not* do these things because of the unfamiliarity of painting with the knife.

While it may all seem clandestine at the beginning, the truth of it is that many people never use brushes again. You may not think so at the beginning, but using a knife can really be enjoyable. It is easier to clean than a brush, you need far fewer knives than brushes, and you don't need to carry additional items such as painting mediums or turpentine, except for occasionally cleaning your palette. It is also a pleasure not to need those extra cans and gear when walking to painting sites. Fluency with the knife becomes so second nature that students easily forget how much they hated the knife at the beginning!

For those of you who still love brushes, never fear—using a palette knife inspires bold, new ways of painting with brushes. You will find that you use less medium, apply richer, thicker paint, and increase the variety in your brushstrokes.

CANVAS VS. MASONITE

Just as musicians practice musical scales, it is important for painters to do many color exercises. The more we do, the more familiar we become with color notes. In order to accommodate Hawthorne's methods, the painting surface must be strong enough to support direct mixing and *restating* or reanalyzing an area of color.

At The Cape Cod School of Art, our students use gessoed Masonite because the panels are easy to prepare. This surface also gives students ample opportunity to scrape away and apply new color as they adjust their color vision. In fact, we often jokingly (though affectionately) refer to the school as "The Scrape Cod School of Art"! The ability to restate an area of color is an important learning tool, and it is easier to do this on stiff, relatively heavy board, especially while using a palette knife, than on canvas. It is also less expensive, and as they begin their color journey students are less concerned about making mistakes on less expensive boards, giving them more freedom to experiment.

Paint also dries more slowly on Masonite than it does on canvas, a clear advantage when working wet into wet, which involves mixing one color into another directly on the painting surface. This can obviously be difficult when the paint is dried and resistant.

It is recommended that students purchase untempered Masonite if they wish to prepare their own panels. For beginning studies, 9 x 12 inches or 12 x 16 inches, either ¼ or ⅛ inch thick, are good sizes. Apply one or two thin coats of gesso, sanding lightly between each coat. You may decide whether you want a smooth surface or would like to leave some brushstrokes showing.

An alternative to Masonite is canvas board that has been primed with at least two additional layers of gesso. This will create a similar painting surface that will not readily absorb paint.

Throughout their careers, many of my students and colleagues at The Cape Cod School of Art continue to use Masonite as their preferred painting surface. I like it because it eliminates the problem of sun reflecting through canvas, and it is less susceptible to punctures. When I paint a large landscape, I use the thinner Masonite to make it easier to transport. When I know that I will be working in a windy area, I use the heavier board for increased resistance.

In regard to permanence, paintings done on Masonite by my teacher Henry Hensche, some of which are over sixty years old, have never needed restoration. The colors are as vibrant and as beautiful as the day they were applied. I believe that preparation, which includes applying thin coats of gesso and careful sanding, is the key to permanence.

PAINTING MEDIUMS

One advantage to working with a palette knife is that the paint is applied thickly, eliminating the need for a medium. Because mediums tend to thin and dilute pigment, they are not useful in the early stages of learning this method.

Students are encouraged to work with rich paint; in many cases, colors will be applied directly from the tube without mixing. Because the paint is not tempered with medium, surface resistance between thick layers of paint is eliminated when painting wet on wet. Incorrect use of medium can prevent the proper adhesion of the paint to the surface of the support. However, there are times I want my last layer of color to be transparent; only then do I temper my paints with medium.

While every plein air artist will swear by his or her favorite setup, you should try different options or survey other artists on their preferences and choose a setup that accommodates your own strengths. You will find that this method of painting won't require as much extraneous equipment, such as brushes, heavy cans of turpentine and medium, and taborets, which makes your load much lighter when you are trying to reach your destination. Although eventually you may use brushes and mediums, one of the advantages of the early stages of this method is the minimal equipment necessary.

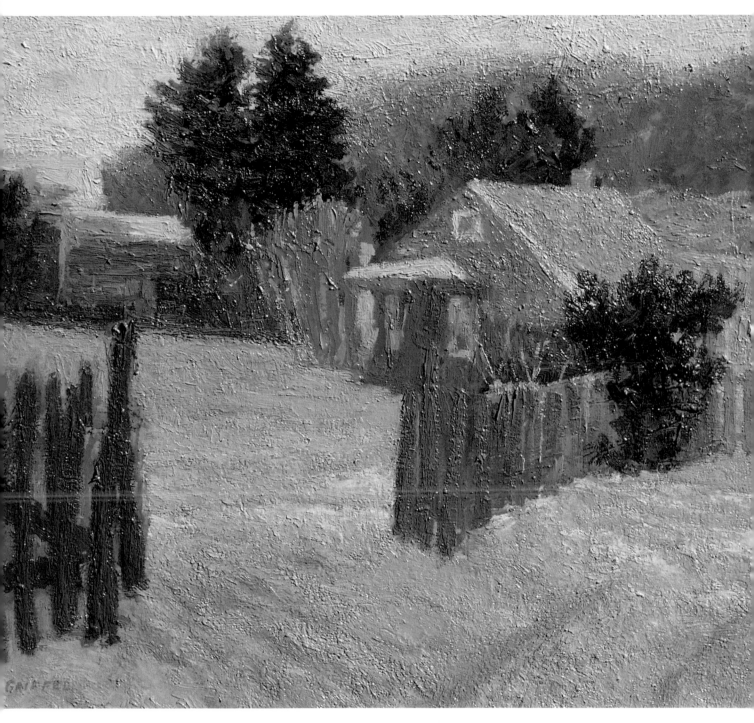

SNOW, SUNSET EFFECT by Lois Griffel.
Oil on Masonite, 20 × 18 inches. Collection of Judith Ferrarra.

I was so enthralled by Monet's series of paintings on grainstacks—particularly those in the snow (see page 59 for an example)—that even the frigid weather couldn't keep me from doing one. My feet weren't the only things that were cold—I soon found out that oil paints can freeze, too! As a result, I might have had to abandon this painting if I had been using brushes; the beauty of the palette knife was clearly evident as I used it to push the paint onto the Masonite.

SUMMER COTTAGES by Lois Griffel. Oil on Masonite, 12 x 16 inches. Private collection.

If this painting had not been started on a white ground, the particularly brilliant sunlight effect and the lushness of the trees in the landscape would have been impossible to achieve. The richness of the whites of the houses and the greens enhanced by yellows and ochre would have been obscured by a tinted ground.

Light in the Landscape

6

*I*n order to interpret light, we must determine how atmospheric conditions affect color in a composition. For example, because the light on a sunny day is completely different from that on a cloudy day and thus will influence the way we see color by changing its saturation and value relationships, we cannot work on a canvas during a cloudy day that was begun on a sunny one. ❧ Because all color is a consequence of nature's light key, the activity of painting requires that we learn how to translate its effects into pigment.

OBSERVING AND COMPARING LIGHT EFFECTS

The differences between the effects of sunny day light and cloudy day light are illustrated in the two photographs of the white block below.

l. Of all the planes shown in both photographs, the sunlit plane of the block in sunlight is the lightest and brightest.

2. The shadow plane of the block photographed on a sunny day looks darker because of the heightened contrast produced by the intense light. Note that this degree of contrast prevents the camera from exposing both of these planes evenly, making the shadow side of the block look almost black.

3. The value differences of the block photographed on a cloudy day are not as pronounced as those of the block photographed on a sunny day.

4. The light of each atmospheric condition affects the color of the block so distinctly that there are no common areas of color or light in either photograph; even the table and background look warmer in the sunny day image.

These careful observations raise the following questions:

1. What is the color of the top plane in each photograph?

2. How can we paint the six different white planes that are discernible in the two photographs?

3. What are the colors of the planes that are not in direct light? How would you describe "dark white"?

4. Can any plane of the block in either photograph be accurately referred to as its "local color"?

5. Are there any similarities between the images of the block in the two photographs? If so, what are they?

By attempting to answer these questions, we can draw some conclusions:

1. Colors and their value relationships must be adjusted to express variations in light. In other words, an object observed in two distinct light keys cannot be painted in the same way because the effects of the light in each situation are completely different.

2. Every plane of an object reflects a different aspect and intensity of light. Repetition does not exist in nature.

3. The effects of light cannot be adequately represented solely with local color.

4. If, while you are painting, an object is obscured by lengthening shadows or the sun is eclipsed by a cloud, the colors of both the object and its setting will change. A color that can be seen in the light cannot be expressed in the same way in the shade.

Photographs of a white block on a sunny day (left) and a cloudy day (right).

INTERPRETING LIGHT

Hawthorne noted that "there is no paint made to make the white on a house; we have to fool the public, make them think it is as we see it." The first step in translating light into pigment—regardless of subject matter or the particular color—is understanding that color cannot be painted as we think we see it.

1. The local color of an object cannot express the effect that light has on it.

2. The same color cannot be used to represent both the light and shade of a single object.

In view of these facts, it is clear that we cannot paint the color of an object by using only its local color. Because black and white are not colors but the absence and presence of light, we must learn to interpret what we see into color. White in sunlight cannot be expressed with only white paint any more than dark shadows can be represented with only black paint.

The photographs on the opposite page of the white block in two different light conditions show that white can look comparatively warm or cool and relatively light or dark depending on the light effect. If you were to lay down a stroke of pure white paint to represent the block's sun plane, you could not use the same stroke of pure white paint to represent its shade plane, even if it had been used to paint the block itself. Because you are attempting to paint the way that the light affects the block rather than the local color of the block itself, you cannot use a single color to fulfill two different conditions in the same painting.

We cannot copy local color; we must learn to interpret it in order to create an illusion of reality.

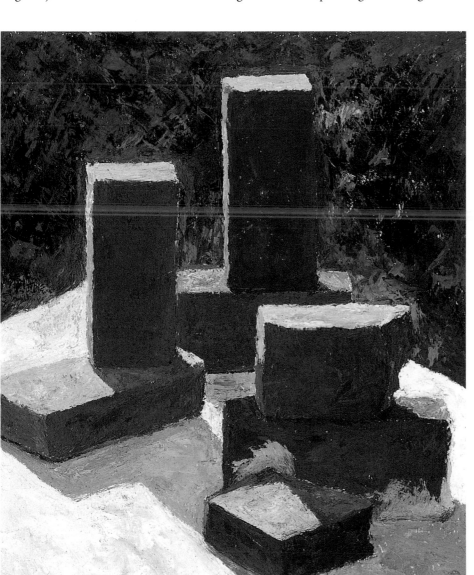

BRICKS AND RED BLOCK STUDY by Dan Neidhardt. Oil on Masonite, 20 x 16 inches. Courtesy of the artist.

This painting is a tour de force in color variations, demonstrating the incredible diversity that can be found within a family of colors, even under consistent light conditions. Neidhardt has painted each object with an individuality that is usually reserved for the subjects of a group portrait.

Painting on a White Surface

The impressionist approach to painting requires that you lay the paint directly onto a white canvas or board. Since you will cover most of the painting surface when you lay down the first notes, it may not be clear as to why a white support is even necessary.

Consider again the effect of simultaneous contrast. Although some artists prefer to tone their canvases with a middle-value color so that they can more easily establish lights and darks, doing so can dull your starting notes. Your first color notes should be as bright and as pure as possible, and they will appear more vigorous against the brilliant contrast of a white ground. These first notes—color at its purest—will thus remain unaffected by the tone of an underpainting, setting a standard of richness for subsequent color notes. On the other hand, if you begin with tepid color your future notes will also be weak and lackluster. Because the success of a painting is based on the first decisions you make, it is important to begin from a position of strength.

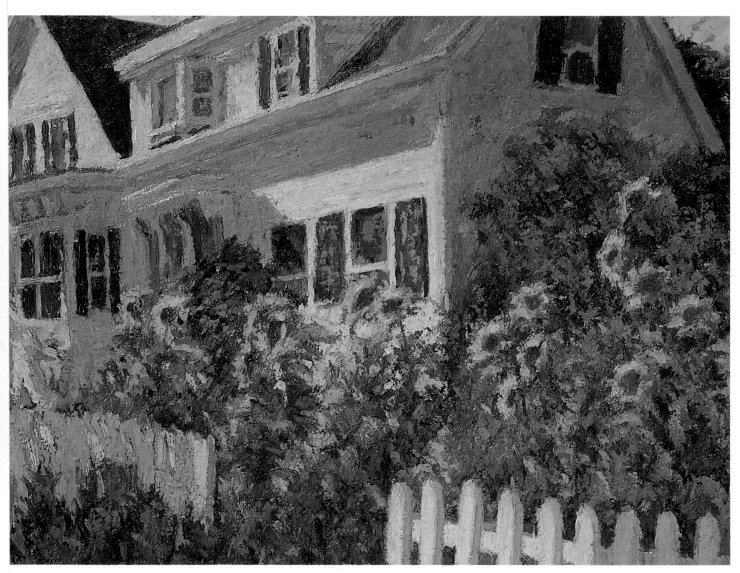

SUNFLOWERS AND MUMS by Lois Griffel. Oil on Masonite, 24 x 30 inches. Private collection.

While there are many situations in which you could use a tinted or toned canvas to your subject's advantage, this bright, sun-filled painting is not one of them, and for an obvious reason: The vibrancy of the landscape would have been destroyed. In a painting like this one, I "push" the color so that it is as rich, pure, and saturated as possible. A toned canvas would distort my first notes, acting almost as a "graying agent."

ABOUT DRAWING

Over the years, a great deal of controversy has been sparked as to the exact meaning of Hawthorne's assertion that "Drawing and form are better separated." Did he mean that he didn't want us to learn how to draw? On another point, Hensche strongly suggested that we free ourselves from jargon (such as the term "value") so that we could react spontaneously to color rather than intellectualize about it.

Debate over these kinds of pronouncements has simmered among the members of the modern impressionist community for a very long time. The situation disturbed me because so many beginners were only vaguely encouraged to "get the spots right" without receiving a coherent overview of the foundation necessary to the approach.

A friend recently figured out how this had happened. He realized that because most of Hawthorne's students were seasoned artists who had already received an academic art education, their familiarity with such basic skills as drawing and concepts like color value could be assumed. In view of this, Hawthorne and Hensche perhaps deliberately avoided using the precise terminology of these subjects to liberate their students from a somewhat rigid set of rules and expectations.

I cannot resist adding one comment of Hawthorne's that shows that even he couldn't completely avoid using standard color terminology. When criticizing a student's painting that contained too many landscape elements, he said, "The values rather than the drawing make a boat stay behind the piles of a wharf."

Since there is no doubt that both Hawthorne and Hensche possessed outstanding drawing and painting skills, it is important for me as a teacher to demystify these concepts, clarify their meanings, and encourage my students to apply them to their own work. While students can teach themselves to see color by studying the principles outlined in this book, I am also determined to give mine the tools they need to understand important terms in order to learn good drawing skills.

MEADOW IN AFTERNOON LIGHT by Lois Griffel. Oil on Masonite, 22 x 18 inches. Collection of Georgette Bolling.

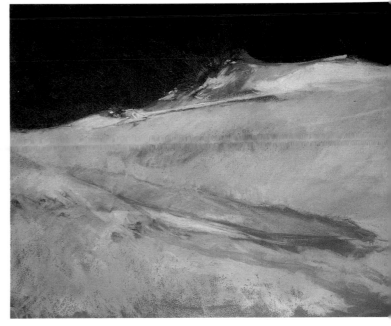

BIG DUNE by Lorraine Trenholm. Pastel on paper, 18 x 24 inches, Courtesy Sola Gallery, Provincetown, Massachusetts.

These two paintings show how large masses of color and their values can be used to effectively interpret landscape. The success of Big Dune *lies in Trenholm's confident handling of the composition's two simple, strong masses, which gave her an opportunity to develop the depth of the colors to their fullest.*

Using a similar concept, I tackled a different set of problems in Meadow in Afternoon Light, *which is again about one large mass of color with two minor color notes. If they were broken up by too many value changes, the painting would lose its continuity.*

PLEIN AIR PAINTING

Because patterns of light are continually moving and colors change as the sun moves, it is important to explain a few of the dynamics of painting outdoors.

If you choose to complete a painting in one session, you would be making a quick, vigorous statement about light, and letting your first impression convey your message. This makes the problem of "finishing" a painting quite simple.

Depending on how many color changes you are after, or even how much detail you wish to describe, you might choose to work on a painting over several sessions. If this is the case, it is important to establish a daily schedule for each painting. Because you want to record nature as beautifully and as specifically as possible, you cannot paint when the atmospheric conditions differ from those when you started. Also, you cannot continue a painting that was begun at a different time of day because the light and shadow patterns will be too radically different.

Regardless of what you are painting, whether still life, portrait, or landscape, it is essential that you stand or sit in the same spot at the same time every day. Because I am excited by light patterns as

well as color, I do not want to change any of the elements in my painting once I have started. If I have set up a painting for a sunny landscape with a house in it, I have established patterns of light and dark on the house, as well as passages of cast shadows from trees, or those of bushes on the ground. All these patterns and colors must be relatively the same each time I paint.

Because the light key of nature is continually changing, a landscape subject such as a white house will also change even if it is backlit and has no obvious light patterns on it. For example, in the morning the house may have a reflection from some element near it that might make its local color look warm and rosy. An hour or two later, the reflection may be gone and the color of the house will appear darker. Thus, the hour of the day can be an element of color change as well.

I make it a habit to record the time I start a painting on the back of the board, and travel to the location at the same time every day until I have finished it. I like to work during early morning and late afternoon because the colors and shadow patterns are the most dramatic. I usually

work on two or three paintings during each session because I am limited to only an hour and a half to two hours per painting because of the changing light. I might have a 7 to 9 A.M. painting, a 9 to 11 A.M. painting, and perhaps an 11 A.M. to 12:30 or 1 P.M. Then I might also have a 4 to 5:30 P.M., and a 6 to 7:30 P.M.

I enjoy changing locations during the day. Your eyes will become accustomed to a landscape's colors after a while, and it is easy for the subject to lose its freshness. As you return to a painting site each day, you are continually reinspired by the subject, its light effect, and the reasons you were first drawn to it. Changing locations keeps you aware of new sights.

I also have paintings for gray days, overcast light conditions, and other outdoor variables. Working on many paintings at one time encourages my visual awareness of specific light keys. However, it is important to keep track of how the variables affect the subject matter. Monet once complained that he had started so many variations of the Rouen Cathedral that he couldn't figure out which was which!

Photographs of Dyer Street taken at 4 P.M., 4:30 P.M., and 5 P.M. Shadows constantly change during a painting session. As the evening progresses, they move more quickly than during afternoon hours. At 4 P.M., although the white house is shadowed it looks very light compared to the dark shadows on the street, where there is great contrast between the shadows and light on the asphalt. Notice how bright the bush in the foreground appears. I have cast a shadow on it while taking the photo, but you can see how warm and rich the color actually is. The shadows on the

fence are vague and light. By 4:30, everything has changed and moved. The bush is not as richly lit, and its color looks cooler and darker. The shadows on the fence are clearer because they are darker, while the shadows on the pavement have clustered and thickened. Notice that the street is also darker because the sun isn't reflecting down on it as much. In addition, both houses are in sunlight. At 5 P.M., not only have the patterns of light changed but the entire scene is warmer, with the color of light everywhere seemingly influenced by yellows and ochres.

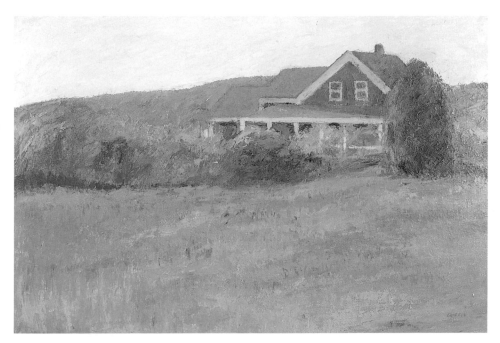

FORSYTHIA IN EVENING LIGHT
by Lois Griffel. Oil on Masonite,
24 x 36 inches. Collection Art in
Embassy Program, Bonn, Germany.

*I started this large painting at
5:30 P.M. The setting sun
illuminated the forsythia and dune
grass in the foreground for a very
brief period of time. The
composition relied on the light
effect of the backlit yellow
blossoms. Because these bushes are
short-lived and the weather didn't
cooperate, I didn't have a chance
to complete the painting during
the spring in which I started it. I
really liked my initial lay-in, and
waited until the following
forsythia season to finish it.*

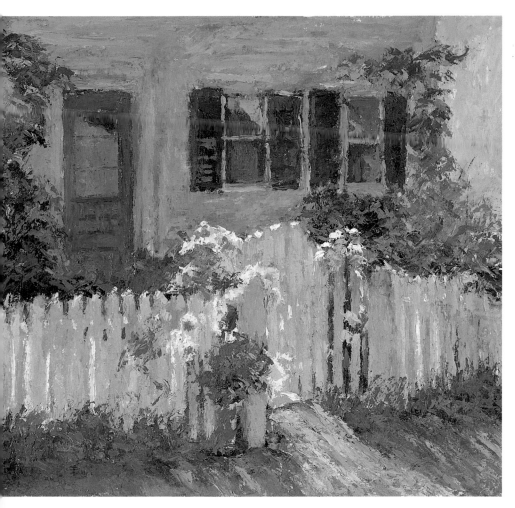

WHITE ROSES, MORNING LIGHT
by Lois Griffel. Oil on Masonite,
14 x 18 inches. Private collection.

*In this landscape, the sun was
coming from behind the house,
lighting only the roses. The effect
was so fleeting that I had less
than my usual hour and a half.
Because the most important part
of the painting is the color, there
is actually less detail than at first
glance. I kept the painting simple
and loose in order to capture
the light.*

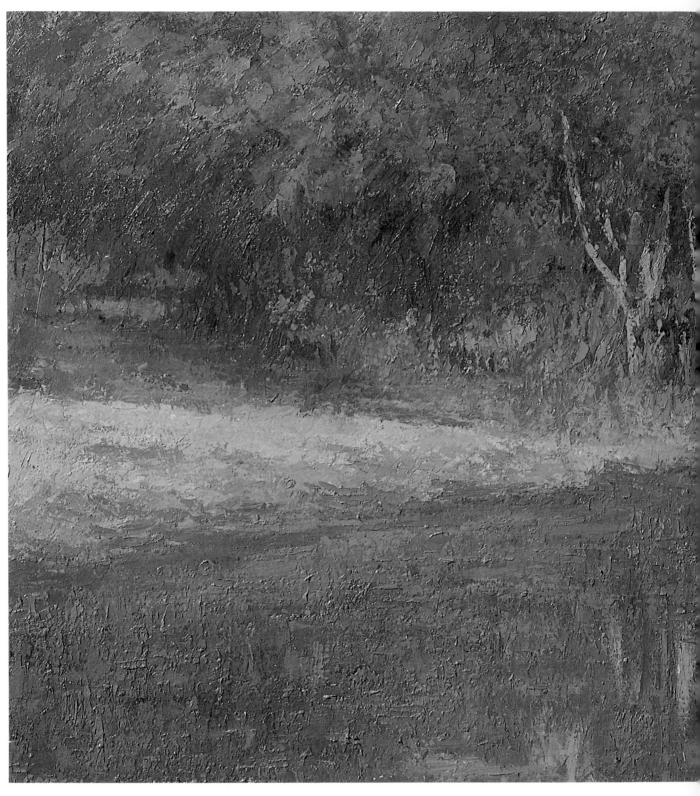

SPRING POND, SPRING GREEN by Lois Griffel.
Oil on Masonite, 18 x 24 inches. Collection of Peter and Phyllis Tomaiolo.

One of the most intriguing characteristics of Monet's paintings is the complexity of their surfaces. Monet broke up his first color masses with many strokes of color, then used so many of those same colors in subsequent layers that it is difficult to distinguish each layer of vibrating color. In this painting I deliberately scumbled the same colors throughout several layers to create areas of interest.

Sunny Day Block Studies

7

*I*t is exciting to learn how to observe the infinite variety of nature's palette and to be able to express its diversity in a painting. For most of us, landscape creates this desire, because we cannot help but notice the beauty of a sunset or the silvery shimmer of light on a foggy day. Before we can work on a subtle landscape composition, we must first establish a strong foundation. Our building blocks for painting the light are actually blocks, and the accompanying exercises will furnish the keys to unlock some of its secrets.

SETTING UP THE COMPOSITION

The blocks I used for this exercise were cut from 2 x 4s and painted with Golden Acrylics matte acrylic paints, which are thick and adhere well to raw wood. The colors in this line of paints are extremely bright and their finish is excellent. Because we want to observe color in its simplest state, a matte finish will help to eliminate most of the reflected light.

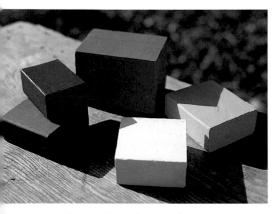

Composition photograph: sunny day block study.

Although I painted the blocks in this chapter with primary and secondary colors, as you become adept at painting block studies you may eventually decide to work with sets of blocks in tertiary colors and other mixtures, including grays and earth tones. Before I begin, I like to have three or four variations of each primary available, such as two different warm red blocks as well as two different cool ones. Painting a block study of various temperatures of one color can also be interesting. For example, because no two trees are exactly the same, a block setup in a variety of greens provides good exposure to the requirements of landscape. By studying and painting green blocks, you begin to reach beyond the limiting perception that all trees are the same hue and value of green.

Even the simplest block composition should interest and challenge you. Vary the sizes of your blocks and place them so that different planes of each can be easily seen. Even if you begin by limiting your composition to the tabletop you should make the cast shadows of your sunny-day study part of the arrangement. You might also include the edge of the table on which you have placed the blocks, as well as the foreground or background in your area of vision. In addition, the color of the table and/or a draped cloth can enhance and change the composition. Are there flowers in a garden beyond the table? Are there shadows cast from a tree overhead? All these elements can take your block study to a more stimulating level. Keep the arrangement simple, but be sure that you can see the color differences clearly.

If your setup is vertical, the painting surface should also be placed vertically on the easel. Placing the composition logically within the frame of the support furthers your chances for a successful color study. Although I do not cover the specific rules of composition at this point, you should take the time to plan your setup's composition. When composition is bad, the strength of even great color is diminished.

PROCEDURE

So that you won't place a color in the wrong area, begin the exercise by lightly drawing in the composition on a white support. Because we are concerned with illustrating the light effect, the patterns of light in the composition are as important as the color choices.

Render the drawing with paints and a brush or with pastel sticks, which make good drawing tools and won't bleed into the first color notes. There are several brands of pastel sticks on the market; I alternate between Nu Pastels and Carbothello Pastel Pencils. Since pastels are basically dry oil paints, catching a paint stroke on the drawing won't distort a color note. Neither detail nor sharpness should be a consideration at this stage. The drawing serves only as a guide to correct color placement, and should not be "finished" in any sense of the word.

I choose colors that are light in value because they are easily seen on a white support. I drew the sketch you see below with a Carbothello No. 11 for the sake of reproduction, but I generally use lighter colors. Regardless of your chosen medium, keep the color light and the lines relatively thin. It is essential that the drawing facilitate—not intrude upon—your first color decisions.

To depict the relationships of the blocks as correctly as possible and to create the illusion of their position on the table, good drawing skills and an awareness of perspective are in order. However, avoid focusing needlessly on perfection; producing a clear rendering is sufficient. There is plenty of time to worry about the details.

I recommend that your support measure about 12 x 16 inches; if you want to work in a larger, bolder format, 16 x 20 inches is appropriate. Fill the board or canvas with the drawing, taking care not to leave an excessive amount of wasted space behind the blocks or in the fore-ground. Large areas of little or no interest are as awkward in block studies as they are in landscapes. Incorporate everything within your visual frame of reference, including the back or front of the table, shadows on the table, and sometimes the landscape near the table, into the drawing.

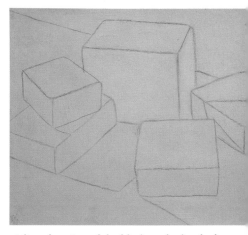

A line drawing of the block study sketched in a light-colored pastel stick.

GENERAL GUIDELINES

Before you begin, there are a few important guidelines that you should bear in mind. They are intended to start you on the right track, to simplify the decision-making process, and to help make your journey swifter and easier. I consistently apply these fundamentals to my own work and in my teaching.

- *Do not use mixed colors as your first color choices.* Each of your first selections should be a pure color; do not mix two pigments together to create variations in temperature or hue. If necessary, however, you may mix each starting color with white to lighten its value.

- *Represent each mass with only one color.* I will guide you through the process of selecting the starting notes, which should be as bright and as pure as possible. For the purposes of the study, the blocks have two primary physical components: light planes and dark planes. The color chosen to express each plane must describe these two components regardless of the block's local color. Because all light planes are expressed with light colors, shadow planes are darker. It is important to clearly delineate light and dark planes so that they properly represent the effect of the light on each block.

- *Use as little white paint as possible.* Many beginners start out by mixing too much white into their first notes because they perceive that the top planes of the blocks are bleached out by the intense light. Later in this chapter I explain how to avoid this kind of error.

- *Do not use blacks or umbers to darken shadows.* Rather than mixing black into a color to create the shadow of that block, select a pure dark color to express it; in fact, each color plane should be represented by a raw, pure color. This is where the color chart on page 53 can help. Remember that the local color of the object does not describe the color of its shade plane.

- *Use a different color spot for each separate color mass.* By using a variety of colors, you will become more adventurous, experimenting with color in ways that you may not have considered.

- *The first round of notes should be as bold and as rich as possible.* No matter how rich and bright you think your color note is, make it even brighter! Train yourself to see and create intensity.

- *Never make a color decision without scanning the entire setup.* Remember that each color in a composition affects every other. Respond to each separate note by comparing it to the whole. You must constantly scan your subject to see color. Staring at one mass of color for a long period will fatigue your eyes, making the mass seem gray. Because a color is defined only by its relationship to the painting as a whole, isolating color actually prevents you from evaluating it correctly.

- *Start in the middle and work out toward the edges of each color mass.* Leave white edges around each color note. Do not worry about neatness or perfection. Laying down the first color notes in the center of each mass keeps the pools of color separate and clean so that as you mix into them they won't bleed into each other. By starting each area this way, the color remains fresh and you won't be as likely to make "mud."

- *Start with the lightest and brightest notes because they are the easiest to see.* Their richness sets the tone for the rest of the painting. Lay down your first notes within the masses that you feel most confident about observing.

Block studies give you an opportunity to examine the simplest breakup of form—nothing but pure colors and basic shapes. Be fearless and have fun!

SUNNY MORNING, COMMERCIAL STREET by Lois Griffel. Oil on Masonite, 12 x 16 inches. Collection of Barry and Sandy Lerner.

At The Cape Cod School we affectionately refer to house and garden landscapes as "large block studies." Including a building in the composition gives us an opportunity to observe the effect of light on man-made, geometric shapes, as opposed to the subtleties of the natural landscape. This is a prime example of how block studies can support all our painting endeavors.

STEP ONE: SUNNY PLANES, FIRST NOTES

Start with the block with the most obvious color, painting all the top sunlit planes first. Work sequentially, moving from note to note (one always influences the others) while continually scanning the setup. Remember that pure color, directly out of the tube, is at its most brilliant and most saturated. The starting notes will be different if the arrangement of colored blocks is changed in any way. I want to impress on you that there are many different choices, and that every artist sees color individually.

THE YELLOW BLOCK

What could be easier to see than a yellow block in sunlight? Its sunlit plane loudly exclaims its warmth and brightness. Scan your palette, then pick the yellow that is closest to what you see. Your choices are the bright but cool Cadmium lemon or the slightly darker and warmer Cadmium yellow pale. Before you add white to either, remember that even a touch of white will cool down a color.

By comparing the two yellows, I decide that Cadmium lemon is too bluish for such a warm color note, so I use the Cadmium yellow pale. I refrain

from adding white to establish a richness on which all my other colors choices will be based.

HELPFUL HINT

Because they set the stage for the rest of the painting, resist your impulse to "bleach out" the first notes by lightening them with white. Pure Cadmium yellow pale duplicates exactly the brilliance and saturation of the yellow block's top plane.

THE WHITE BLOCK

Scan the setup and let yourself react to another color note. Base your next color decision by comparing the other blocks to the color note you just painted. You may become confused if you jump across the setup and begin working on the warm notes of the red and green blocks. Next, compare the yellow block to its neighbor, the white one. Notice that the top plane of the white block is a little lighter and cooler than the yellow one, and warmer than the blue one.

Check your palette for a color that expresses the top plane of the white block, which must be lighter and cooler

than the Cadmium yellow pale you used for the yellow block. Place a spot of Cadmium lemon in the center of the top plane of the white block, then step back and evaluate it. As is, it is too dark to represent the white block. Add a small amount of white to lighten its value. Now it looks just right.

HELPFUL HINT

If I had it on my palette, I could have used pure Lemon yellow, which is lighter and just a little cooler than Cadmium lemon. You have many options, so you can make different choices for each block study and light key.

THE GREEN BLOCK

Which part of the setup should we focus on next? Work on a block that is adjacent to the first two color spots, or on the one whose color is the next step deeper in value. Since you have already painted the two lightest notes, the succeeding colors can only be darker.

Scan the entire setup. Note that the top of the green block, the blue block, and the gray table are similar in brightness, value, and richness, and that they are all slightly darker than the yellow note. It will be easiest to work on one of the two warm elements next and leave the blue block for last.

Although the green block and the gray table are similar in value, you should concentrate on their colors. Let your eyes drift over the setup to gauge your response to the color. The green block appears warmer than the gray table. Because I should use as many colors as possible while not repeating any for the starting notes, I eliminate Cadmium lemon and Cadmium yellow pale as possible choices for the green block's sunlit plane. There are several warm colors left on my palette. Cadmium yellow or Cadmium orange appear light and luminous. Pure Permanent green light and Cadmium green pale are both too dark for the top plane, and if I tried to lighten them they would lose their warmth. I choose to start the green block with a rich, warm note—pure Cadmium

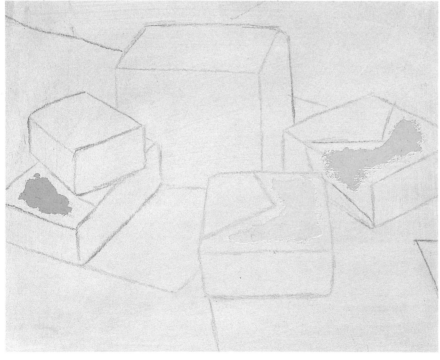

Sunny planes, first notes: yellow block, white block, and green block.

yellow—to express the sunlight, not the local color.

THE RED BLOCK

Now we choose between the red and the blue blocks. Although the blue block is the same value as the green one, it is our coldest note. The red is next because it relates more closely to the warm choices that have already been made. Notice that it is slightly darker than the green block.

Cadmium or Chinese red directly out of the tube are too dark for the top plane of the red block. If they were lightened with white, these already cool reds would become too cool. The red block in the setup looks fiery, so Cadmium or Chinese red simply won't make it! Instead, use Cadmium scarlet or Scarlet red, both of which are highly saturated orangy reds that remain rich and warm even when lightened. However, don't lighten your red too much; it must be darker than the green note. Either is a good choice for our starting red note.

THE GRAY TABLE

Observing the strong sunlight on the table, it is easy to see the warmth of its complementary mixture. Because we have a yellow block in the setup, the table seems more orange. I chose Cadmium orange, which can be neutralized later with its blue complement. If the table appeared yellow due to different objects in the setup, a yellow-purple complement would be used. Remember, all colors in an arrangement are interrelated, and gray is no exception.

As soon as I put it down, the orange appears darker than Cadmium yellow. Since both planes are close in value, I add a little white to the Cadmium orange to lighten it.

Step back and evaluate the results. The colors appear warm and light-filled; nothing seems bleached out or dull. We have successfully expressed the sunlight on local colors.

THE BLUE BLOCK

Because blue is a cold color, we cannot use it to represent the light plane. All of the notes chosen so far have been made from the warmest notes on our palette. Although most of the cool side of the color wheel remains, we must remember that those selections have warm variations. We have dark reds, roses, and magentas, which can be both warm and cool. Blue is a cold color, but the top plane is warmed and affected by the sun, so one of the reds will be a good choice.

At first, Alizarin crimson and Permanent rose appear too warm, but if they are lightened they would cool down, which would relate them to the cool quality of the block. I choose the Permanent rose because of its luminosity. Even when mixed with white it remains rich. The cool aspect of the pink ties in with the blue note, while its warm aspect describes the light effect.

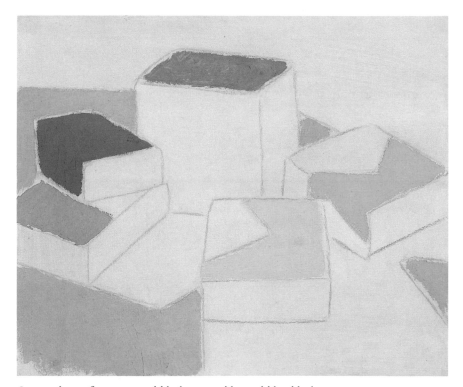

Sunny planes, first notes: red block, gray table, and blue block.

STEP TWO: SHADE PLANES, FIRST NOTES

Before selecting colors for the shade planes, let's review a few concepts about colors in sunlight and shade. Remember that on a few occasions we did not start the sunlit planes of a block with its local color. This is because the presence or absence of sunlight, or any source of light for that matter, changes our perception of color. Sometimes the color appeared warmer and lighter, and sometimes it had

to be painted darker than the local color, as was the case with the white block. For similar reasons, we cannot always paint shade planes with local color.

Shade planes will appear darker than the objects' local colors, and appear colder when compared with their sunlit planes. Some shadow notes will be obvious. How much more inventive do we need to be than to simply make the shad-

ow blue? The same would go for the green block. Since green is made from blue and yellow, its shadow could be started with a cool green, or with Viridian mixed with just a little bit of white in order to give it brilliance. If you find yourself wondering "What color is white in shade?" remember that there are more exciting colors in a white shadow than simply "dark white" as a shade of gray.

IN THE WOODS by Lois Griffel.
Oil on Masonite, 20 x 24 inches.
Collection of Thomas and Kimberly LaBelle.

Shadows express form, light condition, and texture. Spots of color give us the illusion of sunlight. I was challenged to paint this landscape because of the light effect. Because the patterns were not as structured as in Goldstein's painting, I had to establish the very large masses of the trees and ground against the light radiating at the end of the path. The entire tree and ground area was started with the Viridian used in the shadow of the green block, the Indian red used behind the table, and some purple for accent. You can see the strong orange-yellow underpainting influencing the light area. The scumbling worked extremely well here, with succeeding colors added wet over dry.

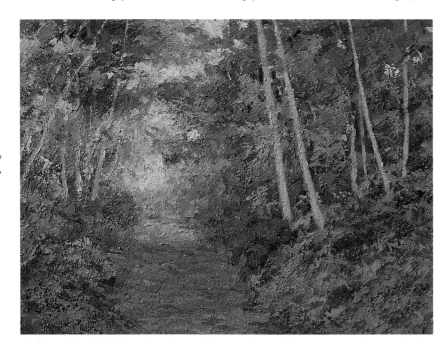

LATE AFTERNOON LIGHT IN SWEDEN by Fredric Goldstein. Oil on canvas, 30 x 36 inches. Private collection.

I selected this painting because of its beautiful light effect and its similarity to the block study, particularly the extreme contast of sunlight and shadow and the range of the palette. The warm orange influence, the warm blue shadow and the yellow light on the white fence, and the warm red house with its Alizarin shadows all follow the block study, and the trees have the same rich foundation notes. You can see where block studies can lead!

THE BLUE BLOCK

As with the sunny planes, we begin painting the shade planes by working on the most obvious first. The coldest shade plane is on the blue block. Because we haven't used blue for any of our notes, we can choose any of the three blues, each of which is slightly warmer than the other. Ultramarine blue, the coldest of the three, is the best choice.

Lay the color down undiluted. Because my Ultramarine blue is very transparent, it looks almost black at first. It needs to be visually "lifted" with a little white, which lightens the color and increases its opacity. If your brand of Ultramarine blue is somewhat opaque, you won't need to add white, and so it may be light enough to use as is for the starting note. Take the time to evaluate it properly.

As before, lay down color starting with the inside of the plane, gradually working toward the edges and leaving a border of the white support around all of the starting shade notes.

HELPFUL HINT

Note that I started the two shade planes of the blue block with the same color. Although they are in fact different, I won't try to distinguish them at this point. By specifying nuances and breaking up masses too quickly, you lose impact and structure, sacrificing the integrity of the light and dark planes and the singularity of individual color masses. To paraphrase Hensche: Keep the darks dark, and the lights light.

THE GREEN BLOCK

Green is a mixture of blue and yellow—both warm and cool—so it was easy to select a warm note like Cadmium yellow for its light plane. Likewise, the "cool" component of its shadow note is immediately visible.

I compare the green shade plane to the blue one. It looks very green. There are two greens on my palette, Viridian green and Permanent green light. The latter is too warm, so I use Viridian, which is very transparent. As with the Ultramarine that I used for the blue block, my pure Viridian is a dark trans-

parent stain that becomes progressively darker as I add more paint. I add white to it for opacity and richness but try not to lighten it too much, aiming for the same value as the blue shade plane.

HELPFUL HINT

Keep the first shade note of the green block similar in value and richness to that of the blue block to maintain parity among masses and to prevent a premature breakup of light and shade planes.

THE RED BLOCK

Lighter than the shade planes of both the green and blue blocks, the shade plane of the red block is next in terms of saturation. This note is so intense that I have only to choose among my reds. Although Chinese red was too dark and cold for the sunny plane, it looks lush and accurate in this context. Because red, like green, can appear both warm and cool, it is a good choice for either plane.

HELPFUL HINT

You might also try Alizarin crimson lightened with a little bit of white for this shadow note. While some colors

will not work where you want them to, you might find that by conducting some experiments in the name of adventure you will improve on your first—and perhaps the most obvious—choices. That's when it really becomes fun!

THE CAST SHADOWS

I notice that the cast shadows are close in value and hue to the starting shade notes that are already painted, and that those of the white and yellow blocks are the lightest. Rather than trying to figure out each cast shadow separately, evaluate them as a single unit and select one note to represent them. These are relatively cool shadows on a gray table. You can either express their colder aspect by using Violet or Purple, or choose an earth tone, such as Indian red, to express their underlying warmth. The color of the cast shadows is warm, but not as warm as the shade plane of the yellow block. Permanent magenta is cooler than the Alizarin crimson that was used for the red block, and is warm in comparison to the blue block's shade plane. Permanent magenta seems to describe the warmth of the gray table in sunlight while still looking like a cast shadow.

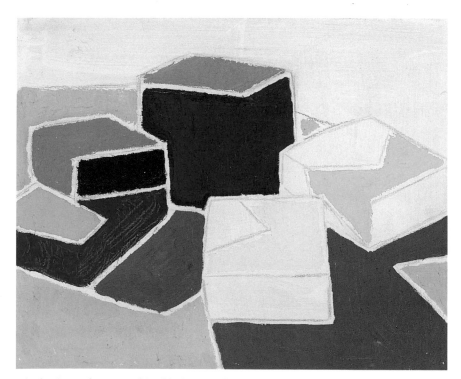

Shade planes, first notes: blue block, green block, red block, and cast shadows.

Paint all of the cast shadows in the study with the same starting note. As your powers of observation develop, you will see that cast shadows are affected by adjacent colors, and eventually you will be able to isolate each one at the start. However, I cannot overstate the importance of keeping them in a similar range of value and color; otherwise, the impact of the light key will be diminished.

THE WHITE BLOCK

The shade notes on the white block are not particularly dark, nor are they as cool as the blue block's. Because we are describing shade, the dominant tendency of the plane is cool, but a "warm cool" because of the reflected light of the table. I have a few selections left: Cerulean blue, Cobalt blue, Alizarin crimson, and a few earth tones. Any of these are good choices, but I choose Cerulean blue because while it is a predominantly cold color it also embodies a certain warmth. I have other plans for the earth tones.

Remember that the best way to observe color is to continually scan the composition. Use this method to record color sensations, then rely on the ones that you have the most confidence in to develop the painting. You will start to see colors in the shadows. Also keep in mind that you cannot "figure out" color by staring at it, and that you should not let your vision linger on a single color mass. Try to stay objective; keep your eyes moving.

THE YELLOW BLOCK

The yellow block contains the last of the shade notes. We must think carefully about how to express "dark yellow." Looking at the color chart, I notice that Yellow ochre is a possible choice, as is Light red lightened slightly with white. I prefer to use Yellow ochre because I don't need to dilute it with white. Remember that pure color, directly out of the tube, is at its most brilliant and most saturated.

Note that we do not need to "blacken" yellow to express a shade plane. Because we don't have the convenience of a definitive local color to express the shadow planes (as with the blue, green, and red blocks), we instead chose a color that relates to the darker nature of the block's local color, which in this case is Yellow ochre. Remember that color in nature is never as dark or as light as we first think it is. We haven't gone to an extremely dark value for this note. This note is dark enough to create contrast between the block's sun and shade planes, making the latter rich and luminous.

THE BACKGROUND

In order to maintain the directness of the painting, we must select a single color to represent the background, which is grass in both sun and shade. We can add more details later on. When I determined the shadow notes for the yellow and white blocks, I was also planning ahead for the background. After comparing the shadow notes, I see the background color as warm and dark, and decide to make this last shadow note an earth tone: Light red, lightened ever so slightly with white.

A still life might be composed of objects on a table with some kind of landscape in the background; this block study provides a fairly elementary example of this. The simplification of shadow patterns is discussed in Chapter 10, "Landscape Painting," but for now depict the background as a shadow note.

Sunny and shade planes: completed first notes.

SUMMARY OF FIRST NOTES

Although the colors chosen for the sunny planes were somewhat lighter or darker than the local color of each block, the effects of light on each were expressed with a single bright, warm color. As a result, the first shadow notes were cooler than their corresponding sunny planes.

Wherever possible, we used brilliant, saturated color, unmixed and undiluted. Mixed color, which potentially can look muddy, was avoided entirely. Where it was necessary to add white, as little as possible was incorporated. These bold color statements create an illusion of sunlight.

The painting of first notes is essentially an exaggeration or overstatement of large, simple masses. We have "characterized" color by keeping the lights and the darks comparable in temperature. Our color choices express a light key that is clearly rich, sunny, and exuberant.

SUNLIGHT AND SNOW by Lois Griffel.
Oil on Masonite, 18 x 24 inches. Collection of Joan and Dale Feid.

I could scarcely believe my eyes when I came upon this scene—a white house and white fence after a snowfall—which illustrated perfectly the effect of light on white. The colors I used were similar to those I used to start the white block: Lemon yellow throughout for the sunlight masses and Cerulean with strokes of magenta for the shadows. The sky also has a pink undertone; its blue is slightly warmed with some yellow.

As your ability to observe and your color awareness matures, you can break up your starting notes with two colors, as in the scumbling exercise on page 58 that uses strokes of color.

STEP FOUR: SHADE PLANES, SECOND NOTES

Work on the second notes for the shade planes by applying the same set of procedures as used for the sunny planes. As before, you will make color choices by constantly scanning the setup and comparing all the notes. The second notes for the sunny planes showed that a range of color temperatures exists within sunlit masses, which means that sunlight can be expressed by both warm and cool colors. By now you are beginning to understand that color is more diverse than you had ever thought possible.

THE GREEN BLOCK
Following the addition of the second note to its sunlit mass, the two planes of the green block's Viridian shade mass now show a difference in color. The shade plane that faces toward the light has a light, glowing quality, while the side beneath the red block is darker and cooler.

It is not necessary to lay down a second color note in both planes in order to distinguish them. By simply adding a cooler color of the same value to the plane in shadow, it will look darker and cooler. I choose Permanent mauve (which is also referred to as Cobalt violet), a relatively

cool violet with a trace of warmth, although Viridian's warmth could make even a cold violet work well in this spot of color. Note that the untouched plane now appears lighter and warmer.

HELPFUL HINT

My objective here is to show you how easily a new color note can affect another. You have altered one plane, without touching it, by changing its neighbor. Each succeeding color note influences the entire painting and produces visual changes.

THE RED BLOCK
The shade plane for the red block needs no adjusting at this point, and so will remain as is.

THE BLUE BLOCK
As with the green block, the two shadow planes now look distinct, although this time the source of the difference is the reflection of the yellow block rather than the lightened sunlit blue plane. The yellow reflection notwithstanding, you cannot lighten the original note so much

that the value of the shadow plane is lost. Adding yellow to it will not only lighten it too much, it will probably make it appear too green.

In spite of this kind of exacting awareness, you will benefit from experimenting with different colors to warm or cool various notes, even if only through trial and error. The only way you will learn whether something works is to try it. I hope my choice—and there are many others—will surprise and excite you.

I chose to warm up this blue shadow with Permanent magenta! The warmth of the red gives the side plane a warm glow, relates wonderfully to the blue block's cast shadow, and appears to subtly reflect the yellow block.

One of the most important consequences of this method is the disintegration of our limiting perceptions about color. Sometimes the "outrageous" choice not only works but is beautifully right.

HELPFUL HINT

As I add progressively more color, I fill the planes to their edges without making them sharp and rigid. In the final notes for this study, you will learn that two planes meeting will create a line that your eye will see as straight. The less fixed your edges are, the more painterly your final results will be.

THE CAST SHADOWS
As was mentioned earlier in Step Two, the color of a cast shadow is significantly influenced by several variables.

- The color of each individual block affects the color of its cast shadow.

- The perception of the light effect varies from block to block.

- Each cast shadow is influenced by adjacent colors. Don't worry if at first you cannot see any variations among them; this will come with experience.

We now must differentiate the cast shadow of the green block and that of the white and yellow blocks. First, cool down the shadow of the green block with Cobalt blue so that it appears dis-

Shade planes, second notes.

tinct from the shade plane of the blue block, since the two masses are immediately adjacent. The warmth of the Cobalt blue also alludes to the fact that the cast shadow is on the sunlit plane of the table. Leave the other cast shadows for the final round of color changes.

HELPFUL HINT

In order to keep from repeating colors, make sure that each new visual mixture doesn't mimic a previously established mass. Learning to observe subtle color differences is part of the challenge.

THE WHITE BLOCK
The shade plane at the front of the white block appears lighter and warmer than the cast shadow on its top plane because of the light reflecting off the table. However, the color of the reflected light cannot be as light or as rich as our initial visual response might dictate because the value of the new note must be the same as that of the first.

By scanning both the setup and the painting, I see a mixture of pink and yellow that is only slightly lighter in value than the first note. I mix Cadmium yellow and Cadmium scarlet, then add enough white to maintain the intensity. When I scumble the mixture over the front plane, the vibration warms the note while preserving the integrity of the shadow mass.

HELPFUL HINT

Determining the source of reflected light can help you make a decision about a color note. However, when you are not sure of the source of a color's influence, you must rely on your analysis of its relationships to adjacent colors.

THE YELLOW BLOCK
Although each of the shade planes on the yellow block is different, I would rather preserve their consistency for the sake of continuity. A light, luminous green quality is evident throughout the shade planes. Either Permanent green light or Cadmium green pale would work. Permanent green light is the darker of the two, and will need to be lightened with white. The home value of Cadmium

THE FLAME TREE by Lois Griffel. Oil on Masonite, 16 x 20 inches. Courtesy Rice/Polak Gallery, Provincetown, Massachusetts.

In addition to making certain values within the composition consistent—the key to successfully capturing light effect—you will apply the lessons you have learned here to use color to express the sense of space within a landscape.

green pale is just right, so you might prefer to use it for its stronger saturation.

Add the mixture to all three of the yellow block's shade planes. I can now see that the shade plane at the front of the block is much lighter than the others. Rather than developing these planes by adding more color at this point, I decide to wait to see how the final round of notes will influence my choices.

HELPFUL HINT

It is not necessary to add or change colors unless you see something new each time you scan the setup. I tell my students, "Stop when you don't see any more new changes." The thrust of this advice is that you should keep the beginning of each painting simple and not expect to finish a perfect painting right away. However, each study will improve your ability to see, as well as your clarity of vision.

THE BACKGROUND
The last shade plane in our second round of notes is the background. Because its first note established its shade aspect, at this point I will merely add the green of the grass. Take care when doing so; you want to embellish the color, not change it or gray it. The background should remain in the background, so do not call undue attention to it by using an excessively bright or warm green.

To avoid lightening the Light red starting note too drastically, I use Viridian to keep the color rich and dark. However, as soon as I put it down I can see that it looks too cool, and actually makes the first note look almost violet.

I then switch to Permanent green light, but it is too light and acidic. As with the second note of the green block's sunny plane, a mixture of the two greens will solve the problem. The combination is not too light, warm, or cool, but just right.

STEP FIVE: FINAL NOTES

Color added as final notes tightens up the painting by finishing edges and describing form. This step is important for all types of subject matter, and is certainly a fun part of block studies as well. If color and value differences between masses appear obvious, we will add them now.

THE GREEN BLOCK

As with the white block, the front plane of the green block is also affected by reflected light. After cooling the interior shadow plane on the previous round of notes, this plane now looks warmer. I decide to further emphasize the difference between the two planes by adding pure Permanent green light to the original Viridian exterior shade note.

I also enrich the shadow plane on the top of the block. The light source is inconsistent, so there are subtle differences throughout the painting.

HELPFUL HINT

Because light travels, shadow and light will always affect a painting, which is easy to see on structured paintings like block studies. Do not respond to this by changing the direction of the shadows or the value structure of the light and dark planes. However, if you notice slight nuances of shifting light that enhance the painting, by all means go for it!

THE RED BLOCK

Although it seemed somewhat lighter at the beginning of the painting, the red block's shade plane is gradually darkening. If I adjust the value and make it darker I will lose that beautiful rich red note, so I prefer to leave it as is. However, I would like to cool this area to bring it in line with the shadows while keeping the new note on the reddish side. For my purposes, Permanent rose is a good choice. Its blue quality will give me the coolness I'm after, and the pink won't dilute the red unreasonably.

HELPFUL HINT

You must decide when it is appropriate to leave a color note alone, when to darken it, and when to lighten it. The main goal is to retain the light key and the initial value relationships of light and shade planes.

THE BLUE BLOCK

I will differentiate between the two shade planes a little further. Because we have already incorporated the reflection of the yellow block into the side plane by adding Permanent magenta, we can easily boost the effect.

The red block casts a subtle warmth over the front plane. A strong red will be too severe, so I choose Alizarin crimson, which we also used to cool the top plane of the white block. Color is used most effectively without a limiting formula.

THE YELLOW BLOCK

The yellow block contains rich colors in its various shade planes. We can lighten them slightly—and the key word is *slightly*—as we add new colors. The darker notes beneath give the planes the necessary depth, while the added color enhances them as masses. The planes facing the white block are receiving quite a bit of its reflected light. However, we should avoid making the shadow planes too yellow.

Although they look like they were painted with yellow, the shadow notes on the side of the yellow block are a complementary mix of Cadmium orange and Permanent green light. I knew I wouldn't gray the orange; only merely refine it with the subtle green. As a result, it remains within the shadow masses while still seeming yellow.

Applying the same idea to the front of the block, I combine Permanent green light with Cadmium scarlet, making the mixture a little darker and richer than the first. Because Cadmium scarlet is pinker than Cadmium orange, this mass looks warmer.

We see that the top sunlit plane appears lighter than the side sunlit plane. It is actually being cooled by the blue of the bright, clear sky, which is out of sight above the composition. I want to retain the warmth of the top plane, so adding a cool color would gray it too much. Why not tint Cadmium lemon with Permanent rose? Both have cool properties, and together they make a luminous new yellow with a touch of "sky" in it. I make the note just slightly lighter than the original Cadmium yellow note. The vibration of the two notes actually creates the precise effect.

HELPFUL HINT

Consider the idea of adding a tint or "hint" of color to another. The result of every mixture doesn't necessarily need to be a completely different color.

THE WHITE BLOCK

To enhance the violet reflected in the shade planes of the white block, mix a cool violet with white to match its value. The two shade masses are still distinct from one another, and the combination of the three planes projects a beautiful "pearlized" effect.

In this particular study, a third note could be added to the white block's sunlit plane. Although it does have a cool aspect, I like its warm effect. The addition of blue or violet can whiten the block somewhat, but I prefer to keep the exaggerated warm quality.

THE GRAY TABLE

There is no question that the tabletop's color has a local gray quality. We could easily add a blue or violet to achieve this, but I prefer the richness of the warm sunlight note. I decide, however, that I want to make the color a bit more subtle, so I cool it down with Cadmium scarlet or Chinese red. Since both colors are less saturated when lightened, the addition of a pink note makes the original Cadmium orange note appear cooler or grayer.

Success! I wasn't forced to specifically interpret the gray of the table's local color, and I was able to preserve the sensation of sunlight.

THE CAST SHADOWS

The nuances within the cast shadows are a result of the reflected color of each

block as well as their position within the composition. For example, the reflected light of the white and yellow blocks makes their combined cast shadow look warm compared to that of the green block. Without compromising the integrity of that cool mass, we need to add a warm, low-value color.

There are many possible solutions. Pure Cadmium orange is too warm and light, so I add its complement to darken it. This gives me the hue, value, and intensity that I need.

Now we must consider the *penumbra,* which is the area of partial illumination between shadow and light. Although it is easy to assume that the penumbra is a halftone somewhere between light and shadow, the point at which the two intermingle is brighter and more intense.

The warmed cast shadow has a Yellow ochre quality, and the darker shadow appears to have a Cadmium orange note. In this case, I keep the penumbra darker than a halftone and close to the shadow note, although sometimes the penumbra is closely allied with the light area, and thus should be painted accordingly.

THE BACKGROUND

I finish the background notes by making a few color changes. I see warm and cool

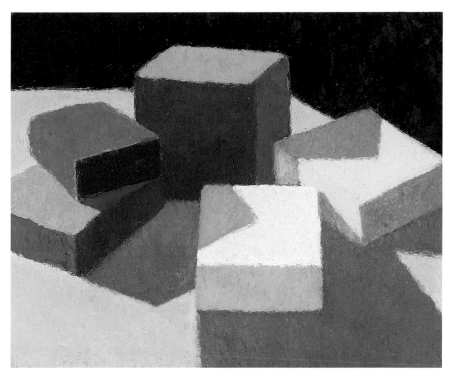

Completed sunny day block study.

greens within the single mass and scumble those variations over the foundation notes. I do not want to try to overload the mass with shadow details, so I keep these last notes simple. However, as the light and shadow patterns on the ground change, we can add those notes. Depicting a landscape's final light and shadow changes is discussed in detail in Chapter 10, "Landscape Painting."

SUMMARY OF SECOND NOTES

The technique of visual mixing (see Chapter 4) enables us to explore color mixing from a new perspective. Color remains bright and vivid when it isn't mixed or neutralized, so we can combine pure colors on the painting surface in unexpected and exciting ways. Also, we don't have to feel inhibited about creating grays or "mud" because we know exactly where to use them. We can do anything we want with color!

All of our second notes were based on our starting colors, which expressed the light key regardless of local color. By beginning a painting with the light effect, you are establishing a greater rich-

ness and variety in the composition. In fact, when the starting notes successfully express the light key, you often don't need to refine them to achieve a more local note. For example, the great American watercolorist Winslow Homer often used a single warm note of Yellow ochre to represent a sunlit plane of grass. As your sensitivity to the color of light develops, your ability to see color will become so acute that you won't instantly see "green" every time you look at a tree.

There are several versions of every color, both warm and cool. If your first note leans toward cool, you might decide to balance it with a warmer color for

your second note. The fact that different combinations can produce similar results allows you to adjust color regardless of the starting notes, and enables you to be more inventive by taking calculated—or even playful—risks. In some instances, this risk-taking can literally open your eyes to color and light.

In this chapter, you have learned to make exciting statements rather than timid ones, and to express light and dark as boldly and as simply as possible. As we continue to seek the endless variety that lies within the realm of color, our new challenge is to resist using the same formula to interpret it every time.

THE VIEW TO THE BEACH
by John DiMestico. Pastel on paper,
24 x 30 inches. Collection of Bob Vetrick
and Ken Janson.

The first color used to express a light key is often so flawless that it isn't necessary to develop the note further. In this painting, the brilliant light on the dune grass, rich and yellow, leaves the first impression of light undisturbed, and we understand exactly what the artist wanted us to see.

WINTER BACKYARD by Peter Guest.
Oil on Masonite, 14 x 18 inches. Private collection.

Learning to layer color teaches us about the diversity of a light key. We experiment with color combinations that can be applied directly to the painting surface. Compare this painting to Sunlight and Snow *(page 87): There is an obvious similarity in color, but a greater subtlety of the application here. The colors are more completely integrated; in some areas, such as the warm light in the house and the bright light on the snow, the colors are almost entirely merged. By reviewing how we painted the white block's light plane, we can analyze Guest's accomplishment: The snow in sunlight is composed of a mixture of the same bright colors, lightened slightly with white, and applied with a painterly finesse.*

Applying What You've Learned

Before undertaking the color exercises outlined in the following chapters, it is useful to demonstrate how the techniques analyzed in this chapter apply to landscapes, and to review some of the basic similarities between the two types of subject matter.

Only after I finished painting *Summer Light on the Roses* did I notice the number of similarities it shares with our sunny day block study. First, I painted its starting notes in the same way: The white areas with yellow, the green hedges and trees with Indian red, the sand (parallel to the block study's gray table) with Cadmium orange, and the blue of the sky with pink. All the shadow notes on the house and cottage were begun with Cerulean, and the grass in front of the cottage, which was similar to the top plane of the green block, was painted with Cadmium yellow. The bright color of the roses gave me a chance to apply some strokes of brilliant red, and the roof of the house in sunlight was evaluated strictly as a light plane. Coincidentally, each first choice was resolved in much the same way as those in the block study.

In addition to this, it is essential to understand why the three landscape areas—the tree in shade, the bush in sunlight in front of the house, and the plane of grass in sunlight—were painted with three different greens. Although both are in sunlight, the grass is painted with a lighter green than the bush because the flat plane of the grass catches the light at a greater angle, therefore reflecting more light.

While I was able to apply the basic techniques illustrated in the sunny day block study to this landscape, it must be said that color, its relationships, and its values always vary, from painting to painting as well as within a single composition. We used Cadmium yellow for the top of the green block in the block study to express the influence of the sun-

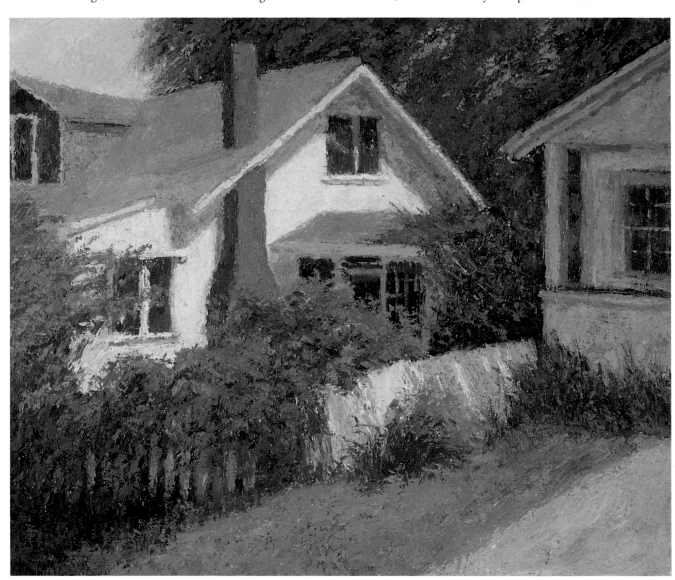

SUMMER LIGHT ON THE ROSES by Lois Griffel. Oil on Masonite, 30 x 24 inches. Courtesy Rice/Polak Gallery, Provincetown, Massachusetts.

light on its local color, which is in fact the objective of all our first notes. But if there were another green block in the study, both would not have been resolved in the same way.

Shown in the painting at right, the Heritage Museum in Provincetown is a popular subject among local artists, though Edward Hopper's painting of it is certainly the most famous. As often as the beauty of the steeple had inspired me to paint this scene, I was able to see it afresh after attending an exhibition of Monet's paintings that included his series on the Rouen Cathedral. Monet's masterful handling of his subject stimulated me to indulge my vision in rich layers of pigment, and to attempt to recreate the radiance he had so splendidly depicted in his own work.

The striking deep blue of the late October sky against the large "blocks" of the luminous and richly shadowed white structure was stunning and dramatic. The color of the sky, which is characteristic of those late autumn days when the air is crystal clear, plainly revealed the differences between these two major areas of color.

The sky is represented with an underpainting of Permanent rose and a mixture of Cobalt blue and Ultramarine blue, resulting in a color note that is similar to the sunlit plane of the blue block. In this case, however, I had to consider the depth or value of the sky in relation to the building, whose light planes are a mixture of Cadmium yellow, Cadmium scarlet light, and Cerulean blue. If I had painted the sky with as light a Permanent rose as I had used for the top plane of the blue block, I would have been unable to successfully establish the brilliant light effect on the building. A color mass must always be evaluated within the context of a specific painting. In *Majestic Rooftops,* the composition is reduced to three main masses: the sky and the light and shade areas on the building. An inappropriate use of color in any one of these areas would jeopardize the integrity of the painting. While I had painted many layers of each color in every mass, I hoped to transcend the physical layering of color and achieve a more coherent visual blending.

MAJESTIC ROOFTOPS by Lois Griffel. Oil on Masonite, 24 × 20 inches. Courtesy of the artist.

WINTERSCAPE by Lois Griffel. Oil on Masonite, 16 x 22 inches. Courtesy of the artist.

Cloudy Day Block Studies

8

Students often avoid painting landscapes on cloudy days because they think that they are drab and unexciting. However, until you've painted a simple block study on a cloudy day you might not be fully aware of its extraordinary potential for opulent color. More important, limiting your interest to one light effect will confine your artistic growth because each variation increases your sensitivity to all the others. Once you have painted a cloudy day block study, you will eagerly anticipate gray days.

SETUP AND PROCEDURE

Although we are using essentially the same setup that we used for the sunny day block study, I decided to reposition the blocks slightly to make the composition more interesting. First, I placed the green and yellow blocks on either side of the setup entirely within the frame of the painting. Because there were none of the cast shadows that created movement around the pictorial plane in the sunny day study, I balanced the spaces between the blocks and their relationship to the table by turning them to generate a similar sense of movement. I also wanted to give the blocks more breathing room in order to fill out the pictorial space and to diminish the role of the table in the painting. I adjusted the position of the blue block from horizontal to vertical in order to create more tension and variation within the arrangement.

The procedure for this study is exactly the same as for the sunny day blocks. On the same size support, sketch the same type of simple line drawing, but this time use a cool color. It makes sense to keep the drawing color consistent with the desired outcome, especially if you use paints and brush instead of pastel sticks, since there is always some "bleeding" of color into the main masses. Review the suggestions for drawing the sunny day blocks in the previous chapter and follow them for this exercise.

GENERAL GUIDELINES

Before you begin this study, note the differences between the sunny day and cloudy day setups.

- *Contrast* While there is great contrast between color masses in a sunny day setup, the contrast between masses on a cloudy day is not as extreme. There is no bright light illuminating the top planes of the blocks, which in turn would make the shade planes appear comparatively dark. In fact, because the cloudy day blocks are not dramatically influenced by the light key, all of their planes are closer in value than they were in the sunny day study.

- *Cast Shadows* On the cloudy day, the blocks' cast shadows are essentially nonexistent, whereas the blocks on the sunny day throw long shadows across the table.

- *Color* Because the light on the cloudy day appears cooler, the colors of the blocks may seem "silvery." However, we should not assume that cloudy day light will simply mean "grayed" color. The colors of the cloudy day blocks are as rich and as saturated as the sunny day's; they are simply not as bright. In addition, the color appears consistently more "local" because the sun isn't influencing the light planes with its warmth, thus making the shade planes appear cool.

As in the sunny day study, our primary goal here is to express how the light of the atmospheric condition influences color. We will rely on the knowledge gained from our experience with the sunny day blocks, which will guide us in our choices.

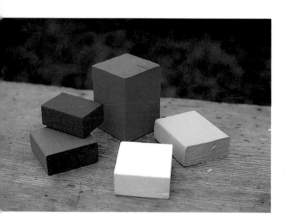

Composition photograph: cloudy day blocks.

SILVER TEAPOT WITH PINK FLOWERS by Margaret McWethy. Oil on Masonite, 8 x 10 inches. Collection of Lavinia Wohlfarth.

In this painting, the artist has successfully captured the silvery subtlety of north light, which has greater contrast and more interesting light patterns than a cloudy day. The beautifully painted silver teapot is composed of many varied strokes of color, and its expertly rendered rounded edges create volume and form.

TOM'S HOUSE WITH ROSES by Hilda Neily.
Oil on Masonite, 16 x 18 inches.
Courtesy of the artist.

FLORIDA SUNSHINE by Hilda Neily.
Oil on Masonite, 20 x 16 inches.
Courtesy of the artist.

These wonderful paintings of similar subject and landscape elements depict two completely different light keys. The light of the sunny landscape, which was created with notes of brilliant warm colors and accented with warm rich greens, radiates so intensely that we can almost feel the intense heat. With its luscious and expressive purples, the cloudy landscape is immediately identifiable. The warm earth tones in the tree notes balance the weight of the cool greens, avoiding the usual clichés.

STEP ONE: TOP PLANES, FIRST NOTES

As we continually scan the composition, we must remain aware of the differences between the two light effects. We have already noted that the cloudy day setup has almost no cast shadows, and that the value differences between the top and side planes are not as extreme as they were in the other exercise. The most obvious difference is in the way that the less intense light preserves the local "identity" of both the top and side planes. Because the top planes aren't as brightly warmed as in the sunny day setup, the side planes aren't by definition colder. As a result, the temperature difference between the planes of each block is greatly reduced.

By reviewing the differences between the two studies and drawing on our recent experience, it is immediately clear that our first choices for the cloudy day blocks must be different from those we made for the sunny day blocks. We are reacting to the appearance of color as it is influenced by the atmosphere. The blocks are the same, but the color relationships have changed completely.

THE YELLOW BLOCK
In this composition, the yellow block is the only clearly warm one. Compared to the sunny day study, the others appear significantly cooler.

In the sunny day study, we began the first note of the light plane of the yellow block with a warm Cadmium yellow pale. In this case we can either choose a cool yellow such as Cadmium lemon or Lemon yellow, depending on which you have on your palette, or cool one of the warmer yellows by mixing it with white. Because I don't have Lemon yellow on my palette, I use Cadmium lemon to represent the top plane of the yellow block.

HELPFUL HINT

Because this particular cloudy day is very gray, you might prefer to start with the duller Lemon yellow. It isn't necessary to have both Lemon yellow and Cadmium lemon on your palette if you

know that you can adjust the brighter one. However, the difference between them gives artists the option of using them as separate starting notes.

THE WHITE BLOCK
I notice that while they are similar in value, the white block in this exercise is much cooler than the yellow one, and I remember that they seemed closer in temperature in the previous study. After scanning the composition, the white block seems very pink in comparison to the yellow one. Because the light of a cloudy day is cooler than a sunny one, I won't use a warm pink. Although Alizarin crimson would work nicely if I cooled it with white, I choose Permanent rose mixed with white for the top plane.

HELPFUL HINT

If I have more than one good color choice, I prefer to start with a note that most closely conveys the color temperature.

THE GREEN BLOCK
Next is the green block, which appears darker in value than both the red block and the gray table, and decidedly darker than in our first exercise.

The green of this particular block appears quite cold. Because the color green is composed of a warm color (yellow) and a cool color (blue), it exhibits both traits, so I do not have to look for a really cold color to represent the top plane of the green block, but simply choose the cooler of the two best greens. Viridian, a beautiful cool green, is very transparent. Adding white gives it body and richness, and lightens it sufficiently to represent the top plane.

HELPFUL HINT

If you didn't have Viridian on your palette, you wouldn't be able to cool the Permanent green light enough to use it here. You might instead start with a warm blue, such as Cerulean. Although you will eventually learn to mix two col-

ors to create a starting note, keep in mind that it is always easier to warm a color than to cool one.

THE RED BLOCK
It is interesting to note that the red block appears lighter than the green one. In the sunny day study, the warming and lightening influence of the light visually equalized the values of all the light planes, as well as those of all the shade planes. In addition, the values of the top planes of the green and red blocks are close to that of the tabletop.

For the cloudy day study, we have quite a few choices for the top plane of the red block. Because red can appear either warm or cold, almost any one from our palette would make a good choice. As a middle-value color, white will cool any of our reds.

Since there isn't a purple block in our setup, we could use Alizarin crimson, although its violet component makes me feel as if it might better serve another purpose. After all, the block is a primary red. Considering that I chose Cadmium scarlet—the warmer of the two reds—for the sunny day block study, I use the cooler one, Chinese red or Cadmium red deep, for this top plane. I mix it with white, making it slightly lighter in value than the starting note for the green block.

THE BLUE BLOCK
As you begin a study, some colors are easier to see than others. For example, in the sunny day study, choosing the warm Cadmium yellow pale for the light plane of the yellow block in sunlight was almost effortless. Likewise, the top plane of the blue block plainly appears blue and cool within the cloudy day light effect and is similar in value to that of the red block. I choose Ultramarine, the coldest blue on my palette, then mix it with white.

HELPFUL HINT

In this instance, almost any cold blue would work effectively, but if you've already used Cerulean for the top plane

of the green block, you shouldn't repeat it here. When casting around for alternatives, simply rule out what *won't* work. For example, you couldn't use red or yellow at this point for this particular plane; both are far too warm to represent a cold color on a cloudy day.

THE GRAY TABLE

Choosing the starting note for the table is easy; you only need to determine the cold component of the table's gray "mixture."

After scanning the setup, I can see that the table most closely resembles the cool blocks. However, it is warmer than the top of the blue block and cooler and lighter when compared to the Viridian of the green. I choose Cerulean for the tabletop and match its value to the Ultramarine of the blue block.

HELPFUL HINT

Almost any gray mixture would work for the table. Don't fret needlessly about which to choose—just put something down! Try to react to color; don't try to figure it out.

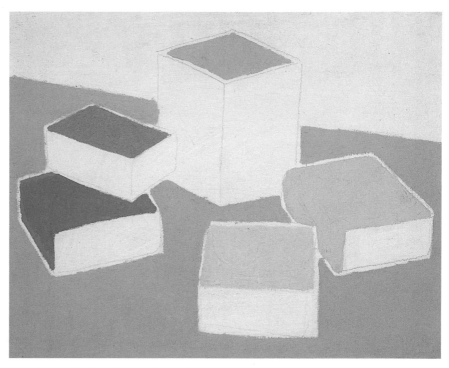

Cloudy day block study: top planes, first notes.

STEP TWO: SIDE PLANES, FIRST NOTES

Because the top planes are not visually warmed by the light, their starting notes are more closely related to the objects' local colors than in the sunny day block study. As a result, those first notes were generally cool.

In the next step, we will compare the side planes to the notes we have already established. Because we need to keep the starting notes similar to avoid visual confusion, our starting notes for the side planes will be primarily warm.

THE BLUE BLOCK

Once again, we work with the most obvious color, or the color that asserts itself most visually, first. Because the first note of the top plane is Ultramarine, the side plane appears warmer. However, it is cooler than the tabletop. This narrows our choice to Cobalt, the last blue on our palette.

HELPFUL HINT

It isn't necessarily true that the starting notes for cloudy day blue blocks *must* be blue. In this case, for example, we could have also used Violet, a purple-blue whose red element would give the side plane the desired warmth. Avoid formulaic thinking about color.

THE RED BLOCK

The red block poses a new problem: Its side plane is in fact two distinct and separate colors. In general, you should treat similar planes as a single entity and avoid breaking them up too soon. Remember that in the sunny day study we did not differentiate between the two sides of the blue block until the final notes.

In this situation, however, the two red side planes are so distinct that we must address them separately. We can use the warmer red, Cadmium scarlet, for the

lighter of the two sides, which is closer to the local color of the block. Because the side plane is facing away from the light it is darker, so its starting note should also be cooler. We have a number of choices. The red influence is clear, but because it is cooler Alizarin crimson is the best option. I make its value darker than the Cadmium scarlet portion of the plane.

HELPFUL HINT

Consider the physical relationships within the composition when two similar planes appear different. In this case, one part faces toward a shadowed area while the other catches more light. These differences also help express the light key more precisely. When nuances are a result of reflected light and/or surface conditions, you would not necessarily attempt to establish them in your starting notes.

THE GREEN BLOCK

Because the top plane is influenced by the cool sky and its lack of sunlight, its cool Viridian starting note contributes to the relative warm appearance of the green block's side plane.

Looking at my palette, I realize that I haven't used Permanent green light yet. Because the side plane is a relatively warm green, it is a convenient choice. I don't have to lighten it because it is a middle-value color.

By responding to the color of the side plane in this way and choosing not to express the note by mixing a green with a dark gray or black, I preserved the richness and integrity of the green block. It could be argued that the basis of this color decision is tonal because both notes are represented by green, but when you consider the fact that Permanent green light is warm and Viridian is cool, it is apparent that our choice transcends tonality.

HELPFUL HINT

Some artists limit their greens to only one, while others prefer to mix all their greens from scratch. If you mix your own greens, you would have used entirely different starting notes for this block. For example, you might have used Cerulean for the top plane, then mixed Cerulean with yellow for the side plane. If you decided to save Cerulean for the side note, you could have used a colder blue for the top. You might also have mixed Ultramarine with yellow for either note, then let it guide your next choice. As you gain experience and confidence, you can mix two colors to create a starting note.

THE YELLOW BLOCK

By scanning the side planes of the two previous blocks, the warmth of the yellow side note is most obvious. Recall how effectively Yellow ochre worked for the first note of the yellow block's shade plane in the sunny day study. This note is definitely cooler than Yellow ochre, but it has an unquestionably yellow influence. I look at my palette and compare the colors that I haven't used yet to the one I am trying to interpret. The earth tones—Burnt sienna, Light red, and Yellow ochre—haven't been touched. I decide to mix white into Light red; the cooling effect of the white is exactly what is required. It is warm enough for this block's side plane and cool enough to express the cloudy day light effect.

THE WHITE BLOCK

The notes we have already established give us many colors against which to compare this last side plane. Although white is a cool color, the side plane of the white block still looks warmer than the top one. After scanning the setup, this plane looks too cool for an extremely warm color such as yellow or red, and too warm for blue. Green is definitely out. Check the palette to see which colors are left. We haven't used a violet yet.

I sometimes include two violets on my palette, one warm and one cool. Because violet is a mixture of red and blue, either would work well on this side plane: The red component creates the visual warmth needed for the side plane, while the blue conveys the cool character of the white. The process of elimination has been successful.

THE BACKGROUND

This block study provides us with an opportunity to paint a landscape element: the grass behind the table. The cloudy conditions and the distance between the ground and tabletop makes the grass color appear colder, darker, and barely green in comparison to the green block. We might think that we could mimic the Indian red used for the shade of the grass in the background of the sunny day block study, but since this isn't a shadow note, I used Permanent magenta for the color of the cold atmosphere influencing the grass plane.

Cloudy day block study: side planes, first notes.

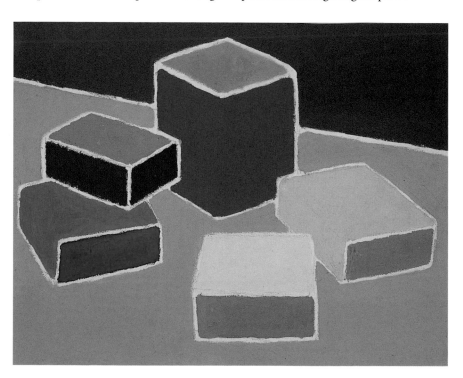

SUMMARY OF FIRST NOTES

At this point we have exaggerated the visual sensation of light on a cloudy day. Without the influence of sunlight, all colors are closer to the local colors of the blocks because the contrast between planes is not as exaggerated. In addition, because the top planes were painted with cool notes, the side planes appeared warmer—the opposite of what occurred in the sunny day study. While we tried to use pure color wherever possible, we effectively used white to cool many warm colors without eradicating their inherent qualities and, when necessary, mixed two colors to create a starting note.

FEBRUARY THAW by Lois Griffel. Oil on Masonite, 18 x 14 inches. Collection of Carol Verburgh.

I included the snow scene here and the one on pages 98–99 to illustrate two possible variations in cloudy day light. The color key in Winterscape *is similar to what I am aiming for in the block study, so I used many of the same cold colors, which I balanced with warm notes in the underpainting. In* February Thaw, *the light key is lighter and warmer. What pleased me most about this painting is that while so many of the color notes are really quite warm the light effect is still accurate.*

Step Three: Top and Side Planes, Second Notes

Although the starting notes are closer to the blocks' local colors than they were in the sunny day study, at this point we may find it necessary to shift our focus from the local colors of the blocks to the influence of the light effect.

Based on our experience from the sunny day block study, the second notes for both the top and side planes will match the first in both value and vibrancy. Also, we will only add new colors if our scrutiny of the composition warrants it, by responding to nuances or color changes that we hadn't seen before. Remember that only after the starting notes have been established—when most of the white of the support is concealed beneath the paint—can you accurately evaluate your color choices or adjust their value relationships.

The White Block

Now that all of the starting notes are down, the pink on the top plane of the white block looks too pink. As I scan the setup, I see that in general it should be cooler. I can't be sure if it needs blue or violet. To help resolve the dilemma, I scan the setup again and compare the white block only to the blue one. Because the blue block looks bluer, it becomes easy to see the violet influence in the white block's shadow note.

I step back immediately after adding the violet to the existing note. Once again, the red influence within the violet is too warm. Rather than painting a blue over the violet, I scrape it off the support as carefully as I can. This time I use Ultramarine blue mixed with white to match the value of the original pink note. Because I left a border of white support around each color note to prevent neighboring colors from intermingling, the new color goes on clean and rich.

The gray tabletop is influencing the color and value of the side plane as if it were reflecting color onto it. Although there is some reflection, the side plane is actually being neutralized by the lack of

strong sunlight, while the gray table, as a top plane, is being lightened by the atmosphere. As a result, the two masses appear very similar.

With this in mind, I add Cerulean to the side note, which makes it look even more like the table. Although I'm not sure that this is exactly right, I decide to leave it as is until the final round.

Helpful Hint

If you are uncertain about a color, or if you see two different colors as you are scanning the composition, try one at a time, but don't mix them because you will dull them. As with first notes, do not try to "finish" each plane or mass in the second round. Since your color choices are interrelated, resolving one area inappropriately in the second round will distort all your remaining choices. You may even find that in the third round some masses will not need any further adjusting.

When you can't make a decision about a color, put _anything_ down. You'll learn more from correcting a mistake than from endlessly scanning the composition until you "see" it. E. Raymond Kinstler, my portrait teacher, always said that he preferred "a frank error rather than a hesitant truth." Your experiments may not only turn out to be correct, they may actually serve to improve your painting.

The Yellow Block

When I compare the yellow block to the revised white block, the top plane of the yellow block looks too warm. If I had painted the first note with Lemon yellow, which is cooler than Cadmium lemon, it's possible that I wouldn't need to develop it further. While scanning the setup, I detect a warm bluish tendency within the existing color, which I see as a very light Viridian. The Viridian beautifully complements the warmth of the yellow block, maintains its brightness, and better reflects the coolness of the atmosphere.

Because the table appears cooler as a result of the addition of the Cerulean note to the side plane of the white block, the side plane of the yellow block still looks very warm. I can clearly see the yellow influence, but none of the other yellows would match the value and temperature of the existing color, and adding Cadmium orange would also make it too warm. After scanning my palette, then the blocks again, I see that the warm influence has a green cast to it. Since I don't have Cadmium green pale on my palette, I lighten Permanent green light, a warm, middle-tone green, with white. At first it is too cool, so I add some yellow into the whitened mixture. The final warm green mixture scumbled into the original note positively illuminates the side plane.

Helpful Hints

If for some reason I couldn't use Viridian for the top plane, I could have either used Cerulean blue or warmed Ultramarine blue with a small amount of yellow or pink to distinguish it from the top plane of the white block. If after you've gained some experience you would prefer to bypass the layering process, you can try putting down mixtures for your starting notes. For example, you might have mixed Lemon yellow with the slightest amount of Ultramarine blue or Viridian (and possibly white) for the top plane's starting note. The result would not have been as vigorous or as saturated as a layered note, but it would still have been effective.

You can choose how to add nuances to color spots by either resolving the mixture on your palette or adding a note directly to the mass itself. For instance, if I had added the first mixture that I had created for the side note—Permanent green light lightened with white—_before_ realizing that it was too cool, I could have immediately scumbled the yellow directly into the note itself.

THE BLUE BLOCK

Although the coolness of this particular blue block actually makes its top plane appear comparatively warm, the top plane doesn't have the pinkish quality that is ordinarily the result of direct light. I do not want to make the top plane look too green, which is what could happen if I tried to warm it with yellow, so instead I will use Cerulean, which has enough yellow in it to warm the plane and not make it look too sunny. It gives the original Ultramarine note the warmish tendency we are aiming for.

As I observe how the light effect travels around the setup (it still changes even on a cloudy day), I decide to add the changes that I see on the side planes. Although the left side looks lighter because it isn't as much in shade as when we started, it isn't as light as the top plane. It is a middle tone, halfway between the colors of the top plane and right side. Because the temperature change is extremely subtle I don't want to warm it up too much. I mix a slightly lightened, very rich Cobalt and use it to produce an almost imperceptible change.

HELPFUL HINT

Because I saw the variation within the side plane mass as a slight difference in values, I chose not to visually break up the block too much by exaggerating the change in color. However, this kind of decision depends on how obvious the difference within the mass is, and how effectively you can paint it. Remember, for example, that we established the differences within the side plane mass of the red block on the first round of colors.

THE RED BLOCK

As with the yellow block in the sunny day study, I see that the top of the red block doesn't need to be changed at this time, so I decide to wait until the final round to see whether any new colors become apparent.

However, the bright Cadmium scarlet side note now looks too bright and saturated. I can dull it a little by adding its complement, which is green, but I don't want to sacrifice its richness. I try reducing its intensity by mixing some cooler Chinese red directly into the existing note. The result is a beautiful warm-cool red, which creates the effect I want.

THE GREEN BLOCK

Because the starting note of the green block's top plane still works, I decide to wait for the final round to see how the color develops.

Much like the red block, the green block's side plane, which is Permanent green light, now looks too warm. Because green contains blue, it will be fairly easy to cool it down. I sort out my options by looking at the note within the context of the whole composition, and see that the blue block is more intensely blue. When I compare it to the white block, the green block's side plane looks both cool and green. I begin to see a purplish quality in the note, so I decide to add Violet, keeping it rich and dark to match the starting note. As soon as I put it down, however, I see that it should be warmer. I add red to the Violet to create a warm purple.

HELPFUL HINT

Either red—Chinese red or Cadmium scarlet—will warm the Violet sufficiently. As your sensitivity to color develops, you will eventually learn that each color has a capacity for a slightly different warming effect, which will influence your color choices accordingly.

THE GRAY TABLE

The addition of the second round of color notes has helped me see many nuances in the gray table. Along with a strong purple influence, I see quite a bit of warmth.

I could easily add a complementary gray mixture of purple and yellow over the original Cerulean starting note, but I'm afraid that it might be too dulling. I scan the composition and see that the gray table's purple element is more prominent at this point, so I scumble Violet over the first color. The resulting color vibration is wonderful.

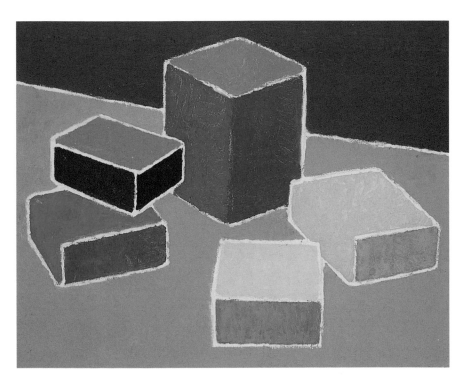

Cloudy day block study: top and side planes, second notes.

STEP FOUR: FINAL NOTES

As in the sunny day study, the final notes will tighten up the painting. Bringing the edges of the notes together will also assist you in your final color analysis.

As your visual perception becomes more accurate, you will find that as you work on a painting's final notes you won't necessarily need to work in an orderly way from one block to the next. You might also be able to finish an entire mass with two or three color spots before going on to another. As you gain confidence, your final decisions will be based on your expertise rather than a rigid set of guidelines. However, because the first notes are based on—and provide a foundation for—the entire setup, the procedures for the first and second notes should remain as is for the block studies.

THE GRAY TABLE

As you learn to see and interpret color, you'll notice that big masses and large expanses are not flat or consistent. For instance, when I look at the table now, I can isolate the area in front of the yellow block and compare it to the area in front of the green one. The reflected warmth of the yellow block makes its part of the table appear darker and gives it a violet cast, while the area in front of the green block looks warmer and lighter. The portion of the table behind the yellow block, which is next to the blue block and closest to the background, appears much warmer than the rest of the table, a result of the coolness of the blue block and the grayish background.

Although it takes experience to be able to see these kinds of beautiful variations, if you understand that they exist then you'll know to look for them, and possibly incorporate them into your paintings.

I decide to add a grayed orange to the area behind the yellow block, and then Yellow ochre in front of it. I also add a little Yellow ochre in front of the green block, but this time I leave more of the underpainting showing through to retain its slightly cooler character.

THE WHITE BLOCK

I don't see the need for any further changes in the top plane of the white block, but its side plane needs some of the same warmth that the table required. I put the slightest amount of Yellow ochre over the side note while retaining as much of the purple influence as possible. The color of the side plane is now much closer to that of the table, but remains true to the character of the white block.

THE YELLOW BLOCK

During this last round of notes I notice a change in the light effect on the yellow block and decide that the side portion of the top mass now needs to be subtly isolated. A middle-tone, more saturated yellow than either the top or front that could not be characterized as bright, this plane is actually receiving a little reflected light from the white block. To adequately define its value, the resulting note must be darker than the top plane. I decide to mix Cadmium yellow—which is dark enough—with its complement. Scanning the mass again, I see that it must remain warm, so I don't want to neutralize the yellow too much. I mix Cerulean, a warm blue, into the Cadmium yellow, and use the mixture to resolve the side plane. It looks wonderful!

THE BLUE BLOCK

After comparing the blue block to the rest of the painting, it appears more pinkish. The top plane looks fine to me, but the side notes need some of that influence. Once again, I look at my palette and compare the block to Permanent rose. It would be too pink and too light. I need to use a darker pink, one that was cooled with the addition of white. I select Permanent magenta and mix it with white to match its value to both sides of the blue block. It imparts just the right amount of warmth.

THE RED BLOCK

Finalizing the edges of the masses helps me see that the top plane of the red block should look redder, or less pink. Since I started with a cool Chinese red, adding yellow would make it too orangy and Alizarin crimson would make it too violet, so I resolve it by adding warm Cadmium scarlet. This final note intensifies the color without sacrificing the individuality of the original starting note, and more accurately describes the red block's local color.

Now that the majority of masses has been resolved, the Alizarin crimson side

plane (the one facing away from the light) looks too saturated. I scan the setup again, and see that it should be made duller and cooler. Because there are both warm and cool components in Alizarin crimson, either of the two reds—Cadmium scarlet and Chinese red—will warm it too much. Because the cooler aspect of the red shade tends toward violet, I will add Violet over the Alizarin crimson, matching the value of the previous note with white. I let a lot of the Alizarin show through, and the vibration gives me the just the right color and temperature.

HELPFUL HINT

Next time you work on a cloudy day painting, you'll know that you can blend a complementary mixture into almost any of your starting notes. The purpose of this step-by-step lesson is to teach you to see when you need to start with a dulled version of a color (without reducing its intensity to the point that you are putting down "mud").

THE GREEN BLOCK

The top mass of the green block is also showing some variation within itself. The top plane looks lighter and warmer than the side plane, so I add Permanent green light to just slightly warm up the original Viridian note.

The far side plane is now a middle tone, as are the side planes of all the other blocks. Since I also lightened the top plane when I warmed it, I don't have to darken the side plane very much, and I also don't want to negate its warmth. I

decide to try something new: I will gently warm and darken the Viridian with its complement, red. I then add white to bring the mixture back to its original value, then scumble it over the side note, creating just the right shade.

HELPFUL HINT

Scumbling Permanent green light over the Viridian top plane maintained the richness of the original note. If I had tried to mix the Viridian with a warming element, I would also have needed to add white, dulling and cooling it more than was necessary. Scumbling

lets you retain greater control over your color, especially its richness.

THE BACKGROUND

Applying what we've learned from the sunny day study, we will resolve the background's Permanent magenta starting note by loosely scumbling it with one of our greens. To correct the temperature of the green and maintain the integrity of the plane, I add a little Permanent magenta (a type of green complement) into the green. I keep this note slightly darker than the underpainting to create the illusion of texture in the grass plane.

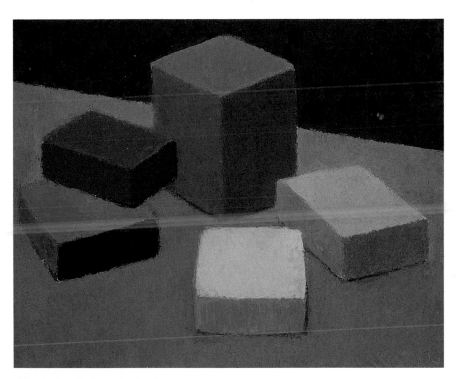

Cloudy day block study: final notes.

SUMMARY OF FINAL NOTES

Because we followed the procedures that were established in the sunny day block study, we can end this chapter by referring to the summary of its second notes. All the second notes in this exercise were based on the starting notes, but since this time the starting notes were closer to the blocks' local colors, the second notes were

used to enhance the atmospheric effect. By seeking answers to a different set of visual problems, we explored new color combinations, found that grayed and complementary mixtures provide an effective way to express the subtleties of cloudy day light, and learned that a color has no single identity or consistent function, as

we were able to use each one to solve a completely different set of problems.

By successfully completing a cloudy day study, you will now be able to see a sunny day light effect with greater clarity. Every light key elucidates others, and encourages you to paint the infinite variety of nature.

EARLY DAY LILY by Rosalie Nadeau. Pastel on Masonite, 18 x 25½ inches.
Courtesy Left Bank Gallery, Wellfleet, Massachusetts.

Rounded Objects: Still Life and Portrait Studies

9

Many artists who are at first convinced that still life painting is an obsolete creative exercise become zealous converts after painting still life outdoors. Light falling on a bright orange vase or shimmering through a cobalt glass yields color of immeasurable richness and intensity. Because it is easier to see color changes that create volume on brightly colored still life objects, we will use them to develop the skills that will take us one step further on our color journey.

EXPLORING COLOR AND LIGHT THROUGH STILL LIFE

Once we have acquired the fundamentals of seeing and expressing form and color, we can challenge ourselves with creative color exercises. For example, a still life composed of objects that are similar in color, such as several green vases, presents an opportunity to study and compare the parallel variations found in landscape, while learning about surface reflections helps us to understand the same complexities found in painting water. Learning to model the shapes, designs, and textures of solid three-dimensional forms will help ease the transition to, and enable us to more fully concentrate on, the amazing variety and subtlety of color to be found in landscape painting.

NORTH LIGHT STILL LIFE WITH FU DOG by Lois Griffel. Oil on Masonite, 16 x 24 inches. Courtesy of the artist.

Using arrangements of richly colored objects to express light, these still lifes are attentive to detail yet loose and painterly in their observance of form. Touches of carefully placed color create volume, giving them a "finished" look without strict rendering, with the "lines" or edges between masses remaining very soft and loose.

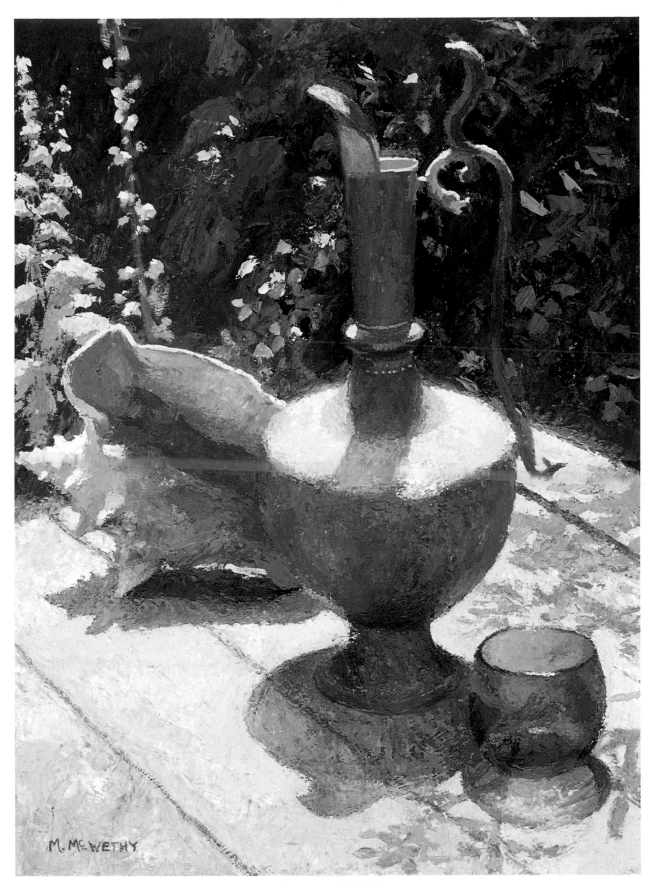

BRASS PITCHER WITH CONCH SHELL AND BLUE GLASS by Margaret McWethy.
Oil on Masonite, 16 x 12 inches. Collection of Til and Bob Chapman.

STILL LIFE STUDY OF ROUNDED FORMS

I was delighted when I discovered a series of matte glass vases in the same bright, rich primary colors as the five blocks that I had used in the two block studies. They will make it easier for you to follow my demonstration, as all you'll need to do is apply what you've learned from the block studies to these rounded forms. Note that although we will rely on what we learned about color from the first exercise to get us started, this arrangement may show some color differences.

While many still lifes feature shiny glass and pottery that play upon the variations within their masses, the visual complexity of highly reflective objects can be confusing, especially for beginning students. Because the surface of the sandblasted glass is not as highly reflective as traditional still life objects, all necessary points of information for rounded objects are covered here with a minimum of difficulty.

HALFTONES

In the following study, rounded forms differ from blocks primarily in their lack of defined edges. That is, a block has clearly distinguishable flat planes while the volume of a rounded form is created by the addition of a middle value between the light and dark planes called the *halftone,* which unites the light and dark notes and creates volume.

- *All halftones are not the same value.* Because each color has a specific starting value, its halftones must relate to it only in terms of value. For example, since Cadmium yellow is lighter than Chinese red, its halftone will be commensurately lighter.

- *Halftones are distinctive colors.* Although many artists blend the edges of their darkest and lightest notes to create halftones, adding halftones of rich color can make your paintings more alive.

- *Halftones create volume.* Determining whether the color of each halftone is dominated by the light or the shade area will give the composition's forms volume and roundness.

- *In extreme light, halftones are usually visually closest to the local color of the object.* In the following study, the vases have three main areas: a lightened and warmed sunlit area, a cool and dark shaded area, and a halftone area that is influenced by neither light nor shade, and so is closest to the local color of the object.

SETUP AND PROCEDURE

As with the block studies, we start with a simple, clear drawing that includes such details as cast shadows, the background, and the table, making each object large enough so that we can add to and change its colors. We are again looking for simple masses of light and dark that describe the objects' basic forms, and for a simple color mass that represents the halftone of the two. Once again, we will put down our starting notes with pure colors, using as many colors from our palette as possible, and adding white to alter their value only when necessary. Because we are building on our experience in order to incorporate the concepts of painting rounded forms into our work, we will draw on the color information provided by the first two studies, particularly that of the sunny day block study. The rules of composition, color, and light effect still apply here: The addition or elimination of an object affects a composition's color relationships, and atmospheric conditions also affect our perception of color.

Your careful observations will help you create the objects' correct shapes and sizes, so take your time when drawing their three main variations: light, shade, and halftone. The shapes of even the more complex objects should be simple, but your drawing should reflect the "reality" of each one; that is, its form, its proportions, and the specific characteristics of each color mass.

Do not try to improve upon or complete a single area or object before moving on to another. Although it is sometimes difficult to resist getting caught up in painting one interesting or beautiful object within a still life, the urge to isolate a part of a painting by attempting to finish it—particularly in the beginning—can jeopardize the light effect on the object as well as the general vitality of the painting. Because they are interdependent, all masses and objects must be developed at the same pace. By working in this way, your ability to interpret and express light will continue to improve.

Composition photograph: rounded still life.

STEP ONE: FIRST NOTES

Although some artists strictly adhere to the procedures for block studies and paint all of the objects' light areas first, then all of the shade areas, then the halftones, I prefer to paint each object in its entirety, first the light masses, then the shade masses, and then the middle tones, because I compare objects rather than planes, as we did with the blocks. As you gain confidence and experience, you can decide how you would prefer to work, and by what means you most clearly see color relationships.

THE WHITE VASE

The white vase is the lightest object in the setup. As with the blocks, I paint its light mass with Lemon yellow or Cadmium lemon mixed with white, and its shaded area, which reflects the warming influence of the table, with Cerulean.

Now we must determine which color best represents the halftone. I know that a mixture of yellow and Cerulean—a greenish color—would never work. I look back at the setup to evaluate the whole of the white vase within the context of the rest of the composition. The white vase is cool, and the halftone reflects that, so I use Ultramarine, which is a cool blue. I paint the interior of the vase, which is darker and cooler than anything on its exterior, with Violet.

THE RED VASE

The red vase, which is directly behind the white one, is unquestionably warmer. As I scan the setup, I see that the sunlit mass of the red vase is cool because the matte texture of the glass absorbs the cooling effect of the blue sky. Both of our reds—Cadmium scarlet and Chinese red—require the addition of white, so either would be a good choice for this starting note. I decide to use the same red that I used to start the light plane of the red block in sunlight, the warmer Cadmium scarlet.

In contrast, the shaded mass of the red vase is extremely cool. I think back to the sunny day block study, where I used the cool Chinese red for the shade plane of the red block. In order to create vol-

ume, we must also consider the halftone, which looks rich and saturated. I see it as Chinese red. The shaded area seems darker and cooler in comparison, so I use Alizarin crimson, which has the right temperature to represent the shade mass, while its saturation conforms to the whole. The interior of the vase looks similar to the shade note, so I use Alizarin crimson there as well.

THE BLUE VASE

The halftone of the blue vase, which is quite similar to the local color, is a rich blue, while the light mass recalls the pink quality that we saw in the light plane of the blue block. I decide to use Permanent rose for this light mass as well, and lay down a large stroke of it to depict the rim. By comparing the light and halftone masses I realize that the halftone relates to the pink note of the light mass, so I paint it with Cobalt, which is warmer than Ultramarine.

Because the center of each flattened side mass is darkened further by the opacity of the glass, the shaded areas look colder, darker, and richer than the halftone. Scanning the setup, I see that the shade masses are Violet, a mixture of red and blue, which will work beautifully when we resolve it with the local color.

THE YELLOW VASE

The shade area of the yellow vase reflects quite a bit of color from the green vase. However, when I compare the two vases, the shade area of the yellow one looks warmer and much less green, so I reserve the strongest and richest greens for later.

As soon as I look back at the yellow vase, I notice that its shade mass is also lighter than the green vase. We can easily create a "grayed yellow" for this note, but why should we mix one when Yellow ochre will do? We also used Yellow ochre as the starting note for the shade plane of the yellow block, so we must be on to something!

By comparing its new ochre note to the rest of the yellow vase, I can see the same rich, bright yellow in the light mass that was evident in the light plane of the

sunny day yellow block. When I lay in the Cadmium yellow pale I note the richness of the halftone. The clear choice for this transition color is Cadmium yellow, which contains a lot of orange.

THE GREEN VASE

Although our experience with the green block in the sunny day study might indicate otherwise, we can't use pure Cadmium yellow for the light mass of the green vase, for two reasons. First, we already used Cadmium yellow for the halftone of the yellow vase, and second—and more important—a rounded object portrays the effects of sunlight differently than a flat-planed object.

After scanning the setup, I see that the sunlit mass of the vase is a bright yellow-green. Recalling the colors that I used for the sunny day green block, I warm and lighten Permanent green light with Cadmium yellow, eliminating the need to add white. Once I put down this ideal starting note, the colors on the rest of the vase are immediately apparent. The halftone looks like pure Permanent green light, whose value and richness give me exactly what I need. There are many subtle nuances within the shade mass, which again can be attributed to the matte glass. I see warmth there, but because the green influence is stronger I paint it with Viridian.

THE GRAY TABLE

The color of the gray table is the same as that in the sunny day block study, but I notice in this setup that the area behind the red vase looks cooler than the area near the green and white vases. This is because the coolness of the latter two cause the table to look relatively warm, while the intensity of the red vase makes its part of the table look pinker. These nuances could be seen in the block study as well, but our experience enables us to see them clearly here.

While I use the same Cadmium orange that I used in the block study to represent the table near the green and white objects, I want to use a cooler orange—a color somewhere between

Permanent rose and Cadmium orange—for the other parts of the table. Since I already used Permanent rose for the blue block, I compare the table to that note. I decide to mix Permanent rose and Cadmium orange, but the rose is too cool and grays the mixture too much. I settle on the warmer Cadmium scarlet, and mix that with Cadmium orange instead. Using the pure color and the mixture as needed, I finish the remaining areas of the table between the cast shadows.

THE CAST SHADOWS

As our color sensitivity matures, we observe the variations within and among cast shadows that are a result of an object's reflected color. Although this effect is more obvious with transparent objects, as light transmitted through glass creates definitive color changes in cast shadows, the matte surface of the glass doesn't prevent the objects in this still life study from reflecting their local color onto their cast shadows. Because of this, the cast shadows of the green and blue vases are cooler and bluer compared to those of the white and red vases, which look very red. I select Cerulean and Violet for these two notes.

THE BACKGROUND

In this study, my painting will express the fact that there is both sun and shade on the grass behind the table. Using the sunny day block study as my model, I again use Indian red for the shaded area of the grass. In order to clearly see the color of the warmer areas, I must compare that green to the green vase.

The vase is similar in value and intensity to what might first come to mind as

Rounded still life, first notes.

the color of grass, though when compared to the grass it appears lighter and more saturated. The light warm green of the vase's light mass is too light for the grass color, which is not only darker but must convey distance. I can't use a color as bright and as warm as I used on the table, so I decide to warm up the Indian red with yellow, which lightens its value and creates the illusion of sunlight on those areas of the grass.

A WORD ABOUT GREEN

Because the color green is so much a part of painting landscapes, it is worth discussing some of its complexities.

Why have we painted the green grass in the backgrounds of our studies so differently from the green objects? Although it is true, the fact that the grass is farther away in the composition than the vase doesn't fully explain this difference. Thus far, we have painted two green forms, a block and a vase. Both have slick, man-made surfaces that react to light differently than green in nature. Because natural forms such as trees and

grass are not singular and unified but are in fact composed of hundreds and thousands of smaller forms (such as blades of grass or clusters of leaves), we are then observing *both* dark and light areas within those masses.

Think, for instance, of a green lawn. Its depth and variety are a result of light illuminating its thousands of blades of grass that at the same time produces its shaded areas and cast shadows. In actuality, you are seeing the equivalent of all three sides of a green block at the same time, so that the visual mixture influences

our vision. So even if there is extreme sunlight and cast shadows on a lawn, the areas of grass in sunlight may be darker than those on a green vase. This is also the case with a green deciduous tree. Sunlight filtered through its leaves may not be as bright as the light that falls directly on a green vase, and its shadows may be much darker as well.

The green of nature is infinitely more varied than the painting of green objects would imply, so we must always remember to look at nature objectively every time we paint a landscape.

Along with the painting on pages 110–111, the two landscapes on this page show an extreme range of light effects and the variations of green that are used to express them. Nadeau shows us that pastel paintings can be as rich and as vigorous as oils. The dark, rich greens are enhanced by the vibrancy of the flowers. In contrast, the light key in Summer Garden *is somewhat brighter and the starting notes are warmer and lighter, so its greens are depicted with a different range of colors. Exhibiting extreme brightness, the light effect in* Summer Landscape *required that Egeli leave his greens considerably more yellow.*

SUMMER GARDEN by Peter Guest. Oil on Masonite, 28 × 34 inches. Private collection.

SUMMER LANDSCAPE by Cedric Egeli. Oil on Masonite, 16 × 20 inches. Courtesy Wohlfarth Gallery, Provincetown, Massachusetts.

STEP TWO: SECOND NOTES

At this point, we depart once again from the framework of the block studies. Where we first learned to draw a linear shape or the outline of an object and fill it in, we are now learning to see, then establish, large shapes of color and light.

That we see form and color before seeing detail is the most important tenet of Hawthorne's teachings. He said, "Let color make form—do not make form and color it in. Our starts, in their great simplicity, have established the light key. It is only after we get these main notes accurate and rich, that we venture into turning more edges and creating greater form." Henry Hensche also believed that the correct way to depict an object was to see the large notes first, then the secondary notes, and last the small color changes that create detail.

In this next stage, we will add new colors between the first three color masses. Although we could easily blend the already established notes, imposing those kinds of transitions would weaken the color rather than make it rich and brilliant. By looking for and expressing the variations in color across an object's surface, we increase the illusion of form and solidity. Each of the color masses must be painted so that it accurately describes the shape of the object or the roundness of its form. As in our previous exercises, color changes must contribute to the illusion of an object's correct proportion and shape. We will follow the example set by the block studies in that these new notes must relate to the colors and values of the original masses. This underlines the importance of correct starting notes, which indicate the intensity and value of any additional colors.

THE WHITE VASE

The white vase, significantly more reflective than the others, is also receiving a lot of reflected light from the table. In contrast to the cool starting notes, the colors that are now evident are very warm. I will use these new colors to soften the edges between the starting notes.

The shaded mass along the bottom of the vase looks very orange to me, but if I used pure Cadmium orange, which is very saturated and light, the new note would be too strong. I must mix some Ultramarine or Cerulean into the Cadmium orange to bring it back to the starting notes. The Cerulean would make the mixture too gray, so I choose the Ultramarine, which creates a silvery cast that blends well with the starting notes.

The warm note at the top of the vase offers an excellent opportunity to create a beautiful transition between the lightest area and the halftone. Because the yellow needs some subtlety, I use pink—which is warm enough to relate to the yellow and cool enough for the blue—as the point of intersection between the two areas.

THE RED VASE

The color between the Chinese red of the halftone (which is influenced by the sunlight) and the warm-cool of the Alizarin crimson shade mass (which reflects the warming influence of the table's reflected light) is the coolest and darkest on the vase. However, the coolness of the white vase won't contribute any warmth to the new note.

This new color looks very violet to me. I lay in a warm violet—a mixture of Violet and Alizarin crimson—that relates well to the reds, and I make a band between the two existing colors. This gives the vase more volume and form.

Because the matte finish of this vase is reflecting the coolness of the blue sky, the color to be added between the light mass and the halftone should actually be warmer than the light area itself. Pure Cadmium orange is dark enough for this purpose, so I lay it in.

THE BLUE VASE

The color between the Cobalt halftone and the flattened Violet sides of the vase is this vase's coolest note. This intensely blue area is essentially unaffected by the reflective warmth of the yellow and red vases. Because its color is so saturated, I use Ultramarine blue mixed with just a little bit of white to establish a link between the two starting notes.

The tone between the Permanent rose highlights and the Cobalt side planes of the vase is almost as warm as Cobalt, but because it is in direct sunlight it needs to be warmer. Because Permanent rose is cool and Cobalt is warm, mixing them together would neutralize both, so I round the edge of the vase with a band of darkened Permanent rose and allow it to dry before scumbling the Cobalt over it.

The neck of the vase also indicates a strong color change. Compared with the other blues on the vase, it appears closest to the original Cobalt halftone note, so I stroke it along that side of the neck.

THE YELLOW VASE

The yellow vase has many beautiful nuances in its large shade mass, but I do not want to break up those colors yet. I must first establish the larger color changes from the light into the darker masses. The new color is very bright and vibrant, though somewhat darker than the Cadmium yellow used for the halftone and lighter than the colors I used on the red vase. Until I made my comparison I thought it was Cadmium orange, but I need something lighter. Because I do not have Cadmium yellow deep on my palette, I mix Cadmium yellow into Cadmium orange, which will give me the color and value that I am looking for. After stroking a little of this color under the lip of the bottle, I decide that it should be a little lighter, so I mix it with a little more yellow.

THE GREEN VASE

The green vase is illuminated by both direct light as well as the light reflected from the tabletop. The most obvious color change is the bright color in the center of the shaded area. If you look at this green mass too long, you will isolate it from the context of the painting. You not only reduce a color's saturation when you look at it too long, but you also distort its value relationships. Because all color is interrelated, we must evaluate the entire composition in order to observe how the value and saturation of the various color masses interact.

Although the color of the shaded area's center note looks warm and orange, comparing it to the orange note we just added to the yellow vase helps us see Cadmium orange would be too light in this case. If you can recall the effect of simultaneous contrast, you know that the two notes look similar only as a result of the influence of their surrounding fields. The warming note on the green vase is darker and redder, so the solution is to darken Yellow ochre with Cadmium scarlet. After making sure that the mixture is warm and ochrey, I scumble it over the green, keeping it lighter in the center and letting it mix and darken the starting note as I spread it out toward the edges of the note.

The outer edge of the vase appears darker because of the visual contrast between the glass and the brightness of the table, making the original Viridian note look cooler. I add Violet over the edge, keeping it rich and clean.

THE CAST SHADOWS

At this stage, the cast shadows exhibit even more of the colors of their adjacent objects as well as that of the tabletop on which they fall. The warmer shadows near the green and yellow vases must be warmed with a color that won't make the purple too green. I warm it with Cerulean, adding it only around the edges where I see it.

The cast shadows near the white and red vases were started with a colder color. Pure Cerulean might look too gray over the first note, so I will either cool it down with Ultramarine blue or use a cooler blue, such as Cobalt.

PORTRAIT OF FRED TASCH
by Henry Hensche. Oil on canvas,
20 x 16 inches. Courtesy Provincetown
Art Association and Museum.

Although Hensche painted this portrait before he began his lifelong color journey, the reduction of form into color masses is clearly evident. The large spots of color, which are almost angular in some areas, give the form credibility and "rotundity," one of Hensche's favorite terms.

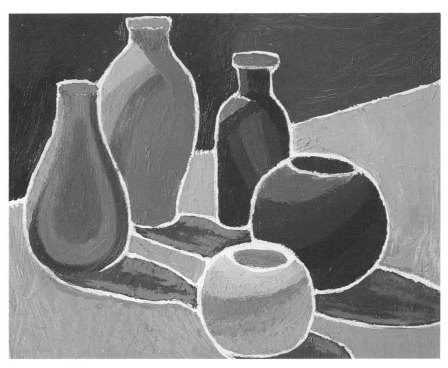

Rounded still life, second notes.

STEP THREE: FINAL NOTES

The look of the vases at this stage is somewhat deceiving. Although it appears that I have added many new colors, what you are actually seeing is how the colors were scumbled into and over each other, which is the advantage of working wet over dry: The new colors vibrate while the underpainting maintains its original richness.

THE WHITE VASE

For the white vase, I bring the pink down over the violet, and the violet up over the pink. Then I extend the yellow up into the violet on the left side, and introduce it on the right side as well, over the pink into the purple. On the bottom of the vase, I mix the Cerulean and the yellow in and out of each other, while retaining the vibrancy of the former. The biggest change is adding pink and Cerulean over the yellow, which is similar to what we did for the top of the sunny day white block. I let more of the yellow show at the edge, which gives the light mass its glow. I give the interior of the vase volume with the same orange note that was used on the bottom.

THE RED VASE

Bringing the colors in and out of each other, I follow a similar procedure for the red vase. Because there are only five simple color divisions and the shape of the vase is so straightforward, blending the colors will bring this particular vase to the point of completion.

I add the brilliant reflection from the table on the vase's right side. If I had added this note at the beginning of the painting, chances are that I would have distorted it by making it too light and warm. Although it is a light reflection, it must remain close in color to the original mass and relate directly to the shade area in which it falls.

I add a small amount of Chinese red to the interior of the vase, which lightens while only slightly changing the original color.

THE BLUE VASE

The Violet mass looks much too red, so I decide to tone it down with blue. If your Violet area is already dry, you could scumble almost any blue over it, but since mine is still wet, I make sure that a warm blue wouldn't be dulled by the underpainting. With this in mind, I use a very cool Ultramarine. The mixture of the two creates a vibrant bluish-purple, exactly the color I see.

I then mix the Ultramarine into the Cobalt, blending them to eliminate hard edges. After looking carefully at the dark Permanent rose note, I decide that it also needs some blue, though it should be a little warmer than the rest. I use Cobalt, allowing it to mix with the dark pink note and softening its edges. I decide to leave a little of that pink for the light effect.

I make the Cobalt note on the neck of the vase a little more subtle and soften its edge by cooling it with a small amount of Ultramarine. After the underpainting is completely dry—about a day or two later—I finish the edges on both the inside and the outside of the lip with the colors I used on the rest of the vase by applying them with the tip of the palette knife. Note that I also use the background grass notes to define this vase's edges.

THE YELLOW VASE

As I did with the red vase, I scumble and blend all of the existing notes into each other. The richness and purity of the original colors keeps the finished vase looking vibrant. Without introducing any others, I bring these colors up into the neck and lip of the vase to describe its form more decisively.

The saturation of the green influence on the bottom of the vase is weak compared to the color of the green vase, so its color must relate to the Yellow ochre of the shade note. Cerulean has enough warmth to "gray" the Yellow ochre and yet match its saturation. I scumble it over

the ochre, which breaks up the density of the mass and gives it more life.

THE GREEN VASE

I finish the green vase with a very rich, saturated green. If you have it, Cadmium green pale would be effective, but I must mix Permanent green light and Viridian. I scumble this mixture over the dark edges of the bottle and into the center of the original Permanent green light halftone note without jeopardizing its character. When I add a little more of the Permanent green light over the Yellow ochre to soften all the edges, I notice that the shaded areas along the edges of the vase need some green. I then finish the lip of the vase with the colors I have already used.

THE CAST SHADOWS

Each cast shadow must express the color of the vase that reflects into it. Any additional colors should be rich but within the value and saturation of the original shadow masses. For example, if I scumbled one of the reds that I used in the red vase into its cast shadow, it would be inappropriate—either too light or too dark, depending on which I had used. The established color of the mass requires that you tone down any red before you use it, so I "gray down" one of my reds with a green and scumble it into the red vase's cast shadow.

I do this for all the cast shadows, each time graying a color that was used in the corresponding vase. Finally, I heighten a few of the shadows' lighter notes.

THE TABLE

I don't want to reduce the warmth of the table by graying it, so I decide to warm it even further by adding Cadmium yellow over the entire table surface. I then unify the surface of the table by adding Cadmium orange to the area that was started with the Permanent rose and Cadmium orange mixture, whose influence is still evident there.

THE BACKGROUND

At this point, we need to resolve the original Indian red and yellow starting notes with green. Because I see both warm and cool greens in the shade mass, I create a few complementary greens and scumble them over the starting notes, mixing and blending them as needed.

I also want to exaggerate the warmth in the sunlit portion of the grass, so I mix two very warm greens, one a little darker than the other. I merge this mixture with the entire background, but the extreme warmth of the sunlit areas provide a good balance for the entire painting. The final grass notes are a combination of the background notes of the two block studies.

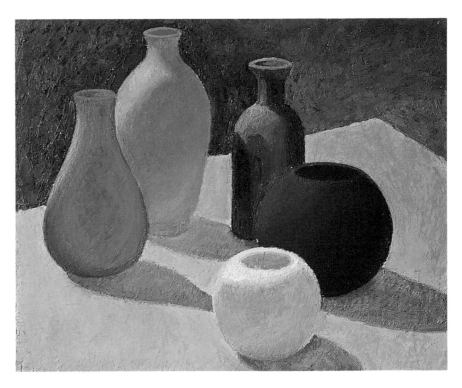

Rounded still life, final notes.

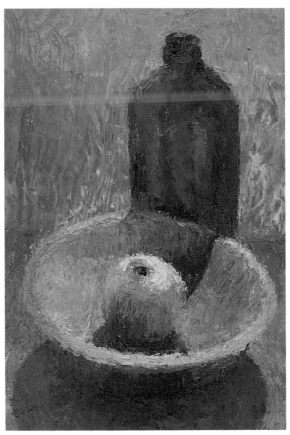

STILL LIFE WITH BLUE BOTTLE by Heather Bruce. Oil on Masonite, 16 x 12 inches. Private collection.

STILL LIFE WITH BROWN BOTTLE by Heather Bruce. Oil on Masonite, 16 x 12 inches. Private collection.

The color in these jewel-like studies has been pushed to the limit. Bruce was able to achieve their richness by keeping her starting notes pure, and then embellishing each one with notes of the same brilliance and intensity. The result in both paintings is a powerful luminosity.

PORTRAIT STUDIES

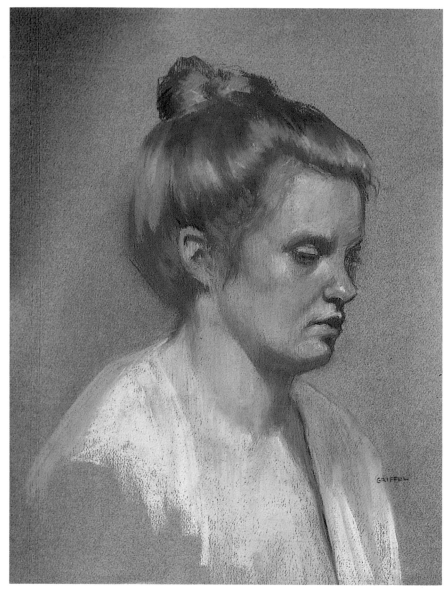

PORTRAIT STUDY by Lois Griffel. Pastel on Masonite, 20 x 16 inches.
Collection of the artist.

I drew pastel portraits for many years, and I cannot overemphasize the fact that my linear approach from that period is a clear example of "what not to do." Although subtle and quite pretty, my tonal portrait plainly lacks excitement. On the other hand, Glenna Hartwell's painting (opposite page) reflects the impressionist technique. With its vigorous flesh notes and strokes of pure orange and pink against cooling strokes of blue and green, Hartwell's portrait is bold, with several examples of greatly exaggerated color. However, the differences between the two paintings' use of color are not the point of this comparison. I gradually came to realize that tonalists were more liable to "miss" a likeness because it is more difficult to control line, while the impressionists' portraits were consistently faithful to their subjects. Starting with the large shapes and masses proved to be the most accurate way to establish an image.

This color theory is an effective tool in learning to do portraits. For those of us that love to do them, seeing flesh notes come alive outdoors makes the process even more wonderful.

Hawthorne developed the "mud-head" (see Chapter 2) to force his student to simplify the structure of faces and figures into simple flat masses so that they could concentrate on making their first color notes express the light effect. The heightened backlit presentation subordinated their flesh tones into deep, rich shadow notes against the contrast of the hot sun on the sand and horizon. In addition, their putty knives made it nearly impossible for Hawthorne's student to render a subject's specific features, prompting them to depict the large spots of colors and masses simply and correctly.

It is amazing to see how much of the face could actually be seen in these unadorned statements about color. Of course, an understanding of facial structure and a skilled drawing hand are very important and will free you to concentrate on color. However, I firmly believe that portraits should be approached similarly to still lifes. John Singer Sargent, who was acutely aware of the need to refine a form to its basic underlying structure, also reasoned that the head "should be painted as a jug." The light effect—obviously an integral part of the plein air portrait—individualizes the color of the hair and face, the lights on clothes, and the features.

The first color notes should establish the key of light as well as the character of the skin tones. It recommended that you squint as you study the face to reduce the details, such as the shapes of the eye sockets and the nose's cast shadow, to broad masses. After the first round of color, add new notes to the masses while developing the halftones to slowly build more definition.

By working from the basic principles of this method of color and keeping your starts simple, portraits and figure studies that strengthen your ability to accurately interpret light effect are within reach.

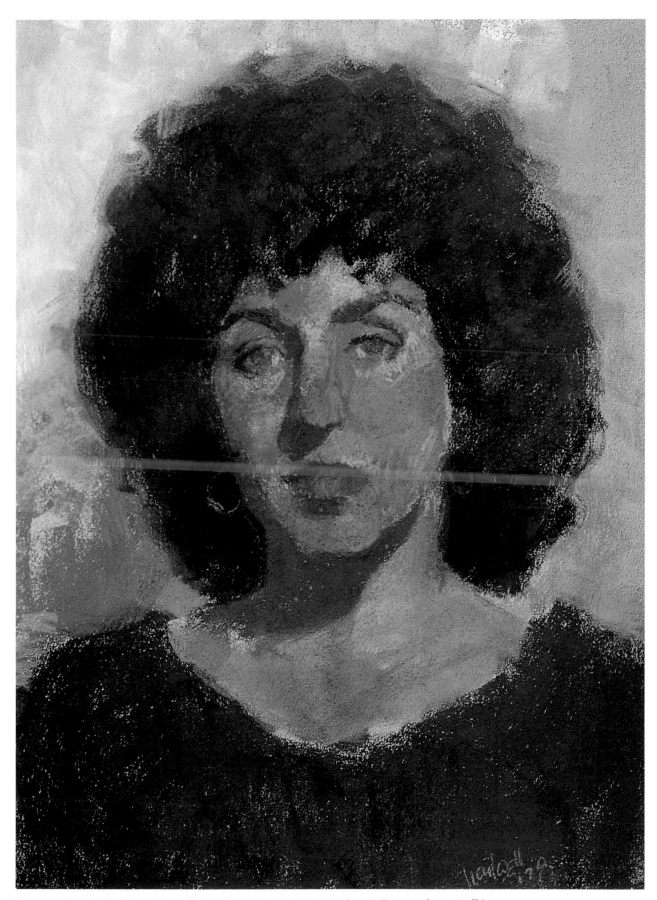

PORTRAIT STUDY by Glenna Hartwell. Pastel on Masonite, 16 x 12 inches. Collection of Lois Griffel.

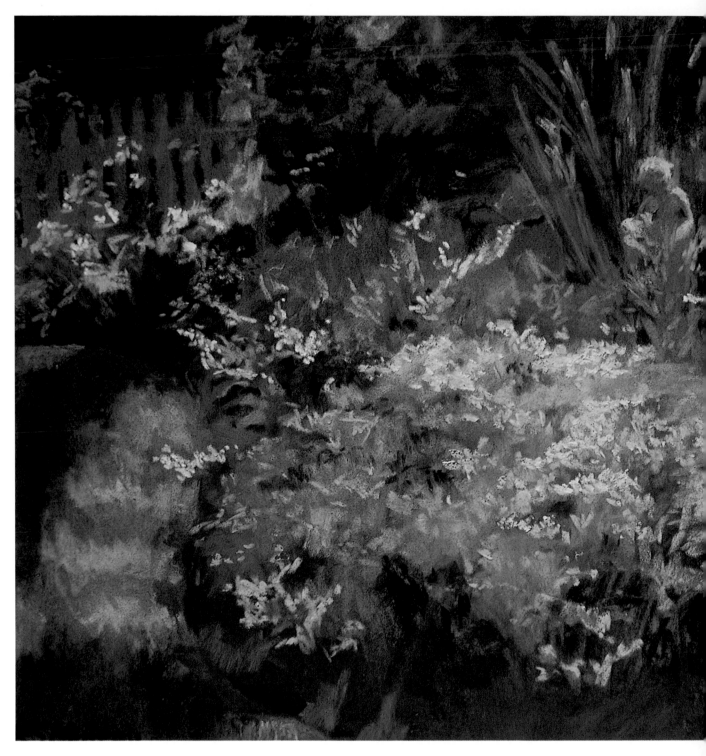

GARDEN CORNER by Rosalie Nadeau. Pastel on paper, 16 x 20 inches.
Collection of Mr. and Mrs. B. Eldridge.

*By applying her masterful understanding of color, Nadeau maintains the brilliance of
the flowers by avoiding fussiness, and instead relies on spontaneity of detail to create a
center of interest.*

Landscape Painting 10

Within the realm of landscape painting, we will pursue endless variations of atmosphere and light effect, as well as the unlimited possibilities of its subject matter. Each artist sees and interprets composition and subject matter individually; for example, four artists standing on the same wharf will paint four different paintings: One might paint a closeup of a fisherman in his sailboat, another will focus on the design created by the boat's masts and sails, a third might paint several boats anchored in the marina, and the last might paint a beach and dunes scene. Regardless of the content of their paintings, however, all plein air artists have one goal in common: to express the effects of light on color.

THE INTRICACIES OF LANDSCAPE

While Hawthorne acknowledged that an artist has the greatest degree of control over the elements of a still life painting—the arrangement of its composition, the light effect, the balance of its colors—he also felt that "landscape differences are more elusive and delicate" than the subtleties of any other subject matter.

An artist is stimulated by what already exists within a particular landscape, but he or she must still interpret—that is, arrange and eliminate—some of its details. I think that by painting landscapes an artist most generously shares his or her vision with the world. When I painted the stippled light effect on an old white house in my neighborhood, my friends were delighted to finally be able to see beyond its own aging, yellowed paint and appreciate its beauty.

In addition to the innumerable effects of both distance and light, landscapes have their own set of pictorial requirements. For example, planning and procedure play an important role in the breakup of large masses into lights and darks. There are many different types of landscapes on Cape Cod from which I chose the subjects for the following three paintings, but I wanted to make sure that those I included covered as many important aspects of landscape as possible. The three landscape demonstrations that are featured in this chapter—a sunny day marsh with a distant view of hills, for an exercise in aerial perspective; a cloudy day panorama of rolling dunes; and a sunny day house and garden—are structured in the same way as the block and still life studies. Because landscape forms have so many variations, I look for the halftones only after establishing the lights and darks of the first masses, and develop volume only after resolving the light effect. To reduce your landscapes to light and dark planes, use the squinting technique to make "jigsaw puzzle pieces" out of them.

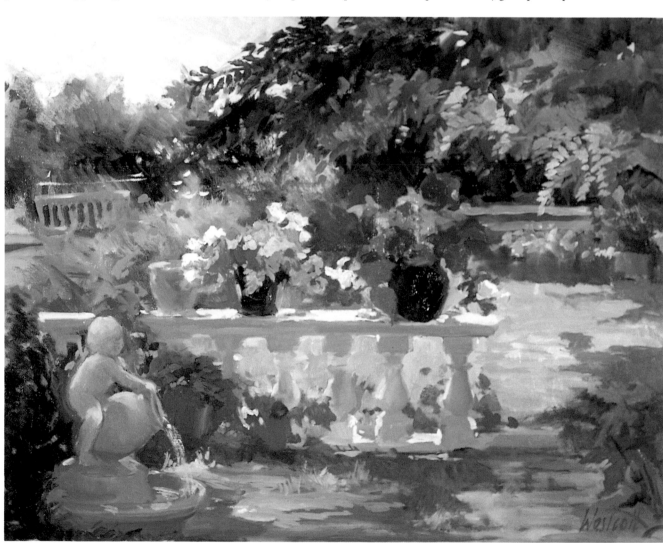

THE TERRACE by Carol Westcott. Oil on Masonite, 18 x 22 inches. Private collection.

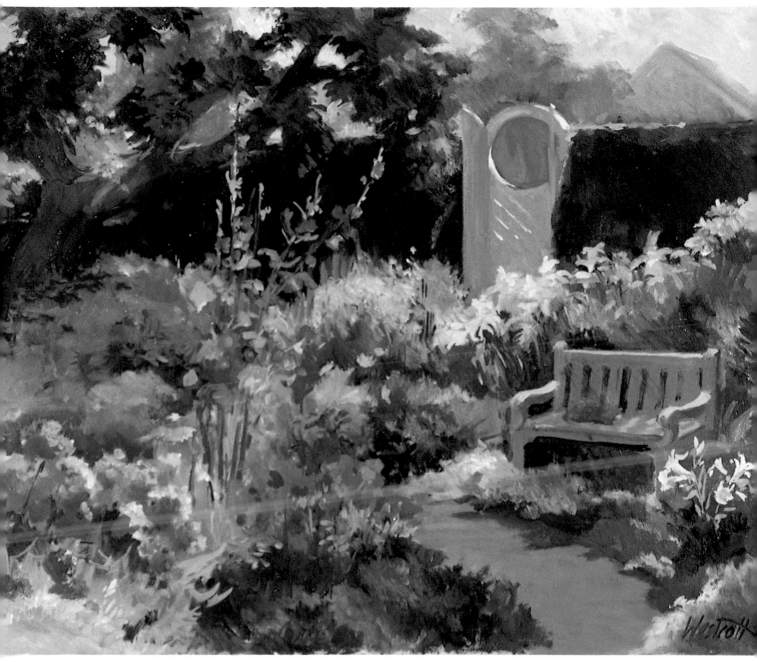

DAVID'S GARDEN by Carol Westcott. Oil on Masonite, 16 x 20 inches. Private collection.

The characteristic shared by the two magnificent paintings you see on these pages and the one by Rosalie Nadeau on the preceding spread is the complexity of subject matter, whose color, light, and beauty belie the difficulties inherent in expressing such subtle light keys. The organization of masses accounts for the success of all three.

Loosely depicting details with her dexterous brushwork, Westcott applies her color in translucent strokes. Although this method advocates painting with a palette knife, the immediacy of these images is not at all compromised—and may actually be enhanced—by the brush.

SUNNY DAY MARSH: AERIAL PERSPECTIVE

This landscape is composed of a marsh and stream with reflections in the water. The optical effect of aerial perspective—the expression of atmosphere and space by gradually making succeeding planes cooler and less intense—creates the sense of distance in a landscape. While in our previous studies we painted objects close by with strong shapes and colors, the large, flat planes of landscape pose different problems. When planes recede, the intervening atmosphere can make masses appear vague and remote, dissolving them into subtle shifts of color.

FIRST NOTES

As with all paintings, I first lightly sketch in the simple shapes of the composition: the two color masses in the distant dunes, the horizon line, a few lines to indicate the winding flow of the stream, and the dark tones that describe its banks.

It is more difficult to distinguish color changes in flat planes than in rounded forms. Form is created with curved masses of distinct color, which are easier to see than the subtle receding colors of flat planes, which flow together almost imperceptibly. Keep the first notes clean and separate to establish the sense of space more effectively.

1. Starting with the sky, I notice two different color spots: the warm mass directly above the landscape and the cooler sky mass overhead. The lower sky mass is much pinker than the water, a result of the light's warming influence. The water note will be Permanent rose, so I decide to use one of my two reds—Chinese red or Cadmium scarlet—for the sky. I use the Chinese red because I want to save the warmest tones for the landscape. I then scumble Cadmium yellow pale over the bottom half of the sky mass to create warmth.

2. Although I have already chosen its color, I do not want to paint the water note at this point. If I isolate it now I may not get the value right.

The trees in the distance are greatly influenced by the intervening atmosphere, making them a sort of bluish-purple. The dunes area, which contains a variety of trees and landscape elements, is not a unified mass. The right side is distinctly purple, while the left appears warmer and greenish, though somewhat

(Above) Composition photograph: Sunny day marsh, aerial perspective.

(Right) Sunny day marsh, aerial perspective, first notes.

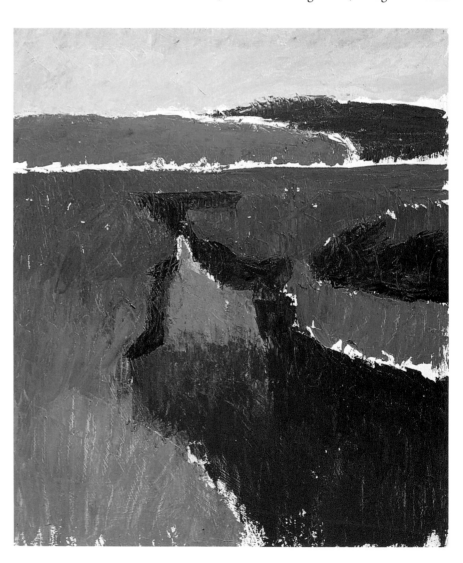

grayed and slightly blue. I paint the right side first with Violet, then the left side with Viridian, a cool green that is actually warmer than Violet. Because of its intensity, the Viridian needs to be cooled, so I scumble Violet into it so that it recedes.

HELPFUL HINT

Some artists prefer to keep the starting notes in their landscapes as structured as those in their still lifes. I generally keep my colors separate to reflect the very obvious differences, such as those in the dunes area. The differences between the sky masses are subtler, so I let those colors blend.

3. I scan the entire marsh to evaluate it, then I lay in a rich bed of color to set the stage for the marsh itself as well as the receding planes. The marsh overall is rich and golden, and its most distant area is very orangy. Cadmium orange is too warm and bright for this plane, as it will bring the entire background area forward visually. I decide to use Cadmium scarlet for most of the area in the distance, keeping it fairly dark.

4. In order to bring the foreground forward, I use gradually warmer and brighter colors to establish first notes of the preceding planes. I mix a little Cadmium orange into and over the Cadmium scarlet, then warm that transition with Cadmium yellow and Cadmium orange. The softened edges make the image appear more "painterly."

5. I now paint the water in the same way, whose foreground is much darker than its middle area, which is very pink and darker than the sky. I don't want the area to be too cold, so I use Alizarin crimson mixed with white. Compared to the background mass of the dunes, the rich, deep color of the water in the foreground is warmer purple. After scanning it again, it begins to look more like Permanent magenta. I first lay it down pure, then I use a darker mixture with Permanent rose to create a halftone "bridge" between the Alizarin crimson and the Permanent magenta.

6. The deep earthen colors of the bank and the bush in the middle ground present the same problem as the cast shadows of still life objects: Though the variations among them are clearly visible, sometimes I'd rather avoid varying these masses too early on. These dark and luminous areas appear to be a mixture of earth colors, so instead of just putting down one pure note, I mix some red into one of my earth tones for a beautiful amalgam of both colors.

SECOND NOTES

After completing the first notes, I scrape off some of the dried edges of each mass. This liberates me from the rigid structure of the underpainting and enables me to use my second strokes of color to more accurately describe form.

1. At this point, almost any blue would work over the pink and yellow that we used for the sky's starting notes. Since these two colors are warm—and still wet, so I can scumble the second note into the first—I use Ultramarine blue. If I used a warm blue, such as Cerulean, the note might become too green. In order to compensate for the darkening that might occur as a result of the wet underpainting, I mix the Ultramarine with white so that it's slightly lighter than the pink and yellow. As I add the blue, I pull the pink and yellow into each other so that parts of the second note become mauvy and warm, creating five or more variations within the mass.

I then bring down the lightened Ultramarine to more accurately describe the edge of the sky against the dunes. Rather than relying on stiff lines to make the distinction between the two masses, I use the varied edges, both hard and soft,

Sunny day marsh, aerial perspective, second notes.

that occur naturally and are more interesting and painterly. Sky notes against background notes, whether mountains, trees, or rooftops, illustrate Hawthorne's observation that two colors side by side create a visual line.

2. There are many color variations in the trees within the dunes mass. As we established in the first notes, the Viridian color mass on the left is cooler than the Violet one on the right. For the Violet note, I warm Permanent green light with a touch of Cadmium yellow, then add a little of the underpainting color, Permanent magenta, to make the mixture almost as dark as the Violet. I keep it a little lighter so that the Violet still shows through and creates a sense of shadows within the tree masses. I do the same for the left side, scumbling the original Viridian note with lightened Yellow ochre, but I avoid over-

mixing them so that the new color exhibits characteristics of both. The link between the two masses is the band of green trees, which looks very light and yellow when isolated. This light, bright green is still relatively dark and somewhat grayed. It isn't as pure as Cadmium green pale directly out of the tube, which it might look like at first glance. As a matter of fact, I can either use grayed Cadmium green pale or grayed and lightened Permanent green light.

3. The large flat mass of the marsh contains greens, golds, and many other beautiful nuances within its rich foundation colors, though at this point I am afraid of mixing "mud" by adding too many colors at once. My primary goal for this round of marsh notes is to eliminate the white line between the marsh and the dunes, so I decide to express only

a few of the green variations and wait to add in the others later. The green is very much like the warm green that I used for the line of trees between the two dunes masses, although it might actually be a little lighter and brighter. I lighten the color I used earlier with a little yellow, which keeps it warm (white might have cooled it too much). After I lay in a band of it between the two masses, I add another directly in front of it as well as along the edges of the distant bank.

4. While working on the farthest areas of the marsh, I decide to continue breaking it up by painting in its dark notes, which are a result of the the depth of the grasses. (While some artists might have used these colors as part of their starting notes, I didn't notice the patterns until after I had established the entire marsh. Either procedure is acceptable.) These areas are about the same in color and value as the original notes of the bank, but I make them a little lighter and cooler to match the richness of the color in the flat plane. I also use this color to create some volume and roundness between the marsh grass and the stream, then lighten it to round the edges of the crest of the stream at the top of the plane.

THIRD NOTES

1. The stream now looks too warm against the colors that were added in the previous round. It is now obviously very blue, but which one should we use? Cerulean might make it appear too green, while Ultramarine might be too cold. Comparing the water to the rest of the landscape, it appears as a slightly warm blue. If I had Cobalt on my palette I would use it here, but instead I mix a combination of Ultramarine and Cerulean lightened with white—a warm-cool blue—and scumble it over the lightest pink in the water.

2. The blue I see in the foreground is darker and a little warmer. I remix the Ultramarine/Cerulean combination, this time making it darker and letting the Cerulean dominate. I leave a lot of the original note showing through, and mix it into the blue I added in the previous step.

Sunny day marsh, aerial perspective, third notes.

3. The area of the stream that is closest to us still looks very violet. I use a predominantly Ultramarine mixture this time, leaving most of the original Permanent magenta note visible.

4. Now that the stream has changed, the other colors in the landscape are starting to make their presence known. The blue of the water helps me see the many warmer colors, subtle oranges and reds. These colors, when isolated, appear rich and conspicuous, yet within the context of the large and distant mass they must be kept grayed and less saturated in order to remain in the background.

I add some of these notes, filling in spaces between the existing colors. I also want to begin defining the variations in the landscape. On the left is a bush that needs some cool spots of green mixed into its warm notes. I add these colors and almost fill out the entire mass. When I add purples to make the entire area darker and more dense, I also round more of the bank's edges. The color changes in the third round have been made with four new colors: beautiful variations of greens, browns, oranges, and magentas. I can still use the foundation color to represent the oranges, so I continue with the greens and some violets, using them to continue rounding edges and eliminating white areas.

I make two greens by mixing Permanent green light with two complements: Cadmium scarlet for a cool green, and Cadmium orange for a warm one. Starting with the area between the dunes and the marsh and working forward, I alternately scumble these two greens throughout the entire marsh. However, because they are middle tones, I do not bring them all the way to the foreground.

5. The marsh area directly above the reflections in the stream isn't as light as the area in the lower left, so I use the same greens there as well. Within this same area, I use a brownish mixture of Violet and a little yellow to create dark notes within the greens and to round a few more edges along the banks.

Because the foreground marsh area is brighter, I use warmer and lighter greens to create a sense of closeness.

FINAL NOTES

The last notes will be used to "finish" the painting. I fill in colors as I see them, leaving small areas of the starting notes showing through to produce the necessary vibration of colors and to make their presence visually active.

1. I add more subtle reds and greens throughout the marsh, gradually darkening within each advancing plane. The colors for the foreground mass are significantly warmer and brighter and the strokes are thicker and larger, which make it appear closer.

2. The edges of the bank need more green, and the reflections in the stream contain some nuances as well. I notice that the background area of the latter is very cool, so I scumble a grayed blue into it. I then bring some of this color forward into the preceding planes of the water notes. For the bank, I gray and lighten Viridian with Cadmium orange and white and lay in the mixture over its dark earth tones, which brings it into line with the rest of the painting and creates the illusion of wetness. I allow the foundation color to show through, especially at the bottom of the bank, which forms a "water line" that I then don't need to draw in. In addition, I bring some of the blues and purples of the water over and into the edges of the bank to establish a reflection without a stiff or rigid rendering.

Sunny day marsh, aerial perspective, final notes.

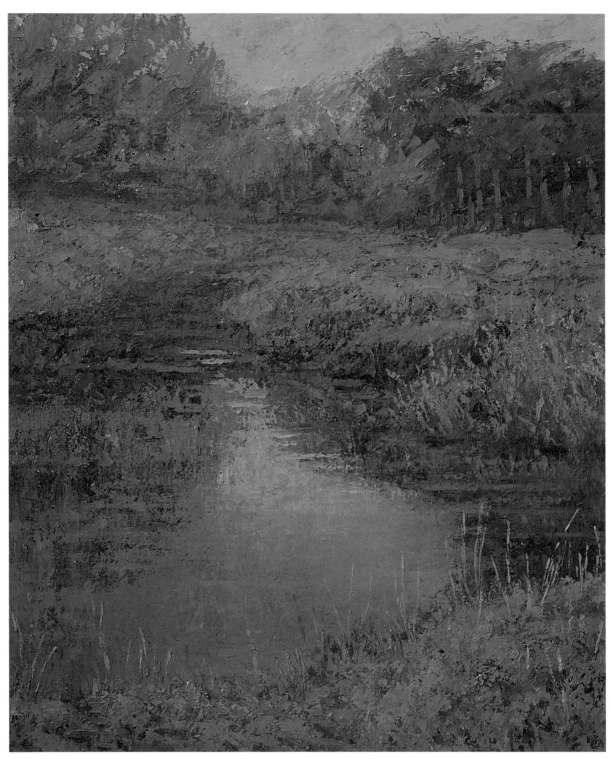

STREAM THROUGH THE PAMET
by Lois Griffel. Oil on Masonite,
24 x 20 inches. Collection of Mark
and Holly Nemiroff.

This painting is similar in composition to the study, but the problem here was that the vibrant orange marsh grass was both in the distance and in the foreground. In order to maintain the sense of space, I used large, staccato strokes of color in the foreground with several layers of scumbling. I kept the foreground very warm by establishing a deep red underpainting, teasing the viewer into believing that the foreground is closer despite the fact that the brightest notes are in the center of the painting. To emphasize the aerial perspective, I applied the background in thinner horizontal layers. The sculptural effect of the layering also enhances the illusion of space.

IRISES by Terry Rockwood.
Oil on Masonite, 18 x 24 inches.
Courtesy Sola Gallery,
Provincetown, Massachusetts.

This lovely, ethereal painting of hazy light incorporates a successful handling of reflections. By squinting you can see the basis of the bold underpainting that composes the main mass of rushes and reflections, which is the focal point of the painting. The details—just a few dark spots of color that distinguish the rushes from the reflections— are established very simply.

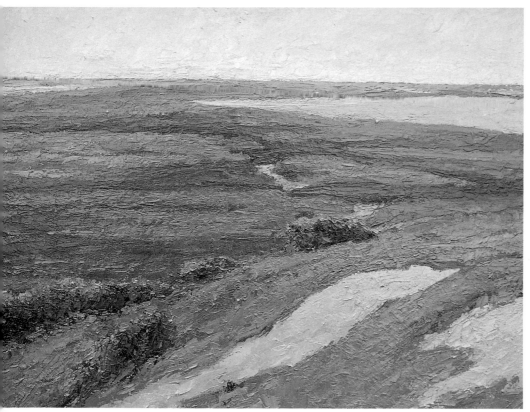

HIGH HEAD, EVENING LIGHT by Lois Griffel. Oil on Masonite, 18 x 24 inches. Collection of Todd Outhouse.

The challenge in this painting was to create the effect of aerial perspective without dulling or lightening the background colors, possibly causing a fog or haze in what was actually clear evening light. While keeping the colors strong and deep enough to express the light effect, I applied the cooled background notes in thin, horizontal strokes to express the sense of distance. Note that the values remain essentially the same from the background to the foreground, where the warm light shimmering through the bushes simultaneously pushes that area forward while making the cooler colors behind it recede.

ROLLING DUNES: CLOUDY DAY PANORAMA

The deep, rich colors of this landscape, a sand dune and scrub pines on a cloudy day, echo those that we used in the cloudy day block study. However, it is interesting to note that the resulting colors are never as blue as they at first seem. The beauty of this painting lies in the design and rhythms of its elements.

FIRST NOTES

There are several areas broken up by smaller clumps of scrub pines and bushes, but I overlook them in the initial drawing in order to retain the simplicity of the starting notes and instead sketch in only the rhythms of the largest masses.

1. This sky mass has a lot of warmth, but is much less saturated than a sunny day sky. Permanent rose is too intense, so I start with the cool violet-pink of Permanent magenta. I also see some yellow in it, so I dull it with a little Yellow ochre.

2. In contrast to the sky, the distant dunes look very purple, and part of them looks more saturated because it is closer. Remembering that warm colors advance and cool colors recede, I deliberately use Violet for the farthest dune. For the warmer plane immediately in front of it, I use Viridian, which is simultaneously cool and warm. It looks just right.

3. I decide to lay in both sand areas at this point. The sand mass in the distance appears slightly darker, while the one in front is a little lighter and brighter. I use Yellow ochre because it is neutral, and I love its pinkish yellow-gray quality. I then gray the color of the background areas with a little blue to make them recede, leaving the foreground area as is.

Composition photograph: cloudy day panorama, rolling dunes.

4. Before establishing their greens, I want to lay in a rich underpainting for the trees that will enhance their texture later. I see two primary masses, and mix a Permanent magenta warmed with Alizarin crimson for the slightly more distant area, and use pure Alizarin crimson for the closer one. These slight nuances in value help to create the illusion of space.

5. The last main mass is the closest to the viewer, so I want its color to be rich without making it too warm or sacrificing the integrity of the light effect. I see it as Viridian, then lay it in. After comparing it to the background mass where I had used Viridian earlier, I see that the background area is cooler than the foreground. I first scumble Permanent mauve into the background, then mix a little Permanent green light into the foreground to enhance its warmth.

SECOND NOTES

The colors for the rest of this demonstration are mostly complementary mixtures, for which cloudy day paintings always provide numerous opportunities.

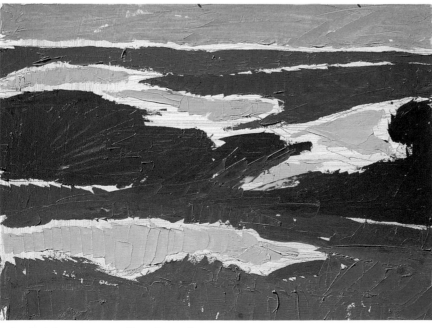

Cloudy day panorama, rolling dunes, first notes.

1. At this point the sky needs to be blued a bit. The slight warmth of the Yellow ochre that I added to the Permanent magenta makes Ultramarine a good choice, but if I hadn't added the ochre I might want to use a warmer blue instead. I lay in the Ultramarine, allowing much of the first note to show through. If my underpainting is already dry, I remix the starting note and restate it when I add the second one.

2. I want to start adding some of the details, which are more visible during this round, and at the same time fill out the masses to their edges. This particular start was very simplified, with a lot of white showing through.

3. Moving forward within the composition, I can see many colors in the tree masses. I first use Viridian to create shadows, keeping the color darker than the starting note and rendering them simply and rhythmically. However, I am not observing and painting each individual tree; that would mean too much detail at this point. I also notice grayed green areas within the tree masses, which indicate bushes and provide sort of a halftone bridge between the trees and the sand. Note that natural landscape elements occasionally serve more than one function within a composition.

4. The autumn colors and brighter greens within the large tree mass are now immediately evident. I dull Permanent green light with Permanent magenta, the color of the original note, which darkens it slightly. (If I had darkened it too much it would look like a shadow.) The richness and warmth of this green keeps it within the framework of the mass. If it were any lighter or more saturated it would look out of place. I neutralize Cadmium orange with Permanent magenta as well, matching the value of the original note while leaving a few "scratches" of pure Cadmium orange to create the variations within the mass.

For the lighter trees, I lighten the Permanent green light/Permanent magenta mixture with both Yellow ochre and white. (White alone would make it too cold.) I then add the lightened Yellow ochre and the lightened green near the

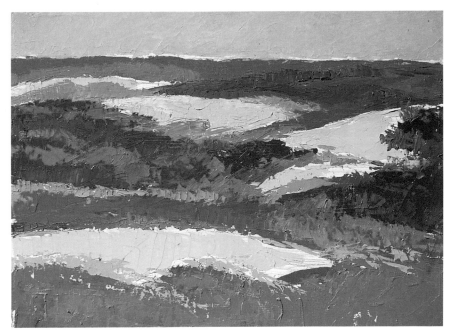

Cloudy day panorama, rolling dunes, second notes.

bottom of the mass. After scanning the landscape, I notice similar greens in the trees on the other side of the composition, and add both dark and light versions with just a few strokes. This begins to break up the tree mass and creates volume as well.

5. Dark shadows within the area of the large color mass in the immediate foreground make the dune grass appear lighter, and there are also shadow notes directly in front of them. For these two notes, I cool Viridian with blue and mix an even cooler version of the Permanent green light mixture by adding Violet, then lightening it with white. As long as each mixture is carefully blended, these grays can be beautifully delicate. I scumble the light purple-green mixture at the top of the mass, then add it on its far right side, scumbling in more Violet as needed or desired. I scan the landscape to see where this color might also be needed.

6. There are many ways to paint the wonderful violets in the sand. You can match the value of a second note of Permanent rose to the original Yellow ochre note. If your ochre note is still wet, you could blend them for a subtle variation. Since my underpainting is dry, I scumble it with lightened Permanent mauve

that's been slightly grayed with Yellow ochre. It matches the value of the first note exactly while remaining above it. I also add this note to other areas in the composition where I see similar color spots. Although I haven't yet painted the bottom dune, I see a similar purple. Because I am using it as a halftone, the color there needs to be richer and a little darker. I use it on the right side of the painting to break up the Alizarin crimson, which establishes the stippled look of the sand within the grassy area.

7. Last for this round is the large tree mass in the far right middle ground of the painting. It has a lot of warmth and many color details. I use the same purple-green that I mixed for the edge of the dune (Step 5). It works beautifully, so I add it as a color nuance in the large mass.

THIRD NOTES

1. There are beautiful purple nuances throughout the landscape. Within the greens of the background tree mass, I gray the purple so it remains in the background and works well with the green.

2. At this point I begin adding some of the autumn colors in the trees. All of these colors appear silvery due to the intervening atmosphere, and so will be

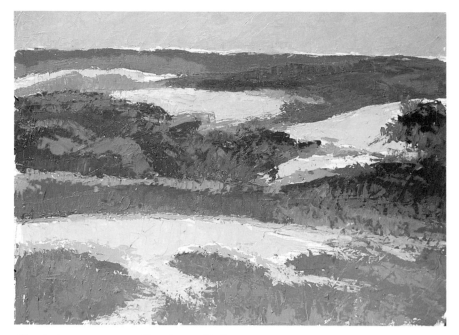

Cloudy day panorama, rolling dunes, third notes.

RAIN by Michael Rogovsky. Oil on canvas, 48 x 48 inches. Collection of Mark Mello.

This artist has boldly used all of the colors that we are applying in our cloudy day landscape, uniquely interpreting both the light key and the feeling of rain. By allowing it to create the illusion of atmosphere and space without the confines and control of drawing and detail, Rogovsky has used color for its purest purpose.

grayed. I use Cadmium scarlet and Cadmium orange to lay in some of the large rhythmic elements of the tree colors. By squinting you can see how the strongest notes will create the desired effect.

3. Now I lay in the rich, dark purple notes of the shadows beneath the trees in the large landscape mass. The shapes of these elements express depth.

4. As we move forward within the landscape, the silvery green notes between the sand and the grass act as halftones, helping to break up the masses further and refine the look of the dunes. After graying a green with red, I create two versions, one for the right and the other for the left. Both are lighter than those in the foreground.

5. To depict the paths of sand that wind through the foreground mass, I use Yellow ochre to cut shapes into the preexisting form. I try to keep the edges painterly, which brings the eye into the painting.

FINAL NOTES

For this step, I will mix more subtle, grayed colors to round edges, fill in any remaining white areas, and generally "finish" the rest of the painting. Although it is important to work consistently throughout a painting, it is not unusual for some areas to be completed before others. In this case, I decide to work on the colors that I see in the largest landscape masses first. I put colors down within the same rhythms of form that I established earlier. I do not "draw in" specific trees, but instead respond to patterns and simplified details of color. The strokes throughout the painting are broad and specific.

1. I add a warmed green to the dark masses to lighten and lift the density of the color. I then lighten this color to soften the edges between other greens as well as between some of the oranges and pinks. The original notes are only "peeking out" between strokes, serving to influence the appearance of the landscape as "cool and cloudy."

2. I add greens into the violet areas throughout the background and in part of the middle ground.

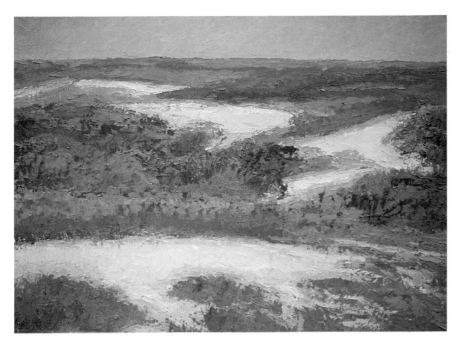

3. I add a mid-tone green to the dune grass in the middle ground, which also serves as a bridge between darks and lights. On the right, I add strokes of light green. As in a Monet, you must observe the painting from a distance to see the colors mix and merge to create cool, rich vibrations.

4. I more clearly define the paths of sand in the foreground by adding halftone greens to make the colors more subtle and finish filling in the white spots.

*Cloudy day panorama,
rolling dunes, final notes.*

DUNE IN OVERCAST LIGHT by Lois Griffel.
Oil on Masonite, 18 x 24 inches.
Courtesy of the artist.

This painting illustrates yet another light key of an overcast gray day, this time with the bright red foliage and warm light of autumn. The greens appeared cool in this light, which gave me a chance to gray them with a red while retaining their original character.

SUNNY DAY HOUSE AND GARDEN

The little house and fenced yard on an intimate and private street on the opposite page is a favorite among many of my fellow artists. I selected it for this study because of its extremely dramatic light effect, and because it gave me opportunities to paint a tree in sunlight and shade, and link the sunny day block study to the white house in sunlight and white fence in shade.

A house in a landscape essentially serves as a large-scale block study. I think of this house as a large white block, even though one side has been painted with a light blue. As with the block studies, I don't want to break up the house too much or too quickly. The landscape's natural elements should be painted as simply as the start of a still life. All areas should be indicated by large masses of lights and darks.

FIRST NOTES

I start with a simple sketch, squinting to eliminate details. Notice the strong light and dark masses of the composition. There are trees that are entirely in sunlight, as well as those that are completely in shade. Hawthorne described the process of painting trees as looking at their silhouettes against the sky, and cautioned against painting leaves as "too many little darks and lights." Instead of drawing each branch of the tree, look at the tree as a single, large dark shape. You must "paint the tree as a whole spot in its relationship to other things." Do not paint all of the "sky holes" in at the beginning, and don't worry about the descriptive edges. The shapes should be simple, but close to the "descriptive outline" of the tree.

While working, I notice that some of the flowers create an obvious color pattern. If the flowers are very scattered, as they are in other parts of the bushes, I add them during the final touches.

1. Since the house and the sunlit portion of the fence are white and the lightest elements in the painting, I will paint them with Cadmium lemon mixed with very little white, keeping it as rich as pos-

sible. The fence has both light and shade elements within the light area. By squinting, the light area of the fence becomes more important. At this point, I won't worry about the details on the house, and will leave the areas of the windows for later color notes.

2. Next, compare the roof to the color of the house. The roof is very warm but grayed. As I scan the landscape, I see the warm influence on the shingles as Yellow ochre. I put it down and notice that it is a little too dark, so I lighten it with white.

3. After the house, I can work on either the trees in the front or in the background. I decide to paint all of the sunlight areas first. Comparing the trees in sunlight against the Yellow ochre of the roof, I want to look at the large main note. Although there is light and dark in the texture of the leaves, I don't want to "speckle in" those details at this time. I must simplify the entire area and only express the sunlight.

The color is almost as dark as the roof and it gets lighter as it edges toward the sky. The green note looks very orangy and is a rich, middle tone. I paint the darkest part of the large mass with Cadmium scarlet mixed with a little white. In the center, I use Cadmium orange, and to draw the eye toward the lightest area I use pure Cadmium yellow. I try to make these puzzle shapes interesting, and let the forms of the trees serve as a general guide.

4. Moving lower in the composition, the area of the grass is much lighter over all. While we know that grass is green, and similar in color to the trees, the flatness of the plane makes it appear lighter. I use Cadmium yellow for the grass note, and mix a tiny bit of Cadmium orange into it for additional richness.

5. Because I have indicated the color of the light tree mass, it is easy to evaluate the sky note. The sky is really bright and warm, and a little lighter than the lightest area of the tree mass. Although it would be easy to start with Permanent rose, in this case it is too cold. I have to warm it first. There would be a number

of good combinations. I see that the sky remains "pinkish," and I paint it with a mixture of Permanent rose warmed with Cadmium scarlet.

6. There is a portion of the path in the light area that is a pale sandy color, close in color to the sky but much warmer. It isn't as yellow as Cadmium yellow or as cold as Cadmium orange lightened with the addition of white, so I decide to mix them together and make that the starting note for the path.

7. Last, there is a part of the bush along the house in sunlight. Because there are so many details, I must reduce everything to solid lights and darks and ignore delicate branches and details. I make a large shape out of the light plane on top of the bush. Since it is bright and warm, I keep all of my light planes consistent, and use Cadmium yellow as I did for the grass.

8. Now we turn to the shadow area of the composition. The large tree-and-bushes mass is consistent with the color of the bushes in front of the fence. I squint, reducing all details so that I can only see the largest of shapes. Again, I do not look at individual leaves, but pattern them into colors. There is a sculptural quality to the forms of the trees as well as the area along the bushes that is described by color and value changes rather than extreme contrasts of light and dark. I use Viridian mixed with a touch of white for the darker areas, and lighten Permanent magenta for the variations. I try to keep these forms large, simple, and solid, but they must refer to individual trees and bushes. Once again, it is important to establish color without looking at details.

9. The fence poses a new problem: It contains the lighter notes of the pickets against the dark color of the shrubs showing through. While some artists use alternating broad slashes of color to start the picket effect, the difficulty in that approach is that you aren't looking at the true color of the fence, but at its details instead. You must decide which is the

more important note of the mass: Is it the color of the fence, or the color coming through the pickets? If this fence were very old, and the pickets broken in many places, chances are that the color of the shrubs would be the important note. In this case, the darks are the detail portion of the mass. Squinting will help you make these decisions.

I clearly see Cerulean blue and put it down very pure with a small addition of white. I keep the color area simple, and although there are leaves and details, I keep those edges sketchy, letting the green blend into the fence.

10. The shade area of the path is cooler than the shadow area of the fence. Any violet will work because of its reddish element. I use Winsor violet because it stays in shadow but gives me a specific color change from the fence.

11. When adding the window and shutters, it is easy to be overwhelmed by detail. As Hawthorne would say, "Let your idea be not that you are doing a portrait of that place, but of that time and day." In order to keep from making a "portrait" of a house, simply scan the large mass and get a color idea of what the shutters look like. Compared to the landscape, they are a very saturated green. Because they are in sunlight, I will use Permanent green light, whose richness and value hardly need adjusting. The windows are reflecting the landscape, which makes their notes darker and cooler, so I use Ultramarine blue warmed with a little bit of yellow.

Composition photograph: sunny day house and garden.

Sunny day house and garden, first notes.

SECOND NOTES

1. The house's first color note is now influencing the color of the roof, which needs to be warmer. I lighten Cadmium orange to match the value of the Yellow ochre, which is still wet. The two colors mixed together make a gorgeous note that gives it exactly what was needed.

2. To create volume within its large mass, I add halftones to the underpainting of the tree in sunlight. Painting this kind of low-contrast mass is almost like modeling a still life form. I gray the Cadmium scarlet note by mixing a little green into Cadmium scarlet, then lighten it with white so it works as a halftone. I mix this between the two darker starting notes. The two lighter colors do not require a halftone transition since the Cadmium yellow acts as a highlight. I simply mix the two starting notes to eliminate the white area.

3. Next I establish the darker accents for the tree in shade, which will give its mass greater definition and bring the foreground forward. I see the color as very cool, either a violet or a blue. However, I want to it be somewhere between the Viridian and Permanent magenta in terms of warmth. I decide to mix Ultramarine blue with a little Viridian, stroking it into some of the darkest passages and filling in most of the white areas. I also use strokes of Viridian and Permanent magenta suggestive of landscape shapes to break up the original notes.

As you become more comfortable establishing large masses, you can consider this stage as your starting statement.

THIRD NOTES

1. In order to make the white of the house look more accurate, it must be distinguished from the warm, rich oranges and yellows used for the tree in sunlight. The concentrated light effect also makes the center of the painting appear very golden, so the house must remain fairly warm as well. I mix one of my pinks, matching the value of the first note. Note that adding a separate note for the blue side of the house would not make an important or interesting statement at this point.

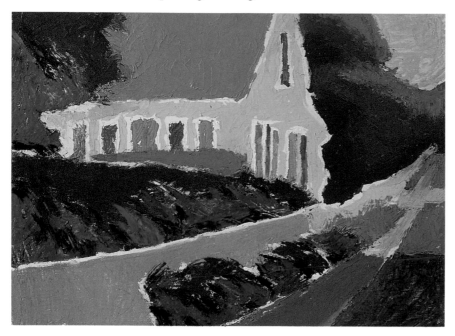

Sunny day house and garden, second notes.

HELPFUL HINT

As soon as you put a pink down, you must decide how effectively it cools the yellow. Sometimes you need the second color to enhance the first note, but not change it too much. When I put my pink down, I noticed that it cooled the first note too much. Since my first note was already dry, I couldn't mix the second color into it, so I added a little bit of Lemon yellow into the pink to warm that instead.

2. For the greens of the tree in sunlight, I mix the colors from the first notes into Permanent green light. This will make a bright yellow green, a warm halftone green, and a silvery dark green, each of which will also be mixed into the first note, creating the modulation of color found within landscape.

I first match the value of the Cadmium scarlet and Permanent green light

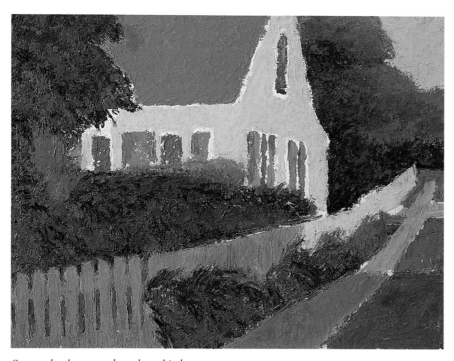

Sunny day house and garden, third notes.

mixture to that of the starting note. I scumble it over the Cadmium scarlet mass, then into some of the Cadmium orange, letting some of it mix into the first notes and some remain on top. The result is a beautiful silvery gray. The underpainting that shows through vibrates against the green, invoking warm, rich notes of light and shade, and of shadows beneath the leaves.

I repeat this process with the area painted with Cadmium orange. I add orange to Permanent green light, which again warms and lightens it. I match the value of the orange by adding a little bit of white to it, and scumble this color over the area, allowing it to mix into some of the darker and lighter starting notes as well. This gives form to the tree mass, without being too careful and tidy.

I notice that the edge of the trees near the sky is very warm. I lighten the green just used with some lemon yellow to cool and lighten the color without using white. I use some of this in the lightest part of the mass.

HELPFUL HINT

You may establish your first notes of green by mixing scarlet, orange, and yellow into the green at the very beginning. Those variations would have been beautiful and accurate, but would not have resulted in color vibration.

3. The sky appears very blue against the new color notes, and looks cool against the greens. If I used a warm blue, the warmth of the original pink note would make the new note look too green. I decide to mix Ultramarine with white, then scumble it over the pink.

4. I use Viridian to create more definition in the fence by indicating the spaces between the slats at the top. Rather than spacing them evenly, I try to vary them with short strokes of color applied with the tip of a palette knife. I stroke on a slightly lighter and warmer Viridian to create the pickets. (The color of the bushes would look too dark against the lighter color of the fence.) Once again, these strokes should vary in thickness and not be rigidly painted. The painterly approach is more interesting and express-

es the form just as clearly. With the addition of the spaces between, the fence itself looks too dark and bluish. I see that it has a lovely violet cast throughout, so I use a slightly grayed Alizarin crimson to enhance its warmth. I scumble it loosely into the slat area, leaving a lot of the original colors showing.

5. I now add another layer of green to the leaves in the bushes. I will scumble this color primarily over Permanent magenta, so I mix that with a warm green. I make it a little lighter than the starting note so that the magenta vibrates and gives the mass depth, and is warmer than the green that I used over the Viridian. I also merge this color with the note to achieve greater variations of warm and cool throughout the mass, and use it for the leaves of the day lilies. By elongating my strokes with the palette knife, I give the leaves more distinction.

I also add leaves to the tree mass, keeping this green a little redder and darker to make it consistent with the other colors. The magenta in the trees shows through to a greater degree and creates the illlusion of depth in the leaves. As I add these colors, I fill out the edges between the masses.

6. As we add more colors, we try to increase the definition of each mass. I now see that what I first thought were trees and bushes is actually part of the house obscured by a shadow pattern. I add a grayed Violet between the tree and the bushes on the left side of the painting, amplifying the space between the house and the landscape and modeling the bush in front of the house a little more specifically.

7. I add a slight warming color over the foundation note of the path. Because this cast shadow is on a warm ground, the color of the sand influences the color of the shadow. I use a little red, which I lighten to pink to match the value.

FINAL NOTES

The speed with which the final notes bring the painting together always amazes me. Several notes will be completed with only a few strokes.

1. It is time to make the tree look less bulbous by painting its individual characteristics. I mix a color that is similar to what I used for the roof in order to describe the leaves against it. Note that I am not looking at each leaf, but at the shape of the tree's silhouette. I stroke the color over and into the edges of the dark green tree, varying the strokes to soften its edges. Many students paint these strokes indiscriminantly, hoping that the variations will take care of themselves, but these edges must be carefully observed as they convey the accuracy of the compositional elements.

Next I add a few "interior" strokes to create the sky holes. This breaks up the tree more convincingly and makes it look much more interesting.

2. The final notes for the trees and bushes in shade will give their masses more volume. Permanent green light would be too light compared with the starting color. To paraphrase Hensche, we must keep the inherent quality of our darks and lights. Since it was our starting color, I decide to use Viridian, but warmed and lightened with Cadmium scarlet. The red maintains the proper value while producing a luminous grayed green which actually looks warm when scumbled into the mass. I use this color to break up the original Viridian note, which now appears as the darker element within the leaves, but I also mix it into all of the other colors.

3. The warm halftone between the light and dark plane of the bush against the house must be very rich and warm. I lighten Permanent green light with yellow and scumble it over the two edges.

4. To finish the tree in sunlight, I take all of the greens used in the third round and gray each of them a little bit. I add these new colors, as well as more of the original greens. I cover more of the starting notes, using the strokes to express the movement of the leaves. The vibration of the oranges against the greens creates a rich visual sensation of a tree in sunlight. Using the fence colors to make the bushes more interesting while at the same time establishing the stalks with long

strokes of color, I repeat this step for the bushes in front of the fence.

5. Because I prefer to leave its mass warm and yellow, I add a light green over the grass note. Keep in mind that we are interpreting color, not copying nature by depicting local color. We are painting the character of color as the light affects it.

6. I must finish defining the shadows on the house. I warm the Violet note and use it to break up the dense shape of the trees and bushes against the house in the same way that I did for the roof. This makes the bushes and trees look less bulbous and boring.

7. I want to give the shutters and windows a more finished look without being too specific. You must convince yourself that you need less detail than you think. For the shutters, I mix a light but very saturated green, adding the slightest amount of yellow to warm it to reflect the sunlight. However, because it is greener and a different material from the landscape, I must distinguish it from the bushes.

I carefully but lightly use it to describe the slats and the rectangular edges of the shutters, though their edges are not stiffly painted. I define the windows with Violet and add some Yellow ochre for the

reflections. Last, I mix some of the pink-yellow of the house and bring it to the edges of these linear elements, as well as to the edge of the roof line. I then introduce some of this color for the stippled light in the area under the tree. I use Violet for the shadow of the roof that hangs above the windows.

8. I add a little more of the grayed purple to the fence, which brings out the slats just a little bit more. As with the windows, I don't want to make the fence look too "finished." I then finish the path by warming it with Yellow ochre, making sure that this last note serves to warm the mass but does not lighten it. Now that the painting is nearly complete, you can still see that the original light and dark design remains intact. I haven't broken up any of the masses, although I have added lighter colors throughout.

9. Now for the day lilies—the best for last! I have used quite a bit of orange in this painting, but the notes for the flowers, which are both darker and richer, are only seen as vibrations under and among the leaves. I mix Cadmium orange with a little Cadmium scarlet for the lilies in the shade, and Cadmium orange and Cadmium yellow for the sunlit flowers. Using color spots to represent the flowers, I lightly stroke the new oranges over the existing greens. They stand out from the colors of the underpainting and give the lilies the effect I am looking for. I prefer to keep things loose and painterly, so I refrain from focusing on the details.

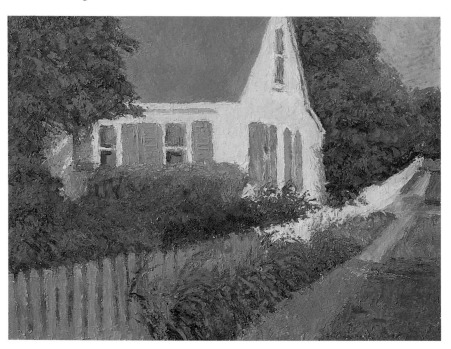

Sunny day house and garden, final notes.

CONCLUDING REMARKS

I hope that as a result of this book you are inspired to paint many more block studies; to collect still life objects and play with as many different light keys as possible; and to discover the world of color and light that is ready for painting, right in front of your eyes.

I love to paint landscape. It is such a thrill to be able to stand before nature and let her challenge me with her infinite variety and endless beauty. Nature is

always a teacher, and we must remain humble and excited students.

I aspire to always be a student. I can never be complacent when I go out to paint because I know I am going to see something wonderful that will renew me. I push myself to continue searching for new answers to understanding light, and hope that nature will reveal more of her secrets each new day. Painting is an obligation as well as a privilege, through

which we must constantly remind ourselves of the beauty and the gifts of nature. It is a great pleasure for me to share this belief through my paintings. I was extremely lucky to meet Henry Hensche, whose influence led me to Hawthorne. I am very grateful to be able to share what these two great teachers have given me with you. If this book has excited your interest in color and light, then I have succeeded.

BREWSTER STREET, 6 A.M.
by Robert Longley. Oil on
Masonite, 16 × 20 inches.
Courtesy Wohlfarth Gallery,
Provincetown, Massachusetts.

*I admire the loose, juicy
quality of Longley's palette
knife strokes, which he uses to
indicate linear details. Even
from a distance, the details in
this painting are completely
clear. On closer inspection, you
can see that they were created
with really thick strokes of
paint that aren't linear or
rigid. The details flow in and
out of the other masses and
have almost no formal
structure. This is an example
of color spots being used to
their fullest potential.*

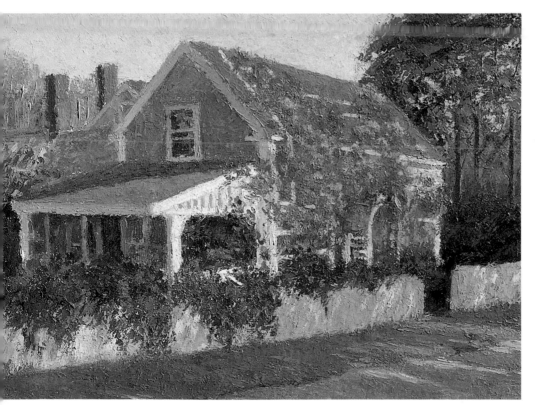

LATE EVENING, SELDOM INN
by Lois Griffel. Oil on Masonite,
18 × 24 inches. Private collection.

*With this painting I include
one more light effect, that of
the rich, golden light of late
evening on a house with a
fence and flowers. I also
selected it for its similarities to
Brewster Street, 6 A.M., and
because it was painted at the
same time of the year but at
6 P.M. It is easy to see their
differences in color.*

INDEX